Y0-AQQ-473

swing stories

swing stories

first-person tales
of sexual adventure

by jan & bridget abrams

greenery press

in cooperation with PseudoVox

© 2002 by Jan & Bridget Abrams.

All rights reserved. Except for brief passages quoted in newspaper, magazine, radio, television or Internet reviews, no part of this book may be reproduced in any form or by any means, electronic or mechanical, including photocopying or recording or by information storage or retrieval system, without permission in writing from the Publisher.

Cover design: DesignTribe

A Greenery Press book, published by PseudoVox

ISBN 1-58754-018-5

Contents

introduction

Several hundred couples-only clubs thrive all over the North American continent. Based on increases in their numbers over the past three years, it's estimated that this figure will rise to well over a thousand clubs early in the new millennium. Tens of thousands of new couples every year are taking out club memberships and refashioning the established traditional role of married couples. Couples-seeking-couples contact magazines have never been more visible at the newsstand. The World Wide Web has thousands of sites where couples can, and do, meet other couples. We are living in the age of the new sexual exploration.

NASCA (the North American Swing Club Association) has published estimates which state that three million Americans are sexually active swingers. Personally, we believe a more accurate estimate would be in the range of five million. (In one major metropolitan center, NASCA literature shows three established swing clubs. There are in fact at least fourteen, only three of which are NASCA-affiliated clubs.) If twenty per cent of these are sexually active, that would indicate between twelve and twenty million people are at least flirting with this lifestyle concept.

Why? Who are these couples? Where are they from? What drives them?

There is no question in our minds that all of the literature we've read which states that "swingers come from all walks of life" is absolutely, beyond a doubt, true! Swingers' backgrounds are as varied as the backgrounds of any random group of folks you'd meet at an airport or supermarket. Their motivations are equally varied.

• why?

Why the resurgence of interest in swing clubs? Our speculative answer to this question comes as a result of speaking with several hundreds of couples who, at some point in their marriage, had expressed interest in becoming involved in the swinging lifestyle, or were currently involved in it. During more than two years of interviews, spanning two decades, we took on the guise of an adventurous couple who were on the edge of finally committing ourselves to swinging. Most of the individuals and couples we spoke

with were under the impression our questions were asked in order to relieve our apprehension about the lifestyle.

On one particular visit to an off-premise club, we were offered a piece of advice, the true meaning of which we finally discovered halfway through the writing of this book. A well-mannered gentleman, upon discovering our "curiosity toward the lifestyle," said, "It can be the most beautiful experience you think you may ever have, but, it can turn into the ugliest memory you'll carry with you for the rest of your life if you're not careful."

What's the attraction? Why do they keep coming back? Some of the reasons we've heard personally are: "because it's erotic adult fun," "it's a turn-on," "a thrill," "it's walking on the edge," "it's an escape," "it's like a holiday," "it's getting away from it all." It's even been called "pure adrenaline" by some. One disturbing reason heard regularly was "it's addicting."

The most pathetic reasoning we heard was, "I thought I might as well or he'd have probably moved out." The most compelling reasoning we heard was given by a couple from Florida. Their youthful photograph belied their actual ages, in their early fifties. Speaking with them by telephone, it was obvious their attitudes and manner were as young as their photographed appearance. The last of their four children had finished his university education and moved out of the family home within the past year. For the first time, in not quite thirty years, they finally had a commitment to no one but each other. Their reasoning was, "We've been faithful to each other, an example for our children to follow, worked hard all our lives, and we've both decided, at this late point in our lives, we could allow ourselves to have a little fun."

• **millennial sexuality** Searching for an answer to our questions about what led these couples to make the decision to join a swing club, we virtually tripped across a startling common denominator: the majority of swingers were fans of explicit adult sex videos. This was indeed an interesting observation.

Over the course of the last fifteen years the sex film industry has come out of the closet, so to speak, and into the living rooms of adults across North America. This is now a legitimate billion-dollar-a-year industry. As recently as ten years ago, the only social gatherings at which movies of this genre would be discussed were all-male stag parties. Today you can overhear the cream of society critiquing the latest X-rated releases at the finest of black-tie dinner parties.

Could it be the resurgence of interest in swing clubs has come as a direct result of the sex film industry's newfound legitimacy? Is it possible this video "product" acts to sell sex itself?

In the early days of the eight-millimeter stag flick, the actors looked as though they were solicited from the dregs of society. Many used masks or cloth bags to cover their faces and heads while performing in front of a camera.

As the adult movie industry evolved, its producers began drawing a new class of actor into the business. This new breed were attractive, wholesome-looking and uninhibited.

The first sexually explicit movie to gain worldwide attention was "Deep Throat," starring Linda Lovelace. Jan remembers, "As if overnight, every guy I knew was talking about oral sex. Having been a part of the free love generation, my attitudes towards sex were as liberal as my libido could sustain. In those pre-AIDS days, one night stands were common, yet most of the people I knew still thought of oral sex as an act practiced by homosexual men." This shift in attitude demonstrates the power of erotic film imagery to shift public fantasy and opinion.

In the '70s and '80s, home video technology became widely available and affordable. Couples could watch their favorite erotica in the privacy and comfort of their own living rooms or bedrooms, without the need to venture into the unknown and frightening territory of an X-rated movie theater.

In the early years of our marriage, we would periodically watch an adult video together. At first this voyeuristic behavior brought on an aphrodisiacal reaction. Dozens of movies and a few years later, although viewing movies was still sexy and fun, the levels of stimulation were gradually diminishing. To reintroduce the initial thrill, we explored movies depicting situations which were not a normal part of our personal sexual repertoire... and our curiosity grew. We were inspired to experiment with new behaviors which, with time, grew to become normal components of our sex lives.

In the mid-'70s through early '80s, just as on-premises clubs were reaching public attention, came an onslaught of adult movies featuring multiple-partner and group sex acts. Were we influenced into attending on-premise swing clubs by our adult film viewing habits? Did our discussions of our attraction to multiple-partner sex come as a direct result of exposure to these exciting videos?

In the first years of our marriage, the last thing in the world we thought we'd ever consider was multiple-partner sex. We now tend to believe that repeated exposure to adult films was ultimately responsible for Jan's thinking that Bridget would "look kind of neat" caught in the ecstasy apparent of on screen actresses participating in multiple partner sex acts. Food for thought? We wonder.

Meanwhile, as adult films exploded across North America, a parallel growth in adult print material was simultaneously taking place. The number of erotica books published increased 324 per cent between 1991 and 1996, according to the Subject Guide to Books in Print, while the overall number of books published increased by only 83 per cent. Much of the new erotica is being written by and for

women. John Heidenry, author of *What Wild Ecstasy*, a new history of the sexual revolution, says: "Seventy per cent of these books or more are being bought by women." Women have clearly become keenly interested in sexual fantasy issues.

• the internet

By 1991, the term "Internet" started to seep into our collective vocabulary. By 1995, it was estimated that twenty million homes throughout North America were wired to the Internet. Twenty million! Thousands of adult Internet sites featuring every aspect of human sexual behavior sprang up as if overnight. By mid-1998, there were commercial enterprises specializing in Internet pornography listed on the New York Stock Exchange.

In the years before the Internet became mainstream, its complexity made it the domain of computer geeks. Major advancements in software development quickly rendered these Internet complexities obsolete. Ease of use became the selling feature responsible for what by now surely must represent hundreds of millions of dollars' worth of Internet browser sales.

The age demographics for Internet users are easily obtainable from dozens of Internet use measurement agencies and readily available by entering "Internet use statistics" into the search windows of *www.yahoo.com, www.google.com*, etc.

Average numbers: 26 per cent are between the ages of 21 and 30,

25 per cent are between the ages of 31 and 40,

23 per cent are between the ages of 41 and 50.

Of these numbers, less than 65% are men, with the gap between male and female 'Net users narrowing every year.

The same type of statistical information for users of adult sites is not readily available; however, the endless number of sites and individual site "hit" counts can only be termed as phenomenal. Hit counters are the cyber-equivalent of a turnstile. As a user enters a site, the visit is counted and a running total is recorded. These hit counts clearly indicate that the users of the World Wide Web are, beyond question, drawn to computer porn.

Can the resurgence of interest in swinging be related in part to the Internet phenomenon? Our informal research enables us to emphatically state that indeed there is a strong correlation. Our information-seeking sessions were made possible through the use of Internet Relay Chat (IRC) computer software and connection with innumerable swingers' channels. During five consecutive months of exhausting days and nights, under the guise of many different aliases, we "spoke" with more than two thousand men and women from the world over.

The IRC channels were alive with thousands who had come to satisfy their curiosities about the subject of fantasy sex. As we spoke with various singles and couples, we captured the remaining open channel discussions to the computer's

hard drive. This capture process is the equivalent of a printout. Later while studying these printouts, clearly defined groups of channel users began to emerge.

The first group, in these many channels, are dozens of what are known as channel ops, or operators. IRC ops are genuine swingers. The second group are the channel regulars, most of whom are sincere, there to meet other like-minded individuals for future face-to-face meetings. By far the largest body of IRC visitors are the curious. The remaining IRC population are known to the ops and regulars as flakes, losers and thrill-seekers, often single men representing themselves as female.

Never before has it been as easy for the curious to quickly find all the information they need to become members of the swing community. Most of the curious are between the ages of 35 and 50. This age group represents approximately 20 per cent of the total number of Internet users. Eighty to 85 per cent of new swing club memberships are within this age grouping.

• **should you try it?** No one can claim to be competently qualified to tell a couple whether they are ready to involve themselves in recreational sex. There are no Ph.D. programs offered for the study of this lifestyle choice. Information contained herein is based on personal experiences of couples who have mastered the art of "getting along." The couples who succeed in any lifestyle are generally those who come into it with an already solid and loving relationship.

Swing Stories may, at times, seem to have a utopian flavor. At other times, it may seem to echo the view of those who hold swinging to be a behavior symptomatic of psychological disorder.

Our true intent is neither to encourage, discourage, condemn nor endorse swinging, nor any decision you make in these matters. Our intent is to provide a fair and balanced overview of the recreational sex phenomenon, and to further people's understanding of their deepest, and in many cases, most secret desires. These secrets can be the source of endless hours of pleasure when shared with the person that's supposed to be the love of your life, the person you are supposed to trust, the person you promised you would be faithful to, your pillar of strength when you need one.

Can it be that total honesty in any relationship may naturally lead to this lifestyle? Is *that* the common denominator among the 20 to 25 million North Americans who, since the mid-1970s, have engaged in some form of recreational sex, or, swinging? Yes, 20 to 25 million North Americans. Shocked? Well, prepare for a greater shock in the very near future.

Now that national couples-only organizations are on-line sharing information via the Internet, the numbers are growing beyond any other time in recent history. You can see this phenomenon for yourself. If you are connected to

the Internet, use Internet Relay Chat (IRC) client software and connect to: *usundernet.org* (port 6667). Once you have established a connection, join channel *#swingers*. It's on this site that you will see as many as 300 people per hour in what amounts to a cyber version of a room full of people with one subject in mind. Men and women from all corners of the world are willing to discuss their interests and curiosities about swinging. Most have never had an experience. Through chatting with them you might be surprised to learn many have never as much as spoken to their lovers about the subject, simply because they don't know how. You will also "cybermeet" couples who are experienced and active within the swinging lifestyle. You may be impressed by the fact these lifestyle couples can truly come across as "lovers."

Couples-only resorts, couples-only cruises, couples-only swim clubs, couples-only parties and events are everywhere. Swinging is everywhere... maybe even in your own back yard. So, what does it take to get involved in swinging? Who are the people who do so?

From the simply curious, to voyeurs, to couples who enjoy having sex in the same room with another couple having sex... even hard-core swingers who seem to live for nothing more than sexual gratification... most share one common distinction: they are living within the bounds of a secure, loving and honest personal relationship. That's it... that simple. It seems many good things in life come easily to those who have actively pursued an honest and love-filled existence.

We think very few people would argue this fact: Sex is a common denominator every human being shares. Since the beginning of human history on this planet, the three most important and necessary basics for survival were, and remain, shelter, food, and sex. Can you remember a time when talking about food or shelter with the one you love was difficult to do? Probably not. Why is it then so many couple have problems with opening a discussion about sex, and further, their sexual desires and fantasies? We all have them.

As we write this, divorce rates are hovering in about the fifty per cent level. Two-thirds of divorces are initiated by the female partner. The majority of divorced women cite a lack of *communication* as the primary factor in marriage breakdown.

Look this word up in a thesaurus and you will plainly see why relationships break down when there is a "lack of communication." Our thesaurus gives these synonyms for the word communication.

noun:

relationship: association, affair, friendship, intimacy, liaison, rapport, union
knowledge: data, disclosure, exchange, expression, facts, information, news, notification

Suddenly, the issue of a "lack of communication" becomes: lack of association... lack of data... lack of disclosure... lack of exchange... lack of

expression... lack of facts... lack of information... lack of news... lack of notification... lack of friendship... lack of intimacy... lack of liaison... lack of rapport... lack of union... lack of knowledge. Sounds to us like a formula for unhappiness.

We're not suggesting that everyone who is into recreational sex is a happy, loving and secure person. There are always people who do not belong, people who are there on a "do this or else basis." You may not be able to tell which couples these are, at least not at first.

What would happen to *you* if you tried swinging? Maybe your relationship would survive, maybe it wouldn't. Maybe you'd like to think it would, maybe you'll never get to find out. Maybe you should give fantasy exploration a chance, maybe you shouldn't even start to consider doing so. Nobody could ever make this decision for you. There are only two people who can make this determination: you and the one you love. Looking for the answer can be an exciting, sexually stimulating adventure into the exploration of your own sexualities, one which will live in your reminiscences forever.

The Lifestyle is about relationship building – first yours, and only then others'.

Personal insecurities have no place within this lifestyle. If you haven't transcended minor insecurities by now, you are not ready. Until you are at ease and comfortable with yourself, how can you expect those around you to be?

Be honest and forthright, not subtle, manipulative and deceptive. Practice being honest and forthright not only with your lover, but with all who are a part of your day.

No double standards: If you can do something, so can your lover. Never initiate any lifestyle situation unless your lover plans it together with you. Any other way is the "You'll do this if you love me" scenario which is a telltale sign of relationship dysfunction.

Go ahead, take the leap, tell your secrets... it's almost like learning how to walk all over again. You don't have to be interested in recreational sex to talk about your fantasies. Everyone has them. Not everybody knows there isn't anything wrong with sharing and enjoying them. Herein lies our ultimate message: *open your lines of communication.*

There are many couples who participate in the "recreational sex lifestyle" without ever becoming involved in a threesome or foursome or whatever it is they think would be their ideal fantasy. There are many couples who do "play" with like-minded others. Only you and your lover can make a decision regarding this issue. Make your decisions together. Make it on the basis of knowledge just as you would any other major decision... and, make no mistake about it, this is a *major*

decision. If you can start a dialogue on this most difficult of subjects, can you see how simple it may be to discuss any other facet of your lives?

the secretive world of swing clubs

New swing clubs are forming everywhere. Where are they located? How does one arrange to attend? What types of people haunt these clubs?

You can find ads for these clubs in the majority of couples-seeking-couples magazines available at most adult bookstores. If you choose to purchase a swinger's publication to look up a club ad, make sure you obtain one from your geographic area.

When you give them a phone call you'll be astonished at how at ease you will be made to feel. Don't forget, these are real people who were, at one time, in the exact same situation you are in. They will bend over backwards to make you feel comfortable without making you aware of their efforts to do so.

It's only a club! Make your reservation to attend and go, have fun, meet people and see what goes on. We can assure you the couples and single women there will be some of the nicest you will ever meet. You'll feel wanted as a person. We expected to see people visually sizing up potential sex partners, looking for possible fits with their fantasy images. Not so. What you will find are people who you would see or meet in every day social situations. The only difference is these are people whose lines of communication are wide open and honest. It's plainly obvious they are comfortable with themselves and one another.

It has been our experience that there are more idiots in a corner bar with a dozen men and women in it than you will find at a swing social consisting of perhaps fifty or sixty couples. In most cases there are no expectations placed on anybody. Many couples go to watch or be watched and nothing more. Limits are respected, no pressure is put on anyone to do anything that they are not ready to do on their own. Again, your objective is to have fun and socialize with new people, the rest happens all on its own, and only to limits established by you.

There are exceptions. We have heard of a number of so-called swing clubs which have a "three strikes you're out" policy. This unwritten rule, in many cases unstated, is in place to pressure couples into swinging. Memberships are withdrawn

if, after attending three or more swing functions, couples have not participated in the open by performing sexual acts, either with each other or with members of these clubs. Find out first and stay away!

There are two types of clubs, on-premise and off-premise. On-premise is a facility set up to accommodate sexual activity. Off-premise clubs are meeting places, the outside world's equivalent of a singles bar, a place to go to score or get lucky, whatever. Again, no expectations are placed on anyone. Have a drink, meet some new people, just have a good time. Both kinds of clubs can be a lot of fun.

jan and bridget, 1977

Times have changed. The men and women once known as swingers are today known as "Alternative Lifestyle Couples," or just simply "Lifestyle Couples." As little as fifteen years ago, nearly every couple who would attend a swing party were ready to have sex with others. Today, with millions involved, only a small percentage, estimated at approximately twenty per cent, will actually have sex with other members of the lifestyle. Others attend in order to have newly exciting sex with their regular partner in a sexually charged, semi-public environment. Our first experience in a swing environment took place back in the earlier, wilder days of swinging...

As told by: Jan

It's still a mystery to us how, as a couple, we eventually became curious enough to open the doors and walk into the world of swinging. I think it was 1977 or '78 when we became thoroughly intrigued by the concept of open sexuality. Our intrigue resulted from impressions created by a featured *Penthouse* article about Sandstone, a swinger's club located in Chatsworth, California.

Sandstone must have been quite a spectacular piece of real estate, because the journalist/writer described it as being an entirely secluded and private resort-like complex. Sprawled over many acres in the mountains of Southern California, this hidden world apparently inspired such a feeling of freedom that wearing clothing on the outside of the clubhouse was optional... as the article illustrated with aerial photographs of the grounds. The well-written article described a married couple's first weekend adventure, during which they ultimately fulfilled long-held sexual fantasies.

Reading this seductively fashioned article made me want to seek out a similar facility in my own part of the world. Using the magazine's list of North American swing clubs, I made a phone call to the geographically closest club. Even though it was the closest it was still located a couple of hundred miles away

from us. During my exploratory call I learned of a closer facility so new it was under construction. Unexpectedly, this particular facility was situated less than a quarter mile outside of the town we lived in. I had discovered "The Red Umbrella Club."

The Red Umbrella's main clubhouse was so well hidden from the roadway, veiled by hills and a forest-like growth of trees and bramble at its entrance, that we were unable to see it during several attempted drive-bys to view its exterior. A month must have passed between the time we learned its location and the day that our curiosities eventually dictated we phone and obtain as much information as was possible without actually visiting this intriguing club.

Both of us had many of the first-timers' questions we subsequently have heard countless times. What would we be walking into? What takes place inside an "on-premise" swinging facility? Is it a safe place for my wife? Would we be seen attending the club and exposed to our community as sexual perverts and deviants by someone that talked too much? Is sexual participation mandatory? Are swingers hardcore, desperate-looking weirdoes? Are all the women there as a result of personal choice or are some coerced into attending? These questions originally came to us from our fear of the unknown.

I recall being favorably impressed with the woman who answered my telephone call. I remember her easygoing, intelligent approach in handling my nervous questions. I called with the expectation that a female would answer my phone call, and further, mistakenly anticipated that she would be a sexy, sultry-voiced female whose job it was to entice callers into accepting her invitation to spend an evening at this club – a sales pitch. This was not the case. The individual with whom I spoke approached the controversial nature of The Red Umbrella in the same tones, as matter-of-factly and sincerely, as if she were answering questions about joining a couples' baseball league.

At the conclusion of my phone call, I had an invitation to look the club over for myself, alone, without Bridget. I wish I could thank the young lady who encouraged me to stop in for a look anytime during the day over the following weeks. If it wasn't for her, I do believe this alluring way of life may have forever remained simply an unstudied curiosity. She was a highly perceptive woman who seemed quick to detect my fear of being found out in our community, or, worse yet, by our families or neighbors.

• **the first visit** On the afternoon I chose to visit The Red Umbrella, the facility was bustling with contractors and crews working toward construction deadlines. For all anyone knew, I could have been an electrical inspector there to examine a connection, or whatever electrical inspectors do. Beginning to relax, I felt secure about my visit remaining an anonymous non-

event to anyone but me. Imagine how quickly this secure "fuzzy" feeling faded when I walked through the front entrance and came face to face with a couple from long-ago high school days, Will and Meryl. I didn't know what to say or do.

After exchanging greetings and sharing small talk, I discovered they were senior members of the club and involved themselves in administrative committees which oversaw the day to day operations of The Red Umbrella. And what was I doing there? Finding difficulty in expressing my thoughts when asked, I said nothing at all for a few moments before asking permission to look over the facilities.

Will and Meryl, acting as my tour guides, presented a kind of resort-like setting that seemed transplanted directly from the sunny south, as if it were a huge scoop of Barbados or some other such paradise island: a tropical theme park, contained in what looked from the exterior to be three large interconnected greenhouses. The greenhouses were connected to a more permanent concrete and glass wing which held a banquet room, dance hall, bar lounge, and various chambers set aside for private and group sexual exchanges. The greenhouse housed an impressive, kidney-shaped, heated in-ground pool. Built into one end of the pool was an immense hot spa complete with molded recliners and Spa jets. On the pool deck was a sunken conversation pit with a massive open stone fireplace surrounded by half a dozen love seats, several couches, and wing backed chairs. At the other end of the expansive pool deck was a hut styled after the thatched huts of tropical jungles.

Every detail was refined and tasteful. The immediate grounds surrounding the hut were landscaped with flower beds in full bloom. Genuine palm trees thrived in the warmth of the sunshine on this crisp November day. Within the hut was what surely must have been the largest Spa ever made.

As we explored the layout and its physical amenities, I felt free to discuss Bridget's and my greatest apprehension of the swinging lifestyle. The uneasiness seemed to be centered around our concepts of the type of individuals involved in this lifestyle. Neither of us had any idea of what to expect, and it was this fear of the unknown which could work to keep us away. We shared a few light moments as Meryl playfully pointed out she and Will didn't have a green eye in the middle of their heads.

Meryl invited Bridget and me to a meeting of the building committee, scheduled later that month, as their guests. Will joked about this being our first date with a "real" swinging couple. He then, quite seriously, said he couldn't think of a more perfect way to allow Bridget and me to meet a few dozen club members and have a view of the premises on a non-party night. This was an entirely non-threatening invitation. What stands out in my mind, to this day, is Meryl's comment about wishing she and Will had had the opportunity to slowly explore the world of swinging the way Bridget and I were being introduced to it. I left the The Red

Umbrella facility looking forward to a very intimate dinner conversation with Bridget.

• back with bridget

We drove to The Red Umbrella Club on the appointed Friday evening not knowing what to expect. There truly existed a feeling of mystery and adventure, the newness of which created a highly pleasurable degree of sexual tension. We were pleased and mildly taken aback to find the dozen or so couples in attendance looked and acted normal, just like us. If we had found ourselves in the midst of this company, not knowing who these individuals were, no one would have been successful in convincing us that these folks were "swingers"... they simply seemed like individuals from notably diverse stations in life. They shared a pride in, and a straightforwardness regarding, their lifestyle choice. A high-ranking firefighter, a very successful restaurateur, and a well-known realtor, all quite prominent in their communities, were immediately recognizable to us.

Bridget would later say Will and Meryl made her feel as though she had known them for as long as I had. We hadn't been together for an hour when Meryl had answered all of Bridget's questions and moved on to making small talk just as if we were attending our first meeting of that previously mentioned couples' baseball league. Alleviated of our mutual apprehensions, we both felt relaxed in the club's lush surroundings. Bridget and I enjoyed our first exposure to the "swingers" we met.

The owners of the The Red Umbrella Club were pleasant individuals. He was an average looking, middle-aged gentleman type, she was quite a few years younger than he, tall, blonde and stately. I recall musing over thoughts of how lucky this fellow was.

Eventually we were ushered to the committee meeting room and formally introduced to the twenty or so couples who had gathered. We felt we were being quite pleasantly and warmly embraced by our congenial hosts. I guess we both expected to be closely examined, but I don't believe they expected *us* to study *them* as intently as we did.

At different times over the course of the meeting I noticed several women, seated alongside spouses and lovers, locked in a stare into Bridget's eyes. The one thing which lives on in people's memories of Bridget is her face. She looks attractive upon waking, first thing in the morning, without the benefit of makeup. When she spends a few short minutes in front of a mirror her face becomes unforgettable, with its classic lines reminiscent of a young Katharine Hepburn.

At times I would catch myself wondering what sounds would be in the air in some of those darkened areas beyond the meeting room had this been a party

evening. Scanning the faces and bodies of the people around us, I imagined Ms. Red Umbrella leading the gathering into one of the group sex rooms after the meeting. So deeply did I become entangled in fantasy images it wasn't until I heard Bridget whisper softly in my ear, "Where are you? The meeting's over!" that I regained a foothold back to reality. Those fantasy images felt so real and probable that they've remained permanently painted in my mind.

Now it was Bridget's turn for her first tour of this curious place. It was plain to see that Bridget's tour-guide, the stately blonde co-owner, was strongly attracted to her. Judging by how she seemed to concentrate her attention, it became significantly obvious that Ms. "Red Umbrella" was bisexual. As the three of us toured the most intimate areas, the hot tub rooms, the whirlpool, semi-private areas set aside for one-on-one sex, and of course, the group sex areas, we felt perfectly at ease and relaxed. Our likable hostess was such an effective communicator that hearing her words projected mental images to a screen in our minds. I had to wonder if Bridget was feeling as aroused as I was during the powerfully graphic details of what typically took place on a party evening.

During our after tour coffee chat we were invited to come back for a second visit to see how the club "worked" during a party night. Ms. "Red Umbrella" invited us to yet an additional night out as their guests. The invitation was for an evening at which an American PBS station was to send on-air reporters, with camera crews, to do a investigative report spotlighting swingers and the swinging craze. It was anticipated that the presence of PBS cameras would all but ensure a social get-together atmosphere rather than a typical Red Umbrella Club swing party. Again we were presented with an opportunity to explore this world without actually being totally submerged in a "working" swing club environment. A turning point for me, being allowed to study this segment of society stimulated a curiosity that lives on to this day. History shows I wasn't alone with my inquisitiveness...

• **swinging in culture** Countless daytime TV talk shows have examined, exposed, inspected, and otherwise pried into every aspect of the swinging lifestyle. Ultimately, the pursuit of TV network rating points brought more exposure to swinging than anyone could ever have imagined. Here was a subject matter which was selling, attracting phenomenal numbers of viewers. The time was right.

The television talk show audiences of the late seventies and early eighties were, in great numbers, the baby boomer "Me Generation." Hippies that grew up and became yuppies (young urban professionals)... an entire generation influenced by the free-love attitudes of the sixties. Hippies with Gold American Express Cards who, coincidentally, were simultaneously wondering if "Letters to Penthouse" were

truly written by average people in middle America. What a marketing dream come true!

Sex was used, like never before, to tantalize the consumer-driven mentality of the yuppies. Swingers' organizations and clubs began forming in every large metropolitan center. The majority of people in average middle America can remember, somewhere along the way, hearing or reading about Plato's Retreat. Plato's was an "on-premise club" in the New York City of the late seventies to mid-eighties, the epitome of "on-premise" swinger's nightclub. In its heyday, Plato's regularly attracted five hundred people a night, night after night. Not hard-core New Yorkers, as one might think... rather, men and women from across the continent. Bus tour operators from everywhere in the eastern half of North America, it seemed, had Plato's as a common destination at some time in their careers.

So great was the allure of "on-premise" swinging that copycat clubs sprang up across North America as if overnight. Every week for almost ten years, literally hundreds of thousands of erotically minded men and women were enticed to these adult playgrounds by the promise of sexual fantasy fulfilment. Here it was, this promise of fantasy, attracting Bridget and me.

• **the crew arrives** In the weeks leading up to the PBS taping, the topic of what awaited us was discussed at length. We knew we both wanted to learn more, but neither of us had any idea how far we could go. In the meantime, to be afforded the opportunity of learning about this lifestyle as if from the inside looking out was an invitation we couldn't refuse.

The PBS visit to The Red Umbrella Club turned into a subdued gathering of at least one hundred card-carrying club members. Also present were fifteen or so curious non-member couples who had, like us, somehow acquired an invitation to attend this "Grand Opening." We essentially spent our entire evening ducking the ever-present PBS video cameras as we met and chatted with numerous couples. The crowd appeared to be just as committed as we were in our collective effort to avoid being forever caught on videotape. In retrospect, it's clear that the intimidating presence of the television cameras seemed to take the pressure off the task of meeting new people. We were all on the common ground of wanting to avoid those intrusive cameras.

The evening seemed to fly by. It only took a couple of hours before one could see the television crew becoming frustrated by the member couples' reluctance to let go, let their hair down, and provide them with visuals more realistically representative of a typical swing party. Bridget and I decided we needed a few quiet moments together. We retreated to the greenhouse pool area wishing to sit in the comparative tranquility of the poolside conversation pit to collect our thoughts for a few minutes.

The fireplace crackled as we lounged on a huge overstuffed couch. We discussed our earlier, narrow-minded view of the type of individual the average swinger must have been. Based on first impressions and very few minutes of separate conversations, each of the couples we met were average human beings. They could have been our neighbors, our local grocery store managers, firefighters, bank tellers, etc. Each of them were considerate of us, in our newness, to their accustomed environment. All were warm, friendly, fun-loving individuals who held nothing in common with images of the perverted eccentrics we wrongly expected to meet.

As we lingered in the privacy of the conversation pit, our chat became quite intimate. We discussed the wonder of being able to explore sexual fantasy within these newly defined terms of fidelity. Waves of pleasurable sensation drifted through our bodies as we mused over thoughts of having sex with couples who, we mutually agreed, had impressed us as being temptingly irresistible. I knew Bridget had grown as aroused as I had.

The rest of the evening was uneventful, save for the couple who had a little too much to drink and ended up in one of the hot tubs making out for the television crew. Several couples finally did agree to appear on camera and tell the world what it was about swinging which attracted them to the lifestyle. The PBS bunch were finally getting the images and dialogue they came for.

Shortly before deciding to leave for home, once again we adjourned to the pool area conversation pit. Noticing our entrance to the pool area, the owners of the club followed to join us. After a few moments of small talk, Ms. Umbrella indicated we had been very favorably regarded by absolutely everyone present. They mentioned we should plan to "come out," as they put it, for an upcoming weekend party. Halloween, which was one of the three most attended events of the year, was quickly approaching. Both assured us we would enjoy ourselves immensely. The last thing Ms. Umbrella said was, "See you in a few weeks. Costumes are a must... not even *you* can come in without them, darlings."

In the days leading up to Halloween Bridget and I had many erotically stimulating conversations, which frequently lead to highly gratifying sexual encounters. We ultimately agreed that a Halloween costume party would be a great way to be introduced to this mysterious and intriguing world of "on-premise" swing clubs.

• **halloween night** We arrived at the club fashionably late, as was the vogue, and found ourselves in the midst of at least three hundred individuals. Area costume rental outlets must have been delighted with the business they did on this particular weekend. Everyone present was fully costumed for this oldest of pagan celebrations. The entire social-only wing of the facility was

overflowing with Romans of the Caligula era, Knights of the Round Table, sexily clad Queens of Hearts, ghosts, goblins... you name it.

For our part, we arrived as a vampire couple. Definitely not of the Bela Lugosi mold, we prophetically chose the role of sophisticated vampire lovers as were to be characterized, many years later, by writer Anne Rice. Bridget wore a stunning floor-length lace gown with a black satin, red-lined, floor-length cape. Her thick mane of long black hair was a mass of curls framing her delicate facial features. Her makeup was of movie set quality, pale and sparse. At the corner of her black shaded lips was an absolutely perfect replica of a shining droplet of blood. She looked fabulous, not to mention quite sexually alluring.

My face makeup was a carbon copy of Bridget's. Our fingernails were painted with high-gloss black polish. Our capes were identical. Under my cape I wore a jet-black three-piece suit with a brilliant white tuxedo shirt, a blood red ascot about the neck. Pinned to my lapel was a flawless fresh blood-red rose cut from our garden. In the corner of my black shaded lips stood an identical droplet of blood.

We were warmly received by a few vaguely familiar faces. All the costumes and disguises were first-rate. Will and Meryl engaged us in conversation for well over five minutes before we had any idea of who they were. Bridget and I were praised for our costumes by folks who went out of their way to pay their compliments. We were showered with positive feelings. It seemed as though this new intimacy satisfied a need in unknown parts of our personal psyches. We became quite comfortable with the energy levels contained within this remarkably fascinating environment.

The first real wave of sexual energy hit me when Bridget left my side for the powder room. A golden-haired "go-go dancer" walked directly to me and seductively said, "Hi. I love your costume. Wanna take me to the Caves?" Stunned by the sudden reality of the moment, to this day I don't know what my response was. I just can't remember. My next clear recall of the moment was hearing her say, "Oh... okay," as she turned to walk back from where she came. Even before Bridget's return, the go-go girl was on the arm of a man strolling in the directions of "the Caves."

Once I had related to Bridget what had taken place in her absence, she gleefully said, "Really? They went to the Caves? Let's go, I'd like to see the Caves." We departed the disco hall through a corridor, and walked across the crowded bar lounge. My heart still skips a beat when I recall stepping beyond the threshold of "the Caves."

We walked through the door, along a narrow catwalk, into the exact center of a chamber approximately forty feet in length by twenty-five feet in width. Opposite the entrance door, along the entire forty-foot section of wall, was a

catacomb-like series of compartments. Each of these nooks was four feet high by four feet wide, by eight feet in length, stacked two high. All were outfitted with mattress-like padding. The entire surroundings were painted in a flat black color, while the lighting consisted of little more than a few five-watt red light bulbs.

With our eyes still adjusting to the near pitch-black environment, we found ourselves in queue with three towel-wrapped couples who were waiting for a catacomb to become available. Spellbinding sounds of lovemaking saturated the entire setting. Slowly, shadows in the darkness became writhing human forms engaged in all manner of sexual exchange. What we were witnessing was an entirely intoxicating first exposure to this mysterious and private world.

On one side of the catwalk was a waist-high platform area of approximately twelve feet by ten feet, topped with a very comfortable-looking leather-like matting. Half a dozen crisp linen-encased pillows were neatly arranged on the mat. Hanging from the ceiling were lacy panels of see-through fabric draped to surround the platform, lending it a gazebo-like appearance. Four naked people were comfortably settled in for the spectacularly erotic sights and sounds of couples in the catacombs directly in front of the gazebo.

On the opposite side of the catwalk was another area of approximately twelve feet by ten feet. Identical leather-like matting, laid out on the floor, was overflowing with the visions and sounds of hard core swingers caught up in a storm of sexual bedlam. Standing motionless in the middle of this scene, I felt a connection to some undefined primal instinct. This was a scene, I was certain, which had been played out by groups of men and women since before the earliest days of history.

We were spirited out of the Caves by Meryl, who had come searching to entice Bridget and me back to the dance floor for the costume judging competition. We were entirely flattered by winning the first prize for best costumes.

Winning the prize made it easy for others to speak with us. What an ice breaker! It was obvious most of the couples who came to congratulate us were more interested in meeting us than actually paying compliments. Several men and women made clear their intentions by boldly inviting us to join them in one of the various rooms set aside for sexual exchanges. We chose, instead, to get out of our costumes and take advantage of the inviting pool and hot tubs in the greenhouse wing.

Save for a fleeting few nervous moments, while shedding our costumes in the locker room, neither Bridget nor I thought twice about being surrounded by nudity. It was as though this sexually inspiring facility was inciting a hidden propensity for the behavior we exhibited. The lights were dimmed, several fireplaces crackled away, huge candles lit the entire complex, incense filled the air: this was a setting deliberately designed for this very purpose. We cloaked our naked bodies

in oversized silk shirts. Bridget wore delicately designed black lace boxers with a light silky bra. I had on the oversized shirt and a towel folded in half lengthwise, which resulted in a cover of mini-skirt proportion.

To properly gain an accurate overview of the Sandstone, Plato's Retreat and The Red Umbrella eras, one must take into context the moral temperament of the masses in the years 1977 through 1981. During the late seventies, "Playboy" magazine would regularly sell out when it was rumored the upcoming "Playboy Pet of the Month" centerfold would exhibit more than just a glimpse of pubic hair. The Bob Gucciones and Larry Flynts of the world were offering new interpretations of what the term *contemporary sexuality* meant. The attitudes of 20- to 35-year-old North Americans were indeed changing, an undisputable fact as proven by the financial empires built by Guccione and Flynt.

This was a time before triple XXX videos were available at the corner video store. The equivalent to adult videos were "stag flicks" – eight-millimeter rolls of film requiring a movie projector. Occasionally you'd hear about couples, at parties, projecting a silent stag flick onto a dining room wall; however, in those days it was considered "weird" to show "porno smut flicks" in mixed company. In most legal jurisdictions, across the continent, possession of an eight-millimeter stag flick was a crime. Stag flick producers were prosecuted and penalized as if they were cocaine dealers. Long hard battles were waiting to be fought over these archaic laws and attitudes. Such was the temperament of the society of 1980.

So here we found ourselves, on the cusp of "1984," in the dawning of a "Brave New World," in the midst of this mysterious place. Agreeing it would be fun to see what would happen if we split up, Bridget offered to take a trek to the bar while I went to wait for her in the conversation pit. The huge corner fireplace fire was roaring while groups of couples in various stages of dress and undress carried on in merrymaking. Wine flowed freely as a succession of food items were made available from a buffet table adjacent to the pit area.

• soloing

Settling into the comfort of a fire-warmed leather sofa, absorbed in people-watching, I became aware of people's stares in my direction. A few tingles of arousal stimulated me as my imagination took over. An attractive young couple leaned to whisper in each other's ear between obvious stares which revealed their interest in me.

Directly across from me, separated by a coffee table, an older blonde woman shifted her head slightly as she studied the edge of the towel in my lap. I followed her gaze to find that the towel wrapped around my middle did not entirely cover my most intimate spot. As the woman watched, my hand touched the exposed flesh to cover it from her view. This excited me so much that had I let go the control I held over myself, I could have easily become very visibly turned on.

I've always regarded these moments to be my personal discovery of the eroticism to be found in exhibitionism. Continuing the game, I sat obstructing the blonde woman's view while studying her fascination. Smiling at me, she subtly moved her eyes and head in a motion suggesting a sweeping away of my hand. Enjoying the moment, I removed my hand and sat unabashed for her to see. Her partner, who had been silently observing us, drew her toward him and whispered something in her ear. As they both got up to leave the area, the lady looked over her shoulder, and again subtly moved her eyes and head as if to say, "come with us"... the classic come-hither look.

Intuitively, I knew Bridget had become entangled in some form of a situation similar to mine. This was made obvious by the length of her absence. Watching Bridget enter the pool deck I saw the young couple with whom I had earlier shared eye play also take apparent notice of her entry. Joining me on the couch she giggled frequently while describing her adventure in obtaining our drinks.

As Bridget described the antics of two older gentlemen at the bar, I slipped into a euphoric, semi-dreamlike state. Mesmerized by the fire, aroused by the sexually charged revelry, distracted by the attractive couple who continued to hold us as a center of attention, I struggled to maintain focus on the story Bridget was relating.

Meanwhile, the blonde go-go dancer re-entered the pool area. Her skin glowed with the flush of a woman who was sexually quite satisfied. Sipping from straws in a drink, lazily sauntering under the palms across the deck to the Spa, she glanced in our direction. A coy grin came to her face when she looked at me and shrugged one shoulder as if to say, "So, what are you waiting for?"

I felt as though I was looking at myself from a perch six feet in the air when I leaned over and whispered in Bridget's ear, "Wanna go back to the Caves?" She looked into my eyes and with a mischievous glint in hers said, "I'd love to!"

• **to the Caves** Later, we agreed that during our trek from the greenhouse area to the Caves, so much pure adrenaline rushed our systems we experienced an overpowering sense of euphoria. Visions and sounds held exaggerated surreal qualities. This euphoria would last into the wee hours of the morning.

Stepping into the darkness of the Caves, we were again overpowered by unforgettable sights and sounds of lovemaking. When we crossed the catwalk we were delighted to find the lace-draped platform was just then being made ready for reuse. How fortunate for us: this was the most coveted spot in the Caves.

We lay side by side, our backs supported by the large assortment of pillows in our gazebo-like surroundings. Transfixed by the compelling scenes of passion, we mellowed out and took it all in for a few moments. When I closed my eyes for

a minute, that strange sense of connecting to a deep-seated primal instinct washed over me one more time. Bridget nestled her head into my shoulder as her hand slowly moved down my stomach to loosen my towel before pulling it away. Exposed, I moved to help Bridget out of her delicate silks.

An exhilaration like none I had ever known completely took us away as we over-indulged ourselves in a myriad of sexual acts. This was an electrifying adventure beyond any eroticism Bridget and I had ever shared. Every time someone in the Caves was taken over the edge in orgasm, absorbing the ensuing sounds fueled my desires. Not wanting to diminish our energy levels, we played to the very brink of completion numerous times before settling back into the pillows to catch our breath and retrieve some degree of composure. Once we came down from our "high," we left the Caves for the comforts of the greenhouse area.

During the hour we spent in the Caves, the mood of the party had changed dramatically. Before we left, nudity was visible only in the hot tubs, showers and the more secluded areas. Some revelers, male and female, were now comfortable enough to carry on as normal while completely nude. A greater number of men wore only a towel wrapped around the hips. The women who were not scantily clad in lingerie outfits wore, as Bridget did, an oversized unbuttoned shirt. A few chose to simply wrap a towel around their hips and go topless. Couples who remained wearing Halloween costumes had become the minority.

By this time all our first-timers' apprehensions, and the resulting uneasiness created by the fear of the unknown, had melted away into a void. These swingers were just normal everyday folks. The only people who resembled weird sexual perverts were the half dozen or so gentlemen who were wearing raincoats, sunglasses and fedoras in their Halloween disguises of "dirty old men" and "flashers." Bridget felt safe. To this point, as for the rest of the evening, no one had intruded on our personal space.

In our absence, the buffet table had been arranged with an extravagant selection of our favorite fresh tropical fruits, melons and berries. Will and Meryl chatted with us at the buffet. The truth was, they noticed us being attracted by the buffet and left a table full of their swing circle friends to speak with us. Following a few minutes of candid discussion they went back to their table. Meryl made clear that they and their friends were going to the Caves, and invited us to join them if we so wished. We had been met with yet another proposition.

Sipping drinks back in the pit, lounging in the comfort of the couch directly in front of the fire, we considered Will and Meryl's offer. After studying Will, Meryl and their circle of friends, we decided to pass on the invitation. In a very short few minutes we came to the conclusions that no member of the group appealed to us on a sexual level. They just didn't have the aura of fantasy it would have taken to seduce us into swinging.

By this time we were getting warm again. Joking about what it was that was generating all the heat, we walked to the pool's edge and dove into the deep end. The water temperature of the pool was as if programmed to provide yet another energizing assault to the senses. After a refreshing few minutes of treading water we swam in the direction of the intriguing hut under the palms at the far end of the pool. My towel and Bridget's top were on the opposite end of the pool, meaning we'd have to cross the deck while nude. We did so, and again I felt that tremendous sense of freedom I'd heard nudists speak of so many times.

Sounds filled the air of the hut. Not the sounds of lovemaking, as was the case in the Caves; rather, the whooshing sounds of Spa jets set on high. When we entered, two couples were immersed in the water having a leisurely conversation. Not ten minutes later, when we were leaving, the air was filled with the licentious sounds of more than a dozen couples engaged in assorted forms of hedonistic expression.

We left the Spa hut to stroll hand in hand, shamelessly naked, across the pool deck in pursuit of our garments. It seemed I could almost feel a touching sensation caused by the eyes of men and women as they visually examined our nude bodies. The excitement added by the newness of this once unknown pleasure was mind-blowing. By this stage we couldn't wait any longer to get our hands on each other.

• **into the greenhouse** The greenhouse area reserved for sexual activity was a large L-shaped space which took up one entire corner section. The small portion of the L was designated as the bi female playground, while the larger part was set aside as a group sex space. Outfitted with mirrors, a continuous built-in couch along the wall side, and soft leather-like matting covering the floor, both areas were alive with the essence of pure fantasy.

As we made our way to a less crowded section of couch, we became aware of a couple who seemed to have been following us. It was the young, attractive, eye-play couple from the conversation pit. Bridget and I slowly became captivated when three feet directly in front of us the woman sank to her knees and began fellating her lover. Her hands on his hips, she turned him slightly, allowing a view of her face, providing herself a view of us.

I'd never been so ardently aroused. It seemed as though every pore on my body became an erogenous zone. We observed the winsome young woman closely in her deliberately exhibitionistic act of oral sex. I caught and held her gaze for a prolonged period of time. As I stared deep into her dark eyes, my every sensory faculty became amazingly heightened. My body was rocked with the same sensations as though it were actually me receiving her oral attentions.

I had always imagined observing someone so closely, so intimately, would have a kind of cheap-thrill quality to it. I never expected to find moments of such beauty in what I saw. We were watching two highly attractive people, who for some reason found enormous pleasure in exposing themselves in this fashion. I wondered if this show was a fantasy they authored earlier, while studying us by the fire in the conversation pit.

Over the next few minutes, Bridget comfortably nestled in beside me for our first deliberate act of voyeurism. Her head on my shoulder, eyes riveted on the young woman and her handsome lover, she moved her hand to caress my hardness. As she delicately stroked my erection, we watched as the male sank to his knees and laid his companion on her back. Entering her in the missionary position, he lasted only a few minutes before both were crying out as waves of orgasm washed over them. Regaining composure, they gathered themselves up and just before they walked away, both looked back and smiled broadly. Very soon afterwards, they disappeared, never to be seen by us again.

No doubt inspired by the young woman's efforts, Bridget slid onto the mat and took me into her mouth. Oral sex was and remains an indispensable part of our sex play. Never before this night had receiving this earthy pleasure been as voluptuous.

My eyes remained closed as Bridget continued to focus on satisfying some unrelenting desire to swallow me completely. I felt like my body was floating, suspended at the vortex of a whirlpool of sensations. Once more I seemed to connect to that haunting sense of passing back through time... back to a time when primal instincts controlled human behavior.

When I opened my eyes, while I moved off the couch to lie on the matting, I became suddenly conscious of the audience gathering to observe our first intentional act of exhibitionism. Dark shadows whispered words which seemed to float through the air, like breezes, muffled, unheard. Every so often a word stood out. "Beautiful," "hard," "gorgeous." Faint unmistakable sounds of sex echoed throughout the entire complex. My sense of touch, giving and receiving, was exaggerated to limits I never considered possible. Bridget was responding in a way which indicated she too had completely surrendered to this world of make-believe reality.

Bridget and I intentionally prolonged our torrid performance. Languishing in the plush matting, we purposely brought one another to the very brink of orgasm before backing off to postpone the logical finality of our acts. There exists a certain space of time between feeling an approaching orgasm and its actual release. We strove to extend this profound and intense time for as long as we possibly could.

Because our eyes were closed, we had no idea of the size of the audience we had attracted. When we eventually opened our eyes we were startled to see at least

twenty men and women had soundlessly gathered to study our performance. Sitting on the edge of the matting a woman was orally pleasuring her male companion while he stood, his eyes fixed on Bridget. The space beyond them overflowed with all manner of explicit sexual activity. We took a break and sat enthralled by the sights before us.

• **watching** Our most memorable scenes of sex, witnessed before or since this particular evening's involvement, came from our first voyeuristic hard-core sex exhibition. The session involved a man and his wife. He looked to be in his early thirties, she in her mid-twenties. Both stand out in our memories as being exceptionally attractive. The pair maneuvered their way into the center of the group sex area. Then, as he lay down on his back, she knelt between his legs and took his very large penis into her mouth.

The woman had long jet black curly hair, large firm breasts with generously lush protruding nipples, and long slender legs. Her body was evenly tanned and well toned. She had one of those gorgeous, hard, heart-shaped bottoms. As she orally favored her husband, a handsome younger man, in perhaps his early twenties, approached the edge of the section of matting they occupied. The woman appeared to believe that the handsome guy had moved in to offer his penis for oral attention. She shifted on the matting to go down on him. He plainly had other plans. He discreetly gestured her back to her husband. She returned to her knees and resumed fellating her lover. The younger man unhurriedly penetrated her vagina from behind.

Meanwhile, several other couples moved into the group sex area to share the space and energy within. Across from the threesome, an older couple, she in perhaps her late forties, he in probably his mid-fifties, were arranging themselves. He sat on the sofa as his mate knelt on the floor to go down on him. Just then, the man in his early twenties let out a long sigh and climaxed within her as the beautiful black-haired woman, now freely moaning, wantonly ravished her husband's penis.

After the younger man had climaxed, he withdrew and sat on the same couch the second couple, the older pair, had come to occupy. The black-haired lady stopped what she was doing to look over her shoulder. The older gentleman on the sofa caught her eye and asked her to come to him, and then, to please sit on his face. She tried to bow out, explaining that the younger man had just climaxed within her. Again, almost pleading this time, he asked her to sit on his face.

The black-haired lady's husband looked up to see the older woman going down, her rear end hiked in the air. Moving into position from behind her, and without uttering a word, he abruptly buried his manhood to the hilt. I'll never forget the sounds which ensued from the older woman. She was crying sweet tears of joy. Her cries were repressed in her throat, muffled by the older man's penis.

The raven-haired lady, in the interval, climbed onto the back of the padded sofa to squat yieldingly over the older man's waiting open mouth. He unquestionably sounded and looked to be enjoying himself immensely as he licked and sucked her semen-sodden pussy.

Two women moved in to take the place the black-haired lady and her spectacularly endowed husband had vacated. One woman lay on her back, her legs spread wide. The second woman sank to the floor. On hands and knees, she lowered her head to perform cunnilingus. A tall well-built fellow approached to offer his penis to the mouth of the woman on her back. She unhesitatingly reached up with one hand to pull him to her open mouth. A good-looking black man slowly trailed the palm of his hand across the smooth raised bottom of the woman lost in performing cunnilingus. She looked over her shoulder, smiled, and willingly reached to guide his penis to her vagina. Only once he was fully engaged did she return to orally favor the first woman.

Beside them, a woman was blatantly screaming out for more as she sat her vagina on one penis while a second penetrated her anally. A third man approached to offer his penis for oral servicing. She declined, lost all control and started enthusiastically issuing commands for her lovers to speed up, penetrate deeper, faster. All the while she chanted "Oh... fuck me... fuck me... oh... It feels so good... harder... oh fuck me... deeper... fuck me... fuck me... OH Fuck meeeee."

Later, coming down from the rush of the night's decadence, Bridget and I sat alone in the rain forest hut hot tub. We mused over what our eyes had seen. As much as what we saw turned us on sexually, we agreed we couldn't visualize ourselves lost in such wild abandon.

Lounging in the warm bubbling jets, holding Bridget close to my body, I can clearly recall a thought which crossed my mind. I somehow felt Bridget would grow to become my best friend for life. Not because of The Red Umbrella or the lifestyle, but rather because there wasn't a subject we couldn't discuss as best friends do. Best friend and lover – what a lucky guy I am!

Oh, what a night it was. It was the night we were to learn how exciting it was to observe men and women absorbed in uninhibited sexual expression. We learned how exhilarating the practice of exhibitionism could be, how literally electrifying to the senses. Those few short hours of men and women so lost in communal sex vividly live on in our memories to this day, fuel for our ever-present fantasies of group sex. Pleasure-seeking abandon, uninhibited, pure fantasy. Oh well, maybe one day!

what happens in the clubs?

orientation sessions Many on-premise clubs hold a pre-party session for couples attending their first party. Attendance is mandatory in most cases. Even if the club doesn't require it, we highly recommend that you attend.

1. **The Code of Absolute Discretion.** You will meet people from all walks of life who, like you, have been attracted to this lifestyle. With the exception of a few courageous couples, the majority do not discuss their involvement in swinging with anyone outside of their swing groups. This discretion is expected of, as well as given to, new couples. Be very careful not to discuss your swinging involvement with friends or acquaintances. When it comes to issues surrounding a person's participation in non-traditional sexual trysts, the people you think will keep your secret are often the first to betray you to others.

2. **No Means No.** The universal cardinal rule of swinging. The ultimate goal of swing clubs the world over is to provide a gracious, no-pressure environment for their patrons. It is expected that couples will be discreet, well-mannered and courteous at all times. No means no, period!

3. **Establish Limits As A Couple.** Acceptable limits should be established by couples well before attending their first party. Couples should stay within the pre-established limits. If you feel that you might like to exceed those limits, we strongly suggest you wait to do so until you've had a chance to discuss it with your partner, preferably after the party – sometimes people don't make their best decisions when surrounded by sexual stimulus. You can always come back and explore your newly established limits another time.

4. **Bisexual Activity.** Although female-to-female sexual behavior is widely accepted by the swinging community, male-to-male behavior remains a taboo in most groups. Male-to-male activity should be confined to secured private areas only.

5. **Come As A Couple, Leave As A Couple.** Self-explanatory.

6. **Drugs.** Drug use, other than legally prescribed medication, is not tolerated. This does include the use of marijuana.

7. **Report Problem Behavior.** Don't hesitate to inform the hosts immediately of any objectionable behavior.

• **on-premise clubs** *The following is an actual Club promo which will provide an insight into a typical night out at an on-premises club.* (name and city have been changed)

The HighLite Club is a private social club located in Diamondville. Our members are hedonistic people like yourselves, who share an appreciation for a cornucopia of pleasures. Our evenings begin with the tasting of fine Champagnes, Cognacs, Ports and Wines, which you, our guests, have selected and provided from your own personal cellars. Our buffet table offers gourmet hors d'oeuvres, such as paté de foie gras, selections of fine aged cheeses, fresh fruit and vegetable platters, regional pasta dishes, chilled prawns, gourmet sandwiches, and festive international selections. We also provide soft drinks, spring water, ice, and glass and plastic ware.

The HighLite Club functions are held in our home; this is typical of most swing clubs in the Diamondville area. Our evenings begin at 9 PM, and they continue until 3:30 AM. Our spa is maintained at a comfortable 101°, and the music is always a blend of cool jazz and hot rock. We ask our evening guests to provide their own towels for the spa, and always come prepared with safer sex products (we do not provide condoms, as we do not guarantee any activity, and in the event of failure of a condom, we will not accept the third-party responsibility).

Our home is set up to party – out on the patio is a fire pit to take away the evening chill; the living room is accented with soft blue lighting and a romantic fireplace to add some additional heat to the already hot party atmosphere. The living room is also our video showcase room, with new first-run films being shown nightly. The bedrooms are wall-to-wall, satin-covered playgrounds, with soft

lighting and music. The Master Bedroom offers a huge canopied brass bed, where the host and hostess entertain. The bar is located in the kitchen and buffet area, with mood music and videos as well.

The HighLite Club meets Monday through Saturday evenings after 9 PM, dress code is absolutely in effect on *each evening*. We prefer that our patrons dress, and behave, to please the opposite sex, so the dress code is, of course, always in effect – that is, no T-shirts, sloppy jeans, or dirty bodies.

It's important to note that on-premise clubs are illegal in many, if not most, jurisdictions across North America, although a few states do allow on-premise clubs.

The consequences of playing in an illegal jurisdiction could include arrest as an inmate of a common bawdy house. That's just one of a long list of criminal prosecution charges which could apply. Sexual charges can devastate any couple's life. Of course, the reporters of local newspapers always seem to love this type of dirty laundry. Names and addresses of players have been published: if you're known in your community, say goodbye to respectability.

On-premise clubs are generally open to couples. There are a few special days on which single men are admitted to mix freely with lifestyle couples. Single women are welcomed anytime. A club which features an established weekly singles night is the Dayton Swim and Social Club in Dayton, Ohio.

The Red Rooster Club in Las Vegas, Nevada, is open to single men twenty-four hours a day. Single men are permitted to access all facilities on the first floor of the complex. The second floor is strictly reserved for couples and single women only.

If you should plan to attend a club open to single men, mentally prepare yourself for the sexually explicit, often raunchy, scenes you will encouter. Many couples seek out this type of environment for the purpose of fulfilling the female's multiple male partner fantasies. If you visit the Red Rooster, you may see women with as many as five or six very eager men who are servicing them in every way possible.

• **off-premise clubs** *The following is an actual Club promo that will provide an insight into a typical night out at an off-premises club.* (name and city have been changed)

The Diamond Couples Club is a club for exciting, erotically interested couples, who meet regularly for exciting dance parties. We usually meet in a locked bar in the downtown Diamondville

area on Saturday nights. Sometimes special events are held in other locales.

The atmosphere at club functions focuses on sensuousness, exhibitionism, eroticism, companionship, touching, and dancing. Each party has its own particular theme, and while members are not obligated to adhere to the theme, most do for their erotic enjoyment and for the benefit of the other couples. You do not have to be sexually participative to come to the parties but you should either be involved in the Lifestyle or at least interested.

While some of the members are totally monogamous and some are swingers, *all* of the members are erotically inclined. Most of the women are bi (at least curious) and some of the men are as well.

We do not let the public come to our parties like other Diamondville clubs, nor do we advertise in the daily papers! You must apply to become a member. We will then discreetly telephone you and interview you to ensure that you will be comfortable with our activities and events and that our members will find you suitable.

Braille Beauty Pageant. Beauty contests are usually judged with your eyes... but if you blindfold the judges, they have to rely on all of their other senses to pick a winner! Contestants love it, as they climb all over the seated, blindfolded judges who simply haven't got a clue of who is who, and the judges... well, they're busy... tasting... and touching... and sniffing... and licking... and listening to whispers and giggles from the contestants (who are wearing as little as they dare!)

Nuts & Bolts. Ladies get nuts, guys get bolts. Find your match for size & color to win prizes! "Wanna screw?," "Can I see your nuts?" and "Would you like to try to fit it in?" are among the lines heard.

Sheer Pleasure. If you can see through it... it's "Sheer Pleasure." A really perfect theme for exhibitionists who like to flaunt it, and also for voyeurs who love to see it! A great contest for the sexiest, shimmeriest, slinkiest, sheerest outfit... either on or off your body!

Toga Party. Wrap yourself up in a sheet for an instant toga! (If it stays on, that's great!! If it doesn't... even better!!)

New York, New York. Glitz and Glamour in basic Black & White! Slinky lingerie, dapper dancin' duds, semi-formal, semi-dressed, or the latest in really way-out Manhattan style fashions.

The choice is yours as long as you get the basic simple colors right... all black... all white... or mix 'n' match a bit of both!

Body Art Bonanza. An erotic scavenger hunt with a twist! Hunt for tattoos (both permanent and temporary!), piercings and other body art. (Remember, though, that good etiquette requires that you ask before ripping someone's clothes off and pawing over them to find their artwork!) Show off those "intimate" tattoos that you just can't show off anywhere else!

Boxers & Briefs. Hey guys ... the ladies want a chance at you for a change! After all, it's only fair. The ladies regularly treat us to some great stuff in their lingerie! So guys, listen up: what the ladies would like is for us to drop our pants and spend the night in our underwear.

Mini Night. Ladies: Wear your shortest, tightest and most daring miniskirts! Is it a skirt, or is it a belt? Wear them with stockings or bare legs. A great night for leg lovers.

In a recent conversation with a gentleman involved in organizing "couples-only" events and parties for more than twenty years, we were offered a number of observations and opinions formulated over his years of exposure to all forms and aspects of the swinging lifestyle. Here are a few of his very interesting thoughts and observations:

Nine out of ten couples who attend couples-only events are there because of the male partner's influence or insistence. Nine out of ten couples also stop attending events because of the male partner's influence or insistence. This is due to the male noticing that "his" woman is rediscovering her power through discovering others find her to be very attractive, desirable, and even sexy. This threatens most delicate male egos and the couple drops out of sight.

Recreational sex is a growing phenomenon which will be commonplace after the turn of the century. That doesn't necessarily mean couples will practice mate swapping. Recreational sex is having sex with your lover in a place where lovers go to have sex. Facilities will be designed and built for this exclusive purpose.

Some couples-only clubs have recently moved to allowing non-married and non-cohabiting lovers to attend club social functions to mix with married couples.

Most women will inevitably have episodes of flirtatious sexual conduct with another woman, perhaps fondling and kissing while on the dance floor.

"It's okay for me, but I will not have another woman touching my husband that way," is an attitude common to probably ten percent of female participants. This attitude can, has and does lead to outbursts of anger.

There are hundreds and perhaps thousands of couples who have developed, and are living in, long-term three-party relationships. By far the majority have never involved themselves in the club scene.

Best nights of the year to attend a couples-only club: Halloween and Valentine's Day.

Remarkably, most couples, even after several years of club membership, have remained monogamous.

roger and marta: a visit to an off-premise couples' club

as told by: Roger

I think you'll get more out of this story if you know who we are and what our sexual experiences had been up to this point. My lover and I have, above all things, built a relationship on a foundation of love and trust. It wasn't easy for the first few years, but over the past ten or eleven years we have become more loving and open with one another than we were in the first several years of our marriage.

Our exposure to involving others in our sex lives was limited to two occasions, very early in our marriage. Our only experience involved a close male friend of ours. It was kind of a letdown afterwards, not very satisfying, somewhat rushed – in retrospect, the word "frantic" comes to mind. I don't think the involvement was as caring and gentle as it might have been. Ah, the misdirected passions of youth.

We had often talked about having a threesome with either another man or woman, and we would go out on a Saturday night with those thoughts in mind. It seemed an impossible task to accomplish, in such a straitlaced world, to go out and meet someone that you could say you wanted to have sex with, as a couple.

We even tried going to a Toronto gay club. We were surprised to see so many couples at the gay clubs and thought this was where we might have been able to meet up with our fantasy single or couple. Forget it. The babes loved her and the guys loved me.

Our search then led us to discover a wild, free-for-all swinger's sex club. It was a blast to go and play at sex for a night. We couldn't keep our hands off each other and had an audience every time we got into a sexual exchange. When we weren't putting on a show we would watch one. We saw every sex act one could imagine. Twosomes, threes, fours, multiple women with one man, multiple men with one woman... every aspect of human sexuality was completely out in the open – with one exception: bisexual or homosexual male activity.

Over the course of our first ever on-premise swing club evening we openly enjoyed each other's sexual favors, bringing each other to the very brink of orgasm and then abruptly stopping. We thought that if we'd had sex to completion, we would have lost interest and left the party. It was such an incredible turn-on to go down on one another, to have sex while she was on all fours and I was on my knees behind her, all completely available to the view of anyone who wanted to spend a few minutes watching. The evening went by far too quickly and we couldn't wait to get home to finish what we started, or should I say, to continue where we left off.

We went out to the club for a second time and had just as much fun as we'd had on our first visit. Then, a few weeks after our second visit, the club was closed down by local political forces that didn't want this sort of establishment within their region.

We never did meet our dream couple. Time went by, my lover and I got away from trying to live out our fantasies and started our long-awaited family. It's hard to believe that here we are, eleven years later, again wanting to meet others who are as sexually uninhibited as we are, like-minded individuals who want to live out fantasies. This time though, we are 45 and 41 years old.

Reopening the subject again, after all these years, was somewhat difficult. Neither of us had talked about our fantasy desires even though, as it turned out, we were both still very receptive to the idea of swinging. Several months ago, while watching an adult flick, we finally brought the subject up again. Being a little older and far more secure with our love for one another, it was easier to talk about fantasies than it was the first time around. We discovered our thoughts of involving other people in our relationship were not at all as threatening as they used to be those many years ago.

In our view... sex is fun! The thought of someone else in bed with us is fun! It's just fun, not a desire that's present because something in the relationship is not right. It's very sexually stimulating to get into a conversation with your lover describing what the ideal fantasy could be. Try it for a few hours and see how sexually turned on it gets you. If you are anything like us, you'll both get so damned turned on and end up in bed having one of those memorable encounters that always seem to leave you wanting more.

We had been talking for so long we knew we were ready to have a firsthand look at a couples' club such as the Diamond. When we located a club in our particular area, Marta phoned for details on how non-members could attend their members-only party nights. She was then given the "Restaurant – Bar & Grill" confidential location and instructed to bring ID's to prove who we were. What a wild night it was to be.

This particular club did emphasize that it was for erotically minded partners only. The non-member price for this evening's festivities was $30. It was Pimp and Hooker night. The guys were all provided with $1000 play money and the richest woman in the club at midnight was crowned as the top hooker of the evening and presented with some small recognition of her accomplishment. The theme of the evening did not scare us off. We agreed it would be fun to see a room full of people playing such a game.

We arrived at the parking lot of the "Restaurant Bar and Grill" to find it located in an industrial mall district of suburban Toronto. This was perfect, for we felt wrapped in anonymity. Identities were more protected than they would have been at the normal downtown restaurant and club type locations. The parking lot was jammed, as was the parking lot of the adjacent group of buildings. Both of us had been rather skeptical when we heard there would be as many as 40 to 60 couples, so when we saw the parking lot we started to feel a little more relaxed. There were enough people there so that two newbies, as first-timers are called, could get lost in the crowd and observe, which was all we intended to do.

We walked into a front entrance foyer to register. Registration required that we present our photo ID and sign a waiver of understanding, a legal document to say we knew what we were getting into. After paying our admission fee, we proceeded to the bar. It was then the dance floor jumped out at us. There in the darkness were more than a dozen women, dressed in skimpy lingerie outfits. Some were in various stages of undress, grinding their bodies against each other in time to a driving dance rhythms. One female couple stood locked in a steamy embrace, tongues licking each other's lips. A blonde woman cupped her breasts in her hands and lightly skimmed over her dance partner's nipples with her own. Fingers examined pubic mounds, necks and nipples were kissed. Tongues explored mouths... the gentle beat wore on.

After a few moments, other couples, previously hidden in the darkened corners, started to come into perception. Our eyes slowly adjusted to the lighting. A crowd of people stood encircling the perimeter of the dance floor watching the unfolding same-sex dance show. Many of the couples were embracing as they watched, their bodies bopping to the beat as they kissed and fondled each other. Two women and a man were standing in tight formation, rubbing their bodies against each other as they shared a lust-inspiring three-way French kiss. We entered the crowd.

Just as it was our turn to order at the bar, the dance music faded and the lights unexpectedly lit up the surroundings. Tables of four, six and eight were scattered throughout the entire room. The explanation for the laughter and shuffling sounds, which had permeated the air in the darkness, became instantly

self-evident. Groups of couples had been entertaining each other by putting on individual erotic performances at the tables. This was one happening place.

Excusing myself, I left Marta alone at the bar for a few minutes. When I returned she introduced the gentleman as Sandy. My first reaction when I saw her talking to Sandy was, "Oh poor sweetheart, he's definitely not her type and he's hitting on her."

As our conversation evolved, Sandy discovered this was our first club visit. We learned he had been a member of the club for less than six months. Sandy confided he met his lover at a singles' club and immediately took out membership at this particular club only two weeks after they met. Sandy's lover, he explained, was openly bisexual.

I found myself a little uncomfortable with Sandy's reality. I mean, here was this gorgeous lady that I was with this evening, my best friend, my kids' mom, my incredibly passionate lover, my life, my own wife of 19 years and 4 days. Hmmmm... It's strange the way my mind works, I see a situation and try to fit myself into it. I had a problem with seeing myself feeling good about bringing a relationship like Sandy's into ours. It seemed they had nothing to lose as a couple.

I know there are couples who have stood the test of time and truly love one another and have a similar outlook on life to ours. Such couples must exist. We may never meet this couple but, for us both to feel perfectly at ease, they would have to have just as much to lose as Marta and I.

Sandy's wife was on her way to him when she literally bumped into one of their female friends. They hugged, kissed and sat down with their arms around each other to talk for a few minutes. We never did say hi to his wife. She had a cute face.

My lovely Marta and I stood against the bar observing soft sexual escapades of people in their early twenties all the way up to folks that looked to be into their late fifties, perhaps even early sixties. There were attractive couples, not-so-attractive couples, skinny, overweight, shy, extroverted, you name it. These were people you would find in any crowded night spot, except these people were a little more excitable, you might say. Now that we were getting a taste of what off-premise clubs were all about, we tried to see ourselves in the people who were partying on this evening.

We didn't know what to expect that night and after an hour had slipped quickly by, we stepped out into the warm night air for a little toke and a breather. As we sat in the car we discussed coming back to the club for another visit. Knowing now what to expect, we started to formulate a scenario for our next off-premise night out. Next time, we found out the hard way, we would be sure to arrive very early in order to choose our own table. Hopefully, we laughed, we might be early and lucky enough to grab a table in one of the darkened corners of the room.

That's where all the real fun seemed to be centered. We talked briefly of what we would feel comfortable wearing, or not wearing. Having observed the behavior of the people we found attractive, we fantasized about how far we could carry on with one another the next time. What a turn on, sitting in the car having a toke, fantasizing... *again!*

We walked back into the club and stayed for another half hour before driving home, getting out of our clothing, and easing the cork on a bottle of our very special favorite vintage red. We lay on our bed, in the candlelight. We discussed some of the people we had seen, what they looked like, what turned us on, what turned us off, who turned us on, who turned us off. Our conversation was playful, exciting and remarkably sexually stimulating.

Of what happened next I can only say that when I was a younger man, I never would have imagined that after nineteen years of making love to the same woman, sex would, or even could, feel as new and exciting as it did that night. We made soft tender love well into the small hours of the morning, slept for a short spell, woke up, had tea and stayed in bed making our love twice more over the course of the following hours. The biggest and most unexpected benefit of our visit became obvious for many weeks following, our sex life went from great to incredible. Imagine that!

• the second visit

as told by: Marta

Several months passed by after our first visit, which provided us more than enough opportunities to compare personal fantasies to the realities of off-premise clubs. Time to ponder some of the memorably erotic visions of our first visit: the female couple locked in embrace, tongues exploring... the blonde woman lightly skimming her dance partner's nipples with her own... fingers examining pubic mounds... the couple locked in a three-way kiss with another woman... intimate fondlings, out of sight, at the darkened corner tables. Our recalled visions were always vivid, stimulating and with time came to tempt us into a return visit. The sexual energy contained in that party space was so extraordinary that it continued to provide fantasy pleasure these many months later.

Could we involve ourselves in such seemingly harmless sexual antics? There were many apprehensions. As corny as it may sound, our apprehensions hit on us like ocean waves against a jagged cliff. Was it really harmless? How could the sight of my lover in someone's arms be harmless? How would we handle the jealousy factor? Would jealousy even become an issue? Could I allow an attractive stranger to touch me in an intimate place? Could I touch a complete stranger in a sexual way? Would my lover look enchanted while dancing with another? What would

my lover think of me? What would I think of myself the next morning? The words, "For every action, there is an equal and opposite reaction," would periodically cross my mind. Could this hurt us as a couple? Would there be emotional fallout?

So many apprehensions stood in our way we seriously considered forgetting about a second visit altogether. Despite our anxiety, the one element that remained constant throughout was our shared yearning to turn multi-partner sexual fantasies into reality. Our sexual exchanges included talking through fantasies as we made love. One night we asked each other a few simple questions. Did we really want to take steps toward meeting a compatible couple for fantasy exploration? Yes. So, what was our problem with going out to a club full of like-minded people? Why did we see the playful sexual cavorting that took place at club parties as being such a major threat? Was this a place where we were likely to meet someone that could make our fantasies realities? Maybe. So why not go out and have some fun? After all, fun is what this was supposed to be all about in the first place, wasn't it?

After countless hours, in fact months full of hours of discussions, carefully thinking over every possible aspect of how our actions might cause distress in our loving relationship, we fantasized about how we might be received at our next party. Would we be accepted by persons we found to be attractive? Would we be desired by people we thought were ideal for us? Were we too old to attract vibrant and sexually desirable people? Would we walk away from the party feeling the bitter and cruel effects of rejection? Where were all these questions coming from? What a dilemma. Hey!... this was supposed to be fun.

It was Halloween week at our household. Memories of the parties and fun we had at Halloween in past years came to mind. I was moved by recollections of how past costumes inspired me to behave as if playing a role in an impromptu play. I couldn't help but feel a twinge of envy that it was the kids and not me going out to play dress-up.

In years gone by, this pagan celebration had seemed to subdue people's inhibitions regardless of which lifestyle they chose to follow. Every Halloween celebration we attended had an underlying sexual, sometimes even risqué, flavor to it. I was certain there was an off-premise club Halloween party that Roger and I could visit on the weekend. If I could think of the perfect costume, something that would let us play as the characters we were dressed as, I wanted to go. Having made the decision, my mind started to muse over many different costume ideas. I tried to think of a disguise which would complement my own character and reflect my feelings toward the curious, exotic and alien world of a swing club environment.

It was Friday night, only 24 hours to party time, when I asked Roger, "Honey, if we can think of an ideal disguise, do you want to go and have some fun

at a couples-only Halloween party?" Inside of twenty minutes we were in our closets seeking out costume options.

I don't know what inspires Roger sometimes. I thought of the *"alien"* world of swing clubs and Roger came up with a costume idea as if he had read my thoughts. Roger casually mentioned if he could find an alien mask, or at minimum, alien eyes, he would dress in spandex pants with a turtleneck and go out as an alien. What a great idea. Roger is six foot five and weighs a lean 185 so his body type would fit, very naturally, the classic alien look.

Roger as an alien, hmmm... long lanky legs, long hands with lengthy fingers, elongated slender feet, black tights with nothing underneath except his long, thick penis bulging in the spandex. These thoughts were exciting me. We fell asleep that night with no real plans to attend the party. Roger and I decided to defer our decision to go until he had a chance to realize his first fantasy – the acquisition of the alien disguise he couldn't stop talking about.

The following morning Roger left to call on the top costume supply company in our area. In less than an hour he was back with two very expensive full-head latex Roswell Alien masks. They were absolutely gorgeous. I felt a wave of intensely pleasurable sensations cross my body when I realized this meant we were actually going out.

The masks were so very erotically inspiring all we did was marvel at them all day long. I finally found the other parts of what was to be my costume. A lace bra, black spandex tights, no panties and a black full length dress with only the top two of the many buttons on the front done up. Evening quickly approached.

When Roger finally showered and dressed, he felt so sexy in only his tights he couldn't keep himself from showing his arousal. With the full head mask on he was now seven feet tall, lankier, longer and definitely, as was about to be obvious to all, very well endowed.

Our last visit to a Couples-Only party taught us that if you didn't arrive shortly after opening, tables and chairs would fill, leaving late arrivals to mill about until an opening became available. We were on the road promptly at seven o'clock.

On our arrival into the hotel parking lot, both Roger and I fitted our masks onto our heads before leaving the car. As we meandered into the hotel lobby, already doing our best to act as though we really were aliens, our reflections were coming back at us from everywhere we looked. I was sincerely amazed that it could possibly be Roger and I behind our disguises. With heels on, and because of the extra height of the mask head, I was now six feet tall and very slender in a surreal way. I loved what I saw. Earthlings at the front desk stood still as we passed.

Walking down the curved stairway to the ballroom other costumed partygoers started coming into view. It was indeed flattering when everyone stopped

what they were doing to glance at the seven-foot-tall alien with his six-foot-tall companion. We could hear oohs and ahhs as we approached the registration table. Several people went into the party room to get friends out into the foyer to see "the aliens." One overly rambunctious middle-aged woman with an accent approached us to say how desirable and delicious we looked. She sounded, mistakenly, as though she knew who we were but wasn't certain because of the disguises. She looked up at Roger and said, "Let me see if I can recognize you." She then moved a hand toward the mass between his legs and fondled him. She soon discovered that she really didn't know who we were, but nevertheless it was plain to see she was swept away by Roger.

The masks limited our field of vision down to about thirty degrees directly in front of us, making it necessary to move slowly and deliberately. This limitation made us look a bit like genuine aliens, although we were, in fact, only doing our best to maneuver through tables and chairs. I started feeling as though we were taken over by our disguises. The masks gave us the rather naughty freedom of looking at people without them knowing they were being watched. Consequently, people were intimately examining us thinking that we weren't noticing them. We were.

Over the next hour or so, the room filled up with as many as 250 men and women from all walks of life. As with our first visit, all age groups from early twenties through mid-sixties were represented. We put on the most provocative and erotically suggestive demeanor we could muster as we prowled about the room looking, without being noticed, into people's eyes, examining their faces and bodies.

Our alien fantasy theme was so very appropriately chosen, I thought, because I did have a sense of being an alien in a strange human world. I know my behavior was certainly alien to me. Here I found myself looking for a form of "love at first sight." I became flushed at times, when, while I observed a sexually stimulating person without them being aware, they would examine my anatomy, their eyes so full of desire.

The apprehensions, the questions about jealousy, the fears, everything seemed to melt away in the moments I thought about the potential of Roger and I having sex with some of the specimens this "alien" was scrutinizing. I became aroused to even greater levels when I imagined Roger having sex with that specimen as I observed.

Taking a breather from the main party crowd, Roger and I found a room full of couches and easy chairs ideally available for us to slip out of our masks and chat about the fun we were having. He assured me that I wasn't the only one that was becoming aroused and asked if we should perhaps consider leaving for home. The kids were, after all, at Grandma and Grandpa's, and we did have the house all to ourselves tonight for a change.

It was at about that time, after deciding to stay for another hour or so, that Roger quietly stated, "Marta, if there's an ideal couple for us in this world, they just walked in the door."

I turned to see who Roger was referring to, smiled at Roger and could do nothing but agree. The couple looked like the perfect fantasy couple, but I didn't think that a man and his wife in their forty-somethings would be an attractive item in the minds of a couple in their early twenties. However, the prospect of making it with a couple almost twenty years younger was an unbelievably appealing thought. Glimpsing in their direction I became sparked when I noticed them both catch my glances and smile at me. Such warm looks, nice faces, I felt a connection of some sort during our glances. Could it be possible we were intriguing them?

Discounting the probability seemed to make it comfortable to talk in bluntly honest fantasy terms. I told Roger that his choice of an ideal fantasy woman came as a complete surprise to me. She was a strikingly beautiful young woman, just under six feet tall, alluring eyes, shy but always glinting; a wide toothy smile; pouting red lips on a chocolate-brown face; and legs, long shapely full legs. A simply elegant young black woman.

Separated from this curious couple by the length of the room, Roger and I continued our fantasy conversation. Roger asked if the thought of this young couple home alone with us turned me on. Again, thinking it would never happen with people so young, I told Roger he knew full well I'd love to have the attentions of a younger man. Wouldn't most women my age? This handsome young man fit perfectly into the mold of my daydream images. He seemed now to be looking at me more intently, obviously catching my own inquisitive glances. This was eye play at its best. My face was aglow with a blush. Was that a look of desire in his eyes?

It seems as though putting the masks back on was slipping back into anonymity. Getting back into character, we rose from our comfortable setting and moved toward the ballroom. As we approached to walk past the young couple, I watched as they both visually scanned our bodies. I saw delight in the young lady's eyes when her eyes locked on Roger's tights. A wide grin lit her face as she leaned to her lover's ear. His eyes fell then locked onto the large half-engorged thing in Roger's pants.

As we passed them on our way, I felt hedonistic, flirtatious, wantonly seductive, and so very desirable. Before Roger came into my life I often played at the social games of getting people to notice me with a fervor. That was what being young was all about, wasn't it? After an absence of more than fifteen years these familiar feelings were like an old dear friend I hadn't seen for far too long. I truly

felt an awakening deep within me as hidden, long-forgotten recollections of youth were aroused.

Moving through the entrance to the ballroom I could now feel the looks of people as we passed. I felt so incredibly vital. The dance floor was alive. Sexually charged bodies bumped and swayed, dancing to the music. We spontaneously fell into our alien roles and stood at the edge of the dance floor sampling the confusion, the puzzlement extra terrestrials might exhibit the first time they witnessed humans involved in this ritualistic expression of joy.

From behind me I heard a pleasant voice say, "Your costumes are the best." I turned to see the young man and his black companion both smiling at me. I thought it might be appropriate to remove my mask, exchange introductions and chat for a few moments. Roger was right in sync with me and so we met Matthew and Stevie.

I felt as though my body was spinning through thin air. There was desire in the eyes all right. I was certain I detected want for Roger in Matthew's eyes. I could see it coming to me from Stevie, and I reveled in the tender shyness of her expressions of eroticism. The last thing on my mind was any apprehension or inhibition. This kind of behavior could become addicting, I thought.

I don't know who started dancing first. Before I realized what was happening the four of us had wrapped our arms tightly around one another and started moving to the beat. I felt hands tracing over my body. Instantly, I became the center of attention. There was a hand at my breast, another kneading one side of my buttocks, a third at my other breast. Because of the mask, I couldn't tell which hand belonged to who. Roger and Stevie then separated themselves from Matthew and me, dancing as they lovingly held each other.

The view of my husband amorously involved with this beguiling young black woman caused my breathing to become urgent. My heart beat wildly as I entirely surrendered to fantasy. One of my earliest questions was answered. Roger definitely did look enchanted as he danced with Stevie, but I didn't feel threatened. Instead, I suddenly remembered having a "thing" for sexy older men when I was Stevie's age. Stevie was definitely holding a sexy older man close to her body. The visions turned me on.

Like four whirling dervishes, we danced our pent-up dance of desire and passion. I felt entirely swept away as Matthew, sensing my lust, ran his hands over my yielding body. The sight of Roger and Stevie inspired me to allow my hands to do some exploring of their own. I touched his chest, my right hand slid over his hard stomach and down to tenderly cradle his fully erect penis within my hand.

As we danced, Roger took my left hand as he and Stevie positioned themselves intimately close to us. My heart pounded, my mind reeled, I felt intoxicated. With my right hand exploring Matthew's hardness, Roger led my

other hand under Stevie's short miniskirt to accompany his fingers in exploring her silk-shrouded pussy. Stevie very subtly and demurely pressed herself into my hand as I reached to experience the saying I'd heard so often, "a woman instinctively knows exactly where and how to touch another woman." I must have known how. Stevie wrapped her arm tenderly around my shoulder, hugged me, and let out a long sexy sigh.

When the music stopped the four of us walked off the dance floor and headed directly to the lounge area once more. I needed to get out of my mask, catch my breath and cool off a little. I was on fire! After a few minutes of nervous conversation, Roger suggested we go to the car for a quick smoke. I was interested but our young friends said they didn't smoke, so only Roger and I ventured out.

Just as we were unlocking the car doors, Matthew caught up with us and admitted he had never smoked but thought that he would like to try it for the first time. I chuckled, feeling like I was about to corrupt this clean-cut handsome young man. As we smoked, Matthew asked us what we were doing later in the evening. Roger shocked me with his forwardness when he responded to Matthew, saying, "We were just thinking about going home. Would you and Stevie like to join us?" Later, he conceded he was astonished at how easily the words of his invitation rolled off his tongue without even thinking about the words which came out of his mouth.

As it turned out, this night was Stevie's first time at a couples-only party. It was obviously premature for her to accept an invitation to someone's home. Stevie was experiencing what we did on our first visit, just observing a couples evening to determine if she could think in terms of further participation. It further turned out that I was right: Matthew wasn't too clear on his own sexual desires. He made that quite clear by asking us what it was we were looking for and then telling us his limits were "pretty nonexistent."

Matthew and Stevie stayed at the Halloween party as we headed for home. While saying our goodbyes to a few of the people we'd talked with, it was plain to see the evening was far from over. People were just now extending their invitations to home parties and to some of the suite parties upstairs, and generally making various plans for the remainder of the night.

I suppose we could have stayed longer, could have accepted an invitation to a private party. Or we could have stayed with the hopes of meeting another couple, or even couples, who would have taken us up on an invitation to a private party at our home. We had that option open to us. I'm glad we went home to our exclusively private night. It seems now we would have been settling for second-best after Matthew and Stevie said no. I'm so happy we chose the course we did – our fantasies are still intact. It would be nice, one day, to answer the phone and

hear Matthew and Stevie say they're ready to accept our invitation. After all, we did exchange phone numbers.

• the aftermath

as told by: Roger

Three weeks have passed since our night out at the Halloween party... an amazing twenty-something days of a wonderfully enhanced sex life. Marta seems undeniably less inhibited than in all the years I have known her. I'm fortunate to be able to have an office at home, and thank my lucky stars that I'm able to be with Marta during the day, especially when we are both feeling a little... ummm... oh... never mind.

As I mentioned, Marta is a little different than she was three weeks ago. I believe her levels of self confidence and self-esteem have increased due to a certain young man's attentions. The thought that she's in her forties and can still be desired by a younger man seems to have rejuvenated her energies. It's wonderful, and what could possibly be wrong with that? She does share a lot more in common with people in their twenties than she does with people her own age. Physically, Marta has kept herself young. It's true, all those years of staying out of the sun does preserve one's complexion. Her 114- pound form even looks girlish at times. She has a glow of confidence I haven't seen for quite some time.

Our sexual exchanges are out of this world. For example, the day before yesterday, Marta was drying dishes at the kitchen sink when I approached from behind, put my hands on the waistband of her jeans and, while playing at tugging it down, I said, "Drop 'em, baby." She did! We coupled as she leaned forward against the counter top. I did everything I could do to bring on her orgasm while holding back my own. Succeeding in a very few moments, I looked forward to our next encounter. Following three separate encounters of this nature in one day, I couldn't wait until our last intimacy of the night where I found a final, almost surreal, release.

Marta hates me for telling this secret but I would feel like I was telling half a story if I said nothing about Marta's newfound enthusiasm toward performing "deep throat" to limits previously unknown, and of her sudden appetite for anal sex. We have always enjoyed an exciting and fulfilling sex life but these new behaviors are beyond the norm for us.

When we first talked about our ideal couple, both of us thought they would be a lot like we are. Unexpectedly, Matthew and Stevie are quite a departure from our original concepts. I mean, please, 24 and 26 years old. We could be mom and dad to them both. Have we lost our better judgment? Nah! I feel as though this is one of the benefits of having worked so hard to keep ourselves looking and feeling young, in body and in mind, young enough to attract youth.

Our fantasy talks during sexual exchanges are hotter than ever since the party. New curiosities and fantasies have been inspired by recent events in both our minds. I have a new fantasy that I would like to see come to life one day: to sit in a rocking chair and watch Marta while she makes it with a handsome and eager-to-please young man half her age. His lady, in turn, is sitting submissively on the floor at the foot of the rocker, between my legs, wetly and noisily performing oral sex.

I'm curious about what Matthew meant when he mentioned his limits were "pretty nonexistent" and how I might react in a situation with a naked and aroused younger man with nonexistent limits. It feels somewhat odd, but I don't feel negative about the issue. Visions of Stevie and Marta sharing a good night kiss the night of the party lead to thoughts of how Marta might react toward Stevie while in bed. Could Marta explore another woman's body without inhibition? I think she would be passionately swept up and lustfully involved before so much as having had a chance to think about her actions.

I wonder if we'll ever hear from them.

• aftermath, part 2

as told by: Marta

In the weeks and months following Halloween, our venture into the world of fantasy, my personal attitudes and philosophy as to the true meaning of monogamy in marriage came into question on a frequently recurring basis. Not being one to jump into any situation without studied deliberation, I searched for as much information with respect to swinging as I could get my hands on. The more I learned, the more time that went by, the stronger became the urge to admit my readiness to accept a sexual experience outside of the standards set by tradition.

Over the many weeks and months of searching, the best information I managed to uncover was written by a respected Canadian sexologist. Dr. Frank Summers was said to be one of the leading authorities on the subject of human behavior as related to issues of sexuality. Having studied on-premise swingers' clubs for clinical research purposes, Dr. Summers' belief was that *"swing clubs may in fact promote mental health."* Couples who possessed the capacity to seek out their sexual fantasies as a couple were far more likely to lead happy and productive lives than those who secretly wanted to but for whatever reasons couldn't. Here was a learned expert in the field proclaiming a belief I had carried with me for most of my adult life.

Dr. Summer's opinion echoed in my mind for days: *"may promote mental health."* I understood his statement perfectly. We're all sexual beings. We all have desires. We all have needs and fantasies. I wondered how many men and women

sacrificed their marriages by not having the ability to discuss their secret fantasies and desires. How many men sought to satisfy their sexual needs outside of the bounds of their relationship? How many women? They're everywhere. Men and women who cheat on one another then live in a lie. One lie leading to another, and another. Yes, I understood what "could promote mental health" meant.

For many years I had shopped at a boutique specializing in intimate apparel. Of course, the shop carried the customary array of adult toys, oils and such related items. On a visit to the store one day, I noticed displayed on a shelf one of those how-to books, a "guide to the swinging lifestyle." I picked up a copy and as I thumbed through, Sadie and Kathleen, the owners of the boutique, noticed my interest.

Because of the nature of their business, I'd always supposed a segment of Sadie and Kathleen's clients were involved in the lifestyle. Over the years I had taken Kathleen into my confidence on many occasions. Fittings of intimate wear, advice regarding a few toy purchases: how much more intimate can you get with another woman? Kathleen came right out and asked if I had a personal interest in the subject matter of the book I was thumbing through. It was simple for me to admit my fascination with the topic because of my rather intimate past dealings. Sometimes, when you are preoccupied with a thought, information seems to find its way to you all on its own. That's what happened on this day.

Our conversation started with Kathleen's own admission of having had enjoyed assorted group sex episodes, not as a swinger, but because of her self-admitted promiscuous nature. I could see by her responsive smile that Sadie may have enjoyed a similar past, but I sensed a reluctance on her part to admit to it as willingly as Kathleen had. The ensuing exchange of views left me with answers to many of the questions I had asked myself. These were not the views and ideas of some anonymous author. These were distilled exchanges of information both Kathleen and Sadie had accumulated in more than twenty years of catering to numerous women whom they knew to be actively involved in swinging.

According to Kathleen and Sadie, and much to my amazement, males are more resistant to the concepts of the lifestyle than females. Meeting a man who was interested in both a genuinely loving long-term relationship and one who would be open to the idea of swinging, they said, was extremely difficult. If it was just for the sake of the sexual promise held by swinging, most men would entertain the notion. But, if doing so meant that their significant other were to share a similar experience alongside them, most would not allow it. How very interesting, I thought. It was the age-old double-standard view held by so many.

After offering a few other tidbits of related information, Sadie told me I didn't know how lucky I was to have an equal partner in my life instead of a "M-a-a-n-n." As she exaggerated her humorous enunciation of the word, she held her

arms akimbo, took a big breath, sucked in her stomach and puffed out her chest in mockery of a macho-type man. She was hilarious. I left the boutique with a decidedly different attitude than I had when I first walked in.

Later in the evening, after the kids were bedded down for the night, I invited Roger to join me for a cup of tea in the solitude of our sunroom. My intentions were to share the new information I had gathered. That's not what was to unfold. Our clothing ended up in a heap on the floor beside the couch. Our newfound thirst for oral sex in those days had grown to become unquenchable. We couldn't get enough of one another. It wasn't until we crawled into our bed, in the afterglow of intimacy, when the reason for all of my years of uncertainties and apprehensions were finally resolved.

When I first met Roger, months of getting to know one another had gone by before we had sex. Why should that process all of a sudden not be as important as it was between the two of us?

The threesome incident early in our marriage was shared with a mutual friend. The three of us shared a long history: we knew him first as a person before we had a sexual encounter. Although we're separated by thousands of miles, the three of us continue to remain in touch. We've managed two visits to the west coast, and, because his parents live not far from us, Jeff has visited with us on at least a dozen occasions. We are friends to this day, just friends. Today, the physical intimacies we shared remain only as pleasant, secret memories.

I really did feel lucky, as the boutique ladies said I should, to have Roger in my life. I thought back to all of the times we questioned if the lifestyle was for us or not. I remembered the night Roger said, "Sweetie, forget about it altogether. This is supposed to be fun and nothing more. If you feel this threatened by the prospects, let's just forget about the whole idea for good. There is nothing in this world I want more than to be with you. If enjoying our fantasies is anything less than fun, it's not important. Let's just walk away from it." We fell asleep that night wrapped in each other's arms.

Yes, it was supposed to be all about having fun. The day after my visit to the lingerie boutique, my insecurities vanished for good. From that day forward, I've been taking on the world with a revitalized sense of self-confidence. Nothing and nobody can or should take this away from me.

• a curious courtship

as told by: Roger

Three months passed before we were to hear from our young acquaintances. Matthew apologized for not having called sooner, saying he had lost our phone number. Fortunately, he had remembered our last name and eventually found us through the Internet-411 service. He asked why we hadn't called them. Did we

have a problem with their appearance or personalities? Not at all. I told him we would have called but thought we might be putting them on the spot by possibly sounding like an older couple in a desperate vulgar pursuit of a couple in their twenties. He chuckled.

Because Stevie was out shopping and Marta was out with our kids, Matthew and I had a freedom to chat for well over an hour. Both of us had a chance to learn more about each other beyond the limits of a club environment. It was easy to talk with him. There wasn't any pressure to try to come across as anything or anyone other than who we really were. It struck me as we chatted that our conversation could have been likened to a kind of a courtship.

I knew neither Marta nor I would consider having anything to do with a person or people who were less than entirely honest and straightforward. Our conversation convinced me that Matthew did in fact possess these essential qualities. Matthew seemed to be searching for the same honesty and straightforwardness which Marta and I viewed as such critically important characteristics.

Over the next few months, the four of us had several long phone conversations which allowed us to become small parts of each other's lives. Meeting in a restaurant or café might have been better suited to getting to know one another, but because of the hundred-mile distance between our homes, our personal schedules, the needs and extracurricular activities of our youngsters, Stevie's schedule and Matthew's busy professional life, this was the easiest way for us to at least get an insight into who each of us were.

By the time we finally did get together, we surely must have appeared to the outside world to be the best of friends. Over the weeks of phone calls we had become intimate with each other's lives. Our social night out was the next logical step in our developing long-distance friendship. Had we called and hastily arranged a date following our initial meeting at Halloween, I'm sure there would have been present an air of uncertainty and apprehensiveness. As we'd never gone out on this type of a date before, I'm certain we would have surrendered to an anxious and nervous frame of mind. Instead, we enjoyed an evening of small talk, a leisurely meal, took in a movie and parted company promising to meet for another such night out on the first available weekend.

During the drive home Marta asked if I had noticed anything odd about our night out. I really hadn't noticed until Marta pointed out that for four people who were supposedly intrigued with one another, not one of us once approached the topic of a sexual liaison. This was our common motive, yet the issue had remained veiled. We confessed to having been tempted several times to bring the subject up for discussion but neither of us had sensed a suitably subtle transition point in conversation. Now that Marta had mentioned it, it did seem a little odd. Six months had passed since Halloween.

Matthew, by now familiar with our schedule, caught me at home alone when he called a few days following our dinner date. This specific call was quite different from all of the conversations we had had up to this point. Matthew sounded like an excited kid in a toy store. He told me of how strongly attracted Stevie was to us as a couple. He went on to say how much more appealing and desirable Marta was than he'd remembered her. He spoke of how, when he and Stevie arrived home after our dinner date, they stayed up all night making love. All I could do was listen, and occasionally, when I could get a word in edgewise, I returned his compliments.

My mind wandered back to Saturday night as I listened. Stevie looked significantly more appealing than when we had first met as well. She seemed taller and shapelier, and her skin was much darker and smoother-looking than I remembered. I was certain she had been working out at a gym.

We both laughed until it hurt when I jokingly told Matthew we had better stop talking in this way as I had gained an erection which would be in immediate need of attention if he persisted. He was howling while trying, over his laughter, to admit being in a similar state. Tears were running down my cheeks from laughing so intensely. When we eventually regained our composure, we made tentative plans for the four of us to once more meet halfway for dinner and drinks. We thought it would be a nice idea for the girls to make all of the specific plans and ended our chat.

I was still grinning when Marta came home. Later, after bringing her up to date on the details of Matthew's earlier call, she called Stevie to arrange a place and time for our second dinner engagement. It was Marta and Stevie's chance to spend an hour chatting. Matthew had obviously brought Stevie up to date on our conversation, because when Marta finished her call she giggled and asked I had enjoyed the phone sex I had shared with Matthew. Technically, I guess that's exactly what had taken place.

The town where we were to meet Stevie and Matthew was a one-hour drive from home. The ride recalled the wonderful feelings of anticipation I'd experienced many years ago while making the trip to meet Marta for a date.

Marta startled me at one point on the drive. "I wonder," she asked, "if this is what world would have been like if Eve hadn't taken a bite from the forbidden apple." How thought-provoking!

The village where the ladies had agreed to meet was a picturesque community of artists and craftspeople – an idyllic backdrop befitting of our circumstance. Noticing Matthew's car in the parking area on our arrival, we knew our friends were already waiting for us inside. We entered, gave our names, and were ushered to a secluded wing of the dining room. There, in in a charming little alcove which afforded a discreet measure of privacy, sat our friends.

Stevie's appearance was always delightful, but this night she looked magnificent. Her long black hair was a mass of flowing locks which shimmered as she stood to greet us. She had on a dark violet dress with a gold fringed plunging neckline which accentuated both her cleavage and an obviously expensive thick gold necklace. Stevie hugged me as Matthew did Marta, then she put an arm around Marta's waist, looked into her eyes, and shamelessly kissed her on the lips.

Whereas our past dinner date had been devoid of any reference to our sexual desires, this occasion started out as a provocative evening of flirtatious and suggestive discussion and conduct. Unexpectedly, it was Stevie who was first to leave all traces of any inhibitions behind. She made clear the desire she had for Marta. She stroked Marta's face, kissed her mouth and, unknown to me at the time, even ran her hand under Marta's dress. I'm glad I wasn't aware of her antics at the time: standing up would have been difficult.

The evening melted away far too quickly, almost as quickly as any remaining inhibitions we might have had. After dinner there came a discussion during which was formed the foundation of a truly caring and loving friendship. When we parted company we parted in an atmosphere of intimacy. The four of us had indeed become friends.

• friends first

as told by: Marta

How many years had gone by between the first time Roger and I playfully spoke of our secret sexual fantasies? I lost count after a dozen, but I was sure it had been a few more than that. Our talks in those early years had been honest, and I believe now, even beneficial to our relationship. Our sharing inspired many nights of extraordinary sexual exchanges which I'm certain were at least partially responsible for having kept our marriage strong and vibrant.

Several months ago I was excited at the prospect of having a group experience which would include this younger man we'd met. But after our last dinner engagement, while I was still drawn to the younger man, that excitement was dwarfed by the prospect of having intimacies with the younger man's woman. This was a surprise to me... but once I'd gotten to know Stevie and gotten to know myself a bit better, the idea of lovemaking with this gorgeous woman was tremendously exciting to me.

When Roger and I first arrived at the restaurant, I had to make the trip to the powder room. Stevie came along and once there she stood with her back to the entrance door, put her arm around me again and drew me close to her. Gazing into my eyes, she moved her face to mine and painted my mouth and lips with her hot, sweet tongue while her hands moved sensually as she explored my body. I had

to stop her when I thought I heard footsteps approaching the powder room. I was wrong. Just before we left, Stevie told me she wasn't wearing any underwear and challenged me to remove mine. I did.

That Saturday night was incredible. The tender feelings left by the experience so closely paralleled the playful times Roger and I shared months after we first met. Part of my excitement must have been from being in a public place. Yes, we were afforded a considerable amount of privacy by the secluded alcove, but getting away with our secret fondlings right under the noses of our husbands electrified me like nothing I'd ever known or even imagined.

The guys had no idea that when our server was taking our dinner order, Stevie's hand was under my dress. She calmly removed her moist finger and licked it while she selected her entree. She had the most devilish look in her eye. I couldn't think of anything but what she in turn would taste like. When I ran my hand slowly up her hard thigh, she tactfully made herself readily accessible. She was smooth, hairless and wet. I boldly moistened a finger and brought it to my mouth. There was a faint fresh scent and a sweet delectable taste to the moisture which I found to be surprisingly pleasant. We were giggling so hard that I'm sure our server must have thought we were nuts!

When we first met Stevie and Matthew, Stevie was the shy one of our group. I wondered what must have taken place to break her out of her shell. There was a brief lull in conversation between dinner and dessert so I came right out and bluntly asked the question. I was glad I did because what came in response provided an insight not only into who this young couple really were, but also into the warmhearted feelings they had for Roger and me.

Stevie took a deep breath as if to imply she didn't know where to start. She thought for a moment or two while her eyes met Matthew's several times. Stevie prefaced her comments by saying she envied us. She knew we were moving toward twenty years as a couple and yet we appeared to her to treat one another as if our relationship were new. Matthew, she went on, brought this to her attention after his very first telephone conversation with Roger.

Stevie went on to say she loved Matthew dearly but was afraid of the future because she came from a broken family. She shared her biggest fear, the fear of raising children on her own. Her older sisters had entered into relationships so full of promise, and yet had ended up as struggling single moms. Stevie was afraid that her future held the same difficult prospects.

She spoke of how Roger and I unknowingly gave them insight into the relationship we had with our children. Over the months of our long distance calls, they learned about our family life by becoming familiar with our busy schedule of extracurricular activities. Stevie's eyes appeared to have ever so slightly filled up when she looked at me and said I had everything she ever dreamed of having. I

put my arms around her. This time when we embraced it wasn't for the sake of satisfying any fantasy. I sincerely cared about this pretty, young and gentle woman. She cared deeply about Matthew, their future, and herself, such a positive ground on which to build a happy life together. She was sharing her deepest fears, the same fears I had lived through in our earlier times. I told her so.

Roger and Matthew sat silently listening. I glanced at them over Stevie's shoulder while we hugged. In their wide-eyed innocence they looked remarkably sexy and more than desirable as they sat entranced by the sensuously provocative visions before them. How powerfully I saw through their eyes the eroticism we inspired. A stunningly beautiful much younger lady, her smooth black cheek nestled against the curve of the neck and chest of a handsome older woman... the older woman delicately stroking the young woman's other cheek with her fingertips. I could see a look of longing on Matthew and Roger's faces.

I felt Stevie's breathing rhythm become a little more urgent as her hand moved up my back to cradle the nape of my neck. I wanted to reach out for Roger's face and kiss his mouth while Stevie's hot breath and cool hand played on my body. Her soft ample lips tenderly opened and kissed the flesh at my throat. I wanted to run my fingers through Matthew's hair as I imagined him playing his hand across our breasts which were tight against one another's body. I was conceding to the heat of passion.

Stevie's breathing became intense, hot. My eyes closing, I raised my head in need of a deep breath of air. I could feel my nostrils flare when my face turned away to escape the heat of our bodies. My heart was pounding as the cool air rushed into my lungs and calmed me somewhat. Almost comically, I became very, very aware of having removed my panties earlier. In an impish way I whispered of my developing dilemma into Stevie's ear. Roger and Matthew were snapped out of their trancelike state when Stevie and I separated and started to chuckle over what turned out to be a shared predicament. God, what a wonder-filled and emotional roller coaster ride, I thought to myself.

We were so engrossed in the sequence of events we hadn't been aware of our server's own growing dilemma. I was a bit shocked, wondering just how much he had seen, when he apologized for taking so long with our dessert. He said he thought he'd wait for "a more appropriate moment" to cart the dessert tray to our table.

It was hard to tell with Stevie, but I could see Roger and Matthew turn different colors of blush. The heat of a blush was there in my own face also. I was excited by the knowing way the server seemed to look at me while serving my choice of a deep chocolate-colored cream cake. I didn't even make the connection between what the server might have made of our earlier behavior, my choice of dessert and Stevie, until I noticed the whimsical coy grin of the server as he looked

up from that chocolate cream cake into my eyes. His eyes twinkled as he raised one eyebrow ever so slightly. Just how much had he seen and heard? The thought was a turn-on. I think he was trying to make it clear he was aware of exactly what was taking place at our table.

All of us became silent while savoring our dessert. Each of us looked as though we were dreamily thinking over the events of the past few minutes. Was everyone rerunning the powerful visual images inspired by the energy of my lustful desires for Stevie? I was. Holding and being held by Stevie filled me with an intense desire. The fact that our men watched, as we delicately explored unfamiliar sexual cravings, filled me with an overpowering sense of individuality. With eyes closed, it was like my body was literally flying through air.

The words *spirits soaring* crossed my mind: my spirits were soaring. Stevie and Matthew were gorgeous, so alive, so energetic. They were the couple we'd been looking for many years ago when we first attempted to meet people with whom to explore our sensual fantasies. Here we were, so many years later, closer to realizing our fantasies than we'd ever found ourselves before. Then I was struck with a series of thoughts which would haunt Roger and me periodically over the next week or so.

Stevie and Matthew were in exactly the same mindset we lived through while looking for our ideal couple. They were looking for a couple who were just like they were. The only difference was, they had met a couple just like *we* were. If we were Stevie and Matthew, I really believed both of us would have considered ourselves lucky to have met a couple like us. If we were Matthew and Stevie, we would have been swept away by a couple who were like we were. We were just like they were, only separated in age, nothing else. One day they'd be just like we were. Narcissistic? Maybe, but who cared?

Without saying a word, I glanced to make sure no was intruding on our privacy. I put my arm around Stevie's shoulder, drew her in and kissed her sweet-tasting mouth. The heat rose in my body once more as I put my other hand above her stocking to the naked flesh there. I wanted her so badly. This was a scene I was sure I would have accepted from an older woman if I were Stevie.

My tongue intermingled with Stevie's. I had a sense of having bridged time, a kind of reaching back. It was as if the person I was kissing was really me. It was me whose tongue was intermingling with the tongue of an older woman. Stevie didn't want to let me go. She held my face in the soft palms of her hands, kissing me deeply one more time, before finally releasing me. I know I would have acted that way too. She was so tantalizing, so enticing. I wished we had made plans to have left the kids with my parents for the weekend. Too soon, the evening was ending. I was sad when it was time to say goodnight.

During our drive home, I told Roger how I was feeling earlier when that reaching-back sensation crept over me. Roger said he'd experienced the same sense of bridging time. Neither of us were able to put our exact thoughts into words, but we agreed we both had an enveloping supernatural kind of sensation during that shift in time perspective. I get momentarily dizzy thinking about it even now. In the immediate days following our dinner date the dizziness was usually accompanied by a yearning, craving, warm pang centered in my abdomen.

The ride home was atypically quiet. It occurred to me that I – no, we, Stevie and I – might have acted selfishly over the course of the night. Roger and Matthew, for most of the evening, sat quietly observing. The four of us never really became involved in conversation; it was all Stevie and I. The pang in my abdomen sent my heart racing. All I wanted at that moment was to get home and into bed. So did Roger, especially after I told him of Stevie's under-the-table antics.

All my year's long worry, over the possibility of causing damage to our relationship by following our sexual instincts, had vanished. The next time Stevie and I spoke on the phone, I expressed myself as if I were speaking to the younger version of me. I innocently beat around the bush, so to speak, until finally I asked her what she thought the next step in our relationship was. What would she like to see? I knew what I wanted. So did Stevie.

After our last get-together, each of us knew what would happen next. We'd let it become inevitable. Initially, I resisted the idea of inviting Stevie and Matthew to our home: the idea seemed sacrilegious in a way. But after hearing Roger's thoughts on the matter – he said he wouldn't want anything to do with anyone he wouldn't feel good about inviting into our home – I had to agree with his point of view. If we was going to share this part of our life, a hotel room would make the whole affair seem like running away to do a secret dirty little deed. We decided to ask Matthew and Stevie to spend Saturday afternoon and night with us. They accepted our invitation, saying they'd see us on Saturday for a late lunch. It was only Tuesday, and Saturday seemed like such a long way away.

For the next few days I tried to recall the fantasies I daydreamed about when I was Stevie's age, the days when Roger and I searched for our fantasy ideals. For the next few days, the excitement caused by the anticipation of what was to come stimulated and aroused me to levels I'd never known. Trying to get through a day without fantasizing was hopeless. I felt so high in the air the only thing I knew for certain was that Saturday would be here before Sunday.

• friends and lovers

as told by: Roger

Early on Saturday morning, Marta took our youngsters to Grandma and Grandpa's, leaving the house all to ourselves for the weekend for the first time in

recent memory. It was a magnificent spring day, sunny and warm… the kind of day the poet says makes young men's fancy turn to thoughts of love. I appreciated the time I had alone while Marta did a little rushing around taking care of a few last minute details. It gave me a chance to relax and think a little.

More than half a generation had passed since our earliest discussions about fantasy sex and we were waiting for a couple from the generation which followed ours. I truly wasn't cognizant of having aged so quickly. Marta and I were Stevie and Matthew not so very long ago. It was as if the years which had passed between our pursuits of fantasy didn't pass us by at all.

By the time we had finished with preparations, what started out to be a light brunch had quickly turned into an elaborate feast. No sooner had Marta completed her finishing touches when the doorbell rang. There, standing at the door, our door, stood our every daydream of the ideal couple. We opened the door and welcomed them inside. More or less instinctively, we all reached for one another and embraced in a four-way hug.

For the next several hours we carried on as if the issues which had brought us together in the first place didn't exist. Marta gave Stevie a guided tour of our home, then the two of them pored over our family photo albums. Matthew was dazzled by the collection of musical instruments and associated electronic hardware in our music room. He and I spent a few hours trading guitar riffs, programming keyboard accompaniment and drum machine rhythms. There were a number of high points in our jamming – so much so that Marta had to poke her head in the room several times to check if it was actually us who were responsible for the music she and Stevie said they were enjoying. I had no idea he could play as well as he did.

Eventually, Matthew and I played ourselves out and left the music room to rejoin the women. From the kitchen window we saw them sitting under the tree in the garden, soaking up the sunshine, involved in what appeared to be a deep conversation. Their general disposition and body language implied the subject matter of their discussion must have been of a sexually provocative nature. The fact that they were enjoying themselves was self-evident. We'd both seen the identical expressions on their faces the weekend before. I thought it best if Matthew and I lounged in the sun room to allow the girls to continue uninterrupted.

In many hours of telephone conversations, there was one particular matter of dormant concern which Matthew and I hadn't discussed. The issue stretched back to Halloween evening, to the time Matthew caught up with us when Marta and I left the party for a few minutes. Back then, while sitting in our car with us, Matthew had suggested his limits were "pretty nonexistent." His comment had crossed my mind every so often since we'd first met. Was Marta right? Was it

possible he in fact insinuated a bisexual tendency when he claimed to have "nonexistent limits"?

I must have looked at a loss for words because Matthew perceptively asked if there was something troubling me. Troubling? The trouble was I wanted to know what "nonexistent limits" meant but didn't quite know how to broach the subject. When I did ask him, Matthew looked out the window in the direction of the girls and said the term shouldn't threaten me in any way. His statement was influenced by Stevie's fantasies which he wanted to fulfil for her.

To bring about one particular one of Stevie's fantasies, Matthew said he'd consider a bi experience. Stevie wanted Matthew to go down on her while she was being vaginally penetrated by a second man. He told me exactly what Stevie had told him she envisioned in such a scene. In bed, she'd act out exactly how she wanted the experience to flow. She left nothing to the imagination, using a toy to illustrated how she would like to be licked and precisely where. I think he became aroused himself, judging from the boyish grin on his face, when the girls left their places under the tree and started toward us.

This is the point when we collectively left our normal lives behind us and began to explore a realm of life which was completely uncharted. What Matthew described aroused me. I was busted in an obvious attempt to conceal my erection when Stevie and Marta walked into the sun room. It was a funny moment.

Matthew, in the presence of our wives, asked me if the term "nonexistent limits" would, in fact, apply in the scenario: I could see Stevie knew the subject of the conversation we'd had. Marta had a knowing look in her demeanor that suggested she too had been painted a version of Stevie's fantasy. Wow! That would be pushing the limits for sure, I thought… but, oddly enough, I didn't feel threatened in any way at the time. Yes, I could understand his calling it "nonexistent limits": I think he was just trying to say he'd do anything for Stevie, anything she asked him.

• flawless memories
as told by: Marta

To me, it wasn't a question of just going out and swinging. It never once was a case of just sex. I was beginning to realize that the reason we'd never explored our desire for other couples is that, up until the time we met Matthew and Stevie, we'd never gotten to know another couple well enough. We just weren't the type to go out and just meet someone for sex. It didn't happen that way for us. And so the years past by while we waited for the perfect couple. I think it had everything to do with not being capable of having had sex with someone for the sake of the act itself, back when we were young, single and carefree.

It's still gratifying to know that Matthew and Stevie regarded Roger and me as their version of a perfect couple. Despite our obvious and markedly different physical appearance, I truly did view our young friends as our younger selves. Our energies were, and continue to be, so similar I frequently experienced an overwhelming sense of *dejá vu*.

There was a sure sense of knowing we were about to share a first... a sure awareness of there being no going back. All of our curiosities about the lifestyle, wondering if we could or even should involve ourselves, all of our many examinations of research data, all of our fears – nothing mattered any more the moment we first became naked. It felt so natural, like just another step in the process of evolution. I know the term "natural" may offend some people, but, if the experience wasn't natural, nobody would have known what to have done next... would they?

The first time we made love – not had sex, made love – it was like stepping outside myself. Somehow I enjoyed the pleasure I was giving to the point I actually visualized myself receiving it. The first time Stevie's mouth touched against my most intimate attribute, I felt myself against my mouth, my lips. The vision was so real I could even make out the textures, taste the spice, inhale the scent.

It's beyond my ability to understand why, when I explored Stevie for the first time, everything was so familiar to me. I thought the experience would have been so new, I'd actually have felt some sense of venturing forth into the unknown. The only time I felt the naiveté of a first-time experience was when I kissed her body on the way down from her mouth. Once I got to the end of the path, I really did feel like I'd made love to a woman many times before. Nothing was new. I knew exactly what I wanted, what Stevie wanted, what our men wanted, and I gave willingly.

Roger was sitting in the rocking chair beside our bed. The look on his face was so innocent, so sincere... he has never looked more like the person I first met. The years seemed to melt away while our eyes were locked. We, Roger and I, were giving each other pleasure beyond any limits we'd ever known before. We gave this pleasure by allowing and accepting one another's fantasies as they became real. My head spins when I think of those flawless memories.

Stevie, while sitting on the floor between Roger's legs, turned her face toward the bed to catch glimpses of Matthew. Matthew kissed my mouth, his lips still wet with my juices, as he gently sank into me from the missionary position between my legs. He stayed perfectly still in me as if he would have erupted if he moved at all. My arms held him into my body as I endeavored to maintain eye contact with Roger. Stevie's mouth moved noisily up and down Roger's penis between intervals of sucking his tight testicles into her mouth.

Our fantasies came true, all of them. The guilt I thought we'd live through for stepping into this lifestyle hasn't manifested itself in any way. I believe it's because the four of us became friends first, and then lovers, the same way Roger and I did so many years ago. Regrets? My only regret is that Roger and I didn't meet a couple like Matthew and Stevie did when we were their ages.

Marta is so typical of the average person who becomes intrigued with the lifestyle. Very few enter the lifestyle to learn about it as they go. Most individuals enter with surprising amounts of information, both pro and con, concerning swingers and swinging.

josef: the single swinger

I became fascinated with the swinging lifestyle during the last year of my university days. It all started after I read an ad in one of those free tabloid newspapers which specialize in club and movie listings, record reviews, and page after page of personal ads. When I scanned the personals, an ad announcing the grand opening of "An Erotic Couples Off-Premise Club" attracted my eye. The body of the ad defined the club's purpose as a soft swing environment where like-minded couples could meet. I ripped the page out, folded it and placed it between the pages of a book I was carrying. Saving that page altered my beliefs, values and attitudes concerning the question of *normal* sexual behavior.

Like-minded couples. Erotic couples. The ideas prompted very unusual new fantasies. Both sides of the saved page, I later discovered, contained *Couples Seeking Couples* personal ads. Several caught my eye. I had seen similar ads previously, but they didn't affect me with the same impact as this latest exposure. For weeks on end the material never failed to inspire vivid fantasies of uninhibited sexual behavior. Two of the personals aroused me so completely I felt jealous of the couple who placed the ad. Fantasies of multiple-partner sex were now my normal sexual fantasies.

I believed then that thirty years of age was probably the right time for a guy to think in terms of settling down – but the big three-O was still more than five years away. I wanted to settle down eventually, but, I rationalized, I needed to live a few years of a life I would need to settle down from! First I needed to become the uninhibited version of my fantasy self, the person I saw while enjoying my most private personal moments of fantasy. The shower was my preferred space to close my eyes and watch the pictures in my mind, if you know what I mean. One such mental reel of visions in particular was a new fantasy so vivid it never failed to bring on an intense orgasm. This fantasy lives in me to this day.

In my fantasy is my wife. She's a tall lusty woman with long flowing black hair, sparkling dark eyes, ample upturned breasts, shapely hips, a firm bottom and long toned legs. We're naked. I'm fully aroused. She bends at the waist to take me into her mouth. A man appears behind her and inserts his penis into her vagina. Two other men appear. They massage her breasts, legs, and upturned bottom, passionately. Her mouth, encircling my penis, emits moans in anticipation of the first man's orgasm. They both cry out as they share a simultaneous climax. That's usually as far as I get before being slapped back to reality as I cum on the shower floor.

I found myself unable to talk with dates about my attraction to the idea of multiple-partner sex. I tried repeatedly to start conversations which would lead to discussion of the couples club scene and swinging, but it seemed impossible to find the right time, situation or place to get into a prolonged conversation about fantasy sex. The only fantasies I was able to pry out of my dates were of the country-home, white-picket-fence, two-kids-and-a-dog variety... so different from the nighttime fantasies I explored.

I often felt guilty about having such off-the-wall sexual desires. This kind of stuff had to stay secret. If it had to stay secret and I couldn't talk about it, how would I ever meet a woman I'd want to be with for the rest of my life, a woman who would consent to this lifestyle? Ideally, I wanted to live a wild existence with the same lover I'd later settle down with.

After graduating from the university, I enjoyed only a few brief weeks of time off before landing a head-office position with the country's most prestigious advertising partnership. Even though my fascination with the lifestyle remained, the pressures of my profession left me with little time to think of anything else but striving for perfection in my professional life. Ironically, my job was to steer me to my first experience at a swing club.

I worked inexhaustibly for eight months to make a reputation for myself as the up-and-coming creative future of the company. I must have had an impact, because the near-legendary advertising business perks were finding a way to my desk. This was life in the fast lane. Designer suits, vouchers for cases of imported premium liquors, and if that weren't enough, a hand-me-down of an imported automobile from one of the VPs in the ivory tower. All my hard work and single-minded effort were paying off: not bad for a 24-year-old art major.

Following the completion of a highly successful campaign on behalf of a major airline, I arrived at my desk on a Monday morning and found an envelope from one of the senior partners. On the back of the envelope was the hand-written message, "What are you doing here? You have a plane to catch. Enjoy."

How eccentric! The envelope contained airline tickets and an itinerary for an all-expense-paid vacation. I couldn't believe my eyes. My first holiday in nearly

a year of being associated with the company and I didn't have to worry about anything except making sure my friends and family knew I'd be away for a couple of weeks. Late Monday evening I was on a flight to Las Vegas, Nevada, my first of two ultimate destinations. I'd never been to Las Vegas before, and didn't know what to expect.

The nighttime flight into the desert city provided an unequalled visual spectacle the likes of which, I'm sure, are unique to Las Vegas. On the plane's final approach I witnessed the most venturesome and audacious use of electricity on the planet. On the way from the airport to my hotel there was such an intensity of sights, lights and sounds – like driving through a cross between a jukebox, a pinball machine and a Nintendo video loop.

• **arriving in las vegas** While checking into my suite at the Tropicana resort, I was astonished to see a number of small discreetly placed signs welcoming delegates to "The LIFESTYLES '98 Silver Anniversary Convention." I wondered if this was the same "lifestyle" I thought it might be. It had to be. It was Monday night and the convention was set to begin on Wednesday. It was almost as if the partners back home knew my secret.

I unlocked the door to my hotel suite and walked into decidedly luxurious accommodations. I poured myself a drink, kicked off my shoes, and settled into a soft leather armchair taking in the panoramic view of Las Vegas far below. A million twinkling lights glowed as I wondered how best to find out if the lifestyles convention was, in fact, what I had a notion it might be. It should be effortlessly easy, I thought – after all, I happened to be staying at the convention's host hotel.

The drink relaxed me just enough to bring an edge of playful fantasy into my consciousness. I was far away from the secure realities of my everyday existence. When you're far from home, I discovered, you take on a less protective attitude toward your secrets. Here was my first chance to go out the door and finally take on the persona of the uninhibited version of my fantasy self. There came a sense of freedom when I realized I could say anything I wanted to anyone I met here. Nobody knew me. For all anyone here knew, I could be Josef Blow from Minnesota, Texas, or anywhere!

"Josef Blow! Yep! But y'all can call me Joe. Joe Blow," I said to myself out loud. Laughing, I got up from the light show to grab a quick shower and freshen up. Las Vegas was waiting. While shaving, I'd look at myself in the mirror, and out loud introduce myself to myself as Joe Blow. Still grinning, all I could think was how exciting a venture into the Las Vegas night would be. This was fun stuff. "Isn't that right, Joe Blow?"

In the normal world, Monday night has a distinct feel to it. Monday night in Las Vegas, however, was more like a New Year's Eve celebration anywhere else.

The only thing missing were the noisemakers and party hats. Merrymaking crowds of people were scattered through out the Tropicana's massive gambling casinos.

I casually wandered through the resort hotel until discovering what looked like an excellent place to meet people. A dimly lit stand-up bar, bustling with people, made up one side of the room. The other half of the area contained a maze of tables mostly obscured by planters of lush green growth. In the rear section of the bar area were a group of perhaps nine or ten couples who looked as though they just might be conventioneers. Putting myself in a position to eavesdrop on their rather unabashed chatter, I was proven right after only a few moments. A few drinks was all it took before four members of the party began loudly and proudly proclaiming their allegiances to the swinging lifestyle.

One particular man and woman in the group looked uncomfortable to be noticed and moved away from the main body of the gathering. Two other refined-looking couples snuck away to the sanctity of the dining room. I could clearly see they were uncomfortable. I couldn't blame them for bailing out… I would have. The loud couples were being clearly heard by nearly everyone in the stand-up bar portion of the establishment and by probably half of the dining area as well. Too much alcohol! I speculated they'd be having cringe-overs the following day for sure.

A cringe-over is the awful feeling you get when you are hung over and suddenly remember something you said the night before, while inebriated, which makes you cringe and say, "Oh no… *I* said *that?*… Oh no!" That's the classic cringe-over. The four silly loudmouths would individually feel like assholes once they had a cup of coffee in the morning. They certainly did say more than a few things to inspire the worst cringe-over attacks I could imagine.

The couple who had earlier withdrawn from the group moved to the bar within only a few feet of me. Catching their glance, I said hi. My greeting was returned. Their smiles made it easy to step forward and introduce myself to Rob and Gina. She was tall and dark-haired, nice… an older woman I guessed to be in her mid- to late thirties. Rob was about Gina's age, a little taller, physically fit and also good-looking. As we made small talk, I was determined to play the part of uninhibited adult in a game of fantasy. I wondered if Rob ever had visions of his wife bending forward to take his penis into her mouth while another man penetrated her from behind her splayed legs and upturned behind. They surely would have looked pleasing caught up in the heat of such circumstances.

Gina was one of those women who became increasingly attractive as the evening passed. It was her easygoing, confident attitude which I'm sure was responsible. After we talked for about twenty minutes or so, there was no need to ask if they were in Las Vegas for the convention.

We were getting a bit playful with one another when Gina said it was too bad I was a single guy. I boldly said, "Don't let that stop us." Just as matter-of-factly she told me her and Rob's favorite number was four and they didn't involve themselves with singles, or did she say swingles. Didn't I distinctly hear her say *swingles?*

I wished Rob and Gina didn't have to leave, but, because of a prior commitment they said they had to run along. Before leaving, Rob mentioned if he were a *"swingle"* in Las Vegas, he'd check out the "Open to Singles" Swingers' Club. This club, he underlined, was one of the few in America which admitted single guys. Gina made note of my room number before they said good night. Earlier, Gina and Rob had promised to deliver convention information to my suite.

Had I noticed another sensual couple or an unescorted attractive female in the bar area, I might have stayed and started another conversation. Instead, I ordered a Perrier and sauntered through the casino to see some high-stakes gambling action before returning to my room. It was barely ten o'clock.

Visions of a swingers' club like the ones Rob had mentioned flickered in my mind. Here was the perfect opportunity to explore my infatuation with the concept of swinging first-hand. When I didn't find the club listed in the phone book, I called a taxi company. The dispatcher I spoke with kindly provided directions as well as a phone number. I called the number and asked what requirements a non-member would have to meet in order to attend the establishment. Save for the single male admission fee, there were no expectations placed on me other than, as was expected of all patrons, to follow the rules of swinging etiquette. The woman on the phone went down the fairly common-sense rules of etiquette before her brief presentation on what to expect once I had entered the premises.

• **a haven for singles** The "Open to Singles" Swinger's Club was on the outskirts of town, not quite four miles off the main Las Vegas strip. I had nothing to lose. The club was only a few minutes away so I decided to take a drive out and have a look for myself.

The clubhouse was located right at the end of the once-paved street in an industrial mall subdivision. I pulled into an available parking spot adjacent to the entrance alcove of a large, well-maintained two-story building. The facility looked as though it might once have been the grandest home in the neighborhood before conversion to its present use. The Club seemed a lot farther away from the excessive glitz and glitter of Las Vegas than it actually was.

Once I parked, I found I had to stay in the car for a few minutes to calm myself down. I was a little nervous, but I was much more curious: I had to see

what waited beyond the front door. When I rang the doorbell, a handsome older woman emerged in the entrance. She warmly welcomed me to the Club, requested an entry fee of fifty dollars and directed me through the foyer in the direction of the bar.

Monday night, I chuckled, and the place was teeming with people. At the bar I ordered my customary brand of bottled water and stood to watch two couples at the pool table playing a game of Boston. There were several men, appearing to be more interested in the players than the play, also watching.

In a darkened corner of the stand-up bar, two women, both single I guessed, were the center of attraction to three men who vied for their attention. Within moments, a fourth and then a fifth man worked their way into the midst of this unconventional competition. The single women, the pool-playing couples and three additional couples in the bar area all had one thing in common: they were the focus of attention of every single male in the room.

A towel-wrapped man walked into the bar through a set of double doors at the back of the room. He sat down near where I was standing, ordered a drink, and lit a cigarette. Making small talk with the bartender and I, the man suggested by Thursday night there would probably be a shortage of guys because of the demands of the conventioneers. He went on to say there was usually more of a "selection," as he put it, of single guys at the club. I wondered what he was getting at.

Following a few more minutes of good-humored banter, the man introduced himself as Gerald. At first I really didn't know what to make of the situation. The way Gerald had spoken about there being a "shortage of guys" and there usually being more of a "selection," I thought he might have been gay. By the time he had finished his drink I learned differently. His wife was being entertained by three gentlemen while he took a time out to have a drink, a smoke and a look to see if anyone interesting had come into the club. I was downright shocked at his casual manner when he suggested I was welcome to join them in a little fun if I was interested. Off Gerald went, two drinks in hand, in the direction of the double doors at the back of the bar.

I sat for a moment wondering what to do. I at least wanted to see this sexual spectacle for myself. I followed Gerald through the double doors into a large area which housed a swimming pool and Spa. In addition to half a dozen fully clothed couples chatting on the pool deck, there were naked couples and single men in the pool and spa. Overlooking the pool was a huge shadowy expanse of space made up of multi levels of fuzzy upholstery and mattress-like padding. This, I learned later, was the group area. Shadows and sounds implied the place was overflowing with men and women. I walked quickly to catch up as Gerald disappeared into a doorway beside the steps leading to the group area.

Sounds of sex met me when I walked into the hallway beyond the door. A woman's loud growl-like moaning emanated from behind a door which was slightly ajar. I looked in to see Gerald peeking out at me. He held the door open. I entered.

The sight that greeted me, once my eyes had adjusted to the low lights, was of a small, slightly chubby, blond lady mounted upon a penis of significant proportion. The man under her lifted her round bottom to the top of his penis and let her drop down its substantially thick length. The growl from Gerald's wife, which I heard from the hallway as I approached the room, came at the end of one of these drops.

Gerald sat at the foot of the bed stroking his inflated penis with one hand as his left hand spread his wife's buttocks. Two men, both in the same age group as Gerald and his wife, stood on the mattress on either side of the woman, in full view of the man on his back. Gerald's wife held both their penises at her mouth, her tongue darting back and forth between the men, to lick the heads of their condom-covered penises. On the next drop she moaned her hot-blooded growl again. She rocked her pelvis in a way suggestive of an approaching orgasm as she became increasingly vocal. The man on his back cried out as he pumped his semen into the condom buried deep in Gerald's wife. She lost control and chanted, "Ohhhhhh, oh, oh," over and over again as she continued sucking and licking the penises of the two standing men. Gerald lowered his head to the mattress for a close-up view of sex organs erupting in orgasm.

Gerald's wife removed herself from the man under her, helped him up off the mattress and literally sent him on his way. He immediately collected his belongings and wasn't yet out the door when Gerald's wife was perched on another man, firmly engaged in penetration once again. This time she wasn't just teasing the penis at her mouth with playful licks, she very skillfully performed fellatio while wriggling her hips to accommodate the entire length of the penis plunging into her vagina.

Gerald watched intently for a few minutes before walking to the door to again peer into the hallway. I quickly learned when there were sounds of sex in the air there was an accompanying non-stop procession of single guys through the hall. Gerald studied them as I stood studying his wife. Once again she moaned through clenched teeth as she was rocked by orgasm. When she got up off the bed so did the spent man. Gerald's wife sat on the edge of the bed in front of the remaining man and continued fellatio. No sooner had the expended man left the room when Gerald opened the door to admit yet another eager-looking male.

Gerald's wife couldn't have been more than five feet two inches tall. The guy who came into the room was at least six foot five. His arms, I swear, were the size of my thighs. Gerald handed him a condom. I could tell it was lubricated when the guy quickly removed his towel and rolled the condom onto his penis.

If this guy's arm was the size of my thigh, my arm was the size of this guy's penis. Gerald's eyes were fixed on it. The guy sat beside Gerald's wife and watched closely as she lustfully performed oral sex. The standing man was practically gasping for breath as she very skillfully drained him of his semen. Following his climax he too gathered himself quietly and was gone in a snap.

Up to this point I had stood silently watching this older woman eagerly and selfishly concern herself only with achieving as many orgasms as she could possibly manage. She seemed to have been bent on nothing less. Now you could sense her mood changing. It was as though she had released her pent-up sexual drives with several orgasms. Now she was ready to enjoy the sex act peacefully, drained of any anxieties sometimes brought on by a desire for orgasm.

Gerald melted into the shadows. Sitting quietly in the chair he observed the scene as though he were in a hypnotic trance. His wife was taking complete control of the episode about to evolve. Taking the man's hand in hers, her facial expression changed completely. She looked unsure of herself. Positioning him onto the middle of the bed, she spread his legs and got down on her knees between them. The man surrendered to her obvious need to be in command and settled in to watch her. Gerald's wife looked in awe at the size of his penis.

For the first time since I walked into the room, I moved. I took a few steps toward the headboard to better see the expressions on her face. Gerald's wife didn't notice me seeking out a better vantagepoint. She simply sat, apparently marveling at the sheer size of the man's penis, for what seemed like several minutes. When she finally moved, she reached to hold the shaft of the fully erect penis. The expression on her face was one of wonder as she wrapped both hands around the thick base of the gigantic fully erect penis. Both her hands held only the bottom portion and the amount of penis left over was still larger than my own. I thought I sensed her wondering if being penetrated by such a large penis would hurt: a look tinged with apprehension came to her face.

I was extremely aroused. So was Gerald. Moans were coming from Gerald as he slowly and deliberately stroked his erection. He observed intently as his wife rolled the condom back off the penis. The man, propped up on pillows, eyes wide open, also watched her closely. Her facial expressions were now of pure lust. With her hands wrapped around the base again, she bent forward to take the head into her mouth.

The contrast in physical size was mind blowing. Because of the sheer size of this guy's body, she looked tiny. The contrast gave an even further edge of eroticism to the exchange. She couldn't possibly have opened her mouth any further. Her lips, stretched to the limit, encircled the glans. The penis was so large she couldn't even manage to slip its head entirely into her mouth. Those were amazingly

erotic moments. All I could do is watch as she lost herself in a repeated quest to completely engulf the smooth glossy glans. My fluids oozed.

Occasionally, Gerald offered words of encouragement to his wife. His most repeated encouragement was to tell her how beautiful she looked. His words seemed to unleash hidden passions. She shifted in the bed to give Gerald the best possible view and again wrapped her hands around the shaft. This time, while gazing into Gerald's eyes, she noisily licked and kissed the tumescent plum-like head. She looked so dirty and sweet at the same time, my entire body was throbbing. I was standing inside a fantasy which was taking place in real life, in real time... yet it seemed so unreal!

Gerald's wife stopped for a second and reached under the pillows to retrieve a tube. She opened the container, applied a copious amount of clear fluid onto the penis, and slid both hands back and forth along its length. Straddling the man's hips, she held his penis while lowering her body until the head of the penis lightly pressed into her glistening center. I moved to a better vantagepoint for a second time.

After several minutes of serious and loud effort, Gerald's wife managed to accommodate the entire head and only two, maybe three, inches of the massive penis. She was cool, calm and relaxed in a struggle to take as much as much into her as she could. She shifted her weight to one side and placed one foot flat against the mattress. The penis shot out of her with a loud wet popping sound. She shifted again to bring the other foot up into the same position. While standing on her feet this time, hunched over, her hands pressing into the guy's muscular chest, her right hand reached to guide his towering organ back to her visibly sopping swollen opening. At the instant she eventually accommodated the plum-like head into her vagina, she took a deep breath and started her "Ohhhhh" chant. The oh's turned to growls each time she bore down with all the strength she could manage. Incredibly, three-quarters of the penis was buried. It didn't look possible. The sight was unearthly. So were her noises.

You could easily tell when an orgasm would wash over Gerald's wife. If the sounds she made didn't convince you, the way her middle convulsed would. Another telltale sign, I noticed, was the way her body shivered after an orgasm. She shivered a couple of times before needing a few moments' breathing space. Disengaged from the penis, she stood right up on the bed and stretched her arms in the air. When she came down, she lay on her back beside the man. Methodically, she drew her knees up into her shoulders, inserted the middle two fingers of each hand into her vagina then, almost savagely, she pulled herself open. Her low guttural growl filled the space. The man moved his face toward her exposed puffy flesh and diligently licked and sucked her to climax one more time.

Once the waves of the latest in her string of orgasms passed, Gerald's wife lay down and stretched out on the bed. Reaching over to her, while lying on his side, the man kneaded and caressed her breast. She whispered in his ear before he shifted his body over hers. Gerald's wife again lifted her knees to her shoulders and reached around her hips to hold herself open with her hands. The man, from the missionary position above her, slowly lowered his penis to her core. His penis was so stiff they didn't need a guiding hand before the head was pressing into her opening once again.

Unhurriedly he pushed, not in thrusts, but with a restrained, steady pressure. Her growl increased in intensity. Her hands were tugging at her folds, further opening herself to his prodding. There came a point when her outer lips seemed to open and contract in caterpillar-like movements, taking more and more penis into her. She was out of her head with a urgent desire to take it entirely. Flailing from side to side, she periodically raised her head to look down as if to check the depth of penetration. She crashed back into the pillows, moaning, panting, bearing down to take more, stretching and pulling herself open with her hands.

For the first time, the man started to slowly pump his penis back and forth to her ever-yielding limits. At first he would fully withdraw until her vaginal lips held only the head of his penis. Then he aggressively lunged into her, but just to the depth of his previous thrust. Her breath came in short gasps between the building intensity of his penetration. She stretched her legs into the air, placed her elbows behind her knees, and drew her knees up to the pillow in line with her earlobes. She took a big breath and held it as she wildly rocked her body back to meet the man's forceful lunging thrusts. At last she held the penis completely inside her. Gerald's wife immediately became still, her cries weakened. With his penis buried to the hilt, the man remained motionless. Gerald's wife was shivering.

When her shivering stopped this time, she raucously encouraged the man to continue pumping himself all the way into her. When she felt his intensity building she told him, in no uncertain terms, not to come inside her. With her head up off the pillow, curled toward her middle, she watched the man's final thrusts. He withdrew his penis until the tight circle of swollen flesh was all that held the head of his penis inside of her. Her vagina gripped the glans of his penis so firmly that at the end of the man's withdrawal motion, her vaginal lips actually pulled away from her body. Both moved their heads to watch as he descended all the way until his testicles pressed against her wet flesh. He swiftly plunged several more times and then, with a final overwhelming lunge to his testicles, he withdrew and grasped his enormous throbbing penis in his hand.

Gerald's wife cried out as if she had been wounded. In the blink of an eye she grabbed the base of his pulsing penis just in time to guide the first streams of spraying semen. She lowered her face and directed a jet of his liquid at her open

mouth. Then she hastily tucked the penis between her breasts, wrapped her legs around the man's waist, arms around his neck and slid her body up and down as the penis continued throbbing and ejaculating. She kissed him wetly on the mouth, sharing the droplet of cum she had collected. A shiver ran down my spine.

I didn't have any guilt at all over simply walking out the door and back into the hallway. Maybe I had purposely blocked him out, but I had entirely forgotten about Gerald sitting in the shadows. By the time I walked across the pool deck, through the double doors, back to the bar area, I was exhausted. More than 90 minutes had passed since I followed Gerald to the private room section of the club.

I spent the next few minutes deep in thought. I was more aroused now, thinking about what I'd just seen, than I was in the room while I watched. There was a patch of wet on my thigh. A few minutes later the big guy walked into the bar area. He noticed me, came up to introduce himself and offered me a Jack'n'Coke. A Texas boy: I should have known. Everything's so big in Texas, I thought to myself and grinned.

Jake had lived in Las Vegas for about three years and worked for the city's leading security company. I'd never have guessed he was a year younger than I was; he'd looked so much older a few minutes earlier. Fortunately for me, Jake was in a talkative mood. There were many questions I could ask which I knew he'd have had some answers to.

Jake had visiting the club about once a month for the past two and a half years. He told me, on any given night, even weeknights, there might be as many as 70 people in the club, of whom perhaps 30 will be single men. The second floor is strictly reserved for couples. Many couples, he claimed, made short forays onto the first floor, satisfied their curiosities, and dashed back upstairs. That meant there was usually an extreme imbalance of men versus women on the first floor of the club.

Couples like Gerald and his wife are quite common, said Jake. There are innumerable numbers of men who enjoy watching their wives having sex. And many women in their forties, he went on, are willing to take on as many men in one night as they can find. According to Jake, the best sex imaginable is with a woman who was "fucking for her husband"… especially an attractive woman who had only "dreamed of getting fucked by a big dick."

Twenty minutes later, just as Jake was leaving, two new couples stepped into the bar from the entrance alcove. One of the women was an absolute knockout. She had dark red hair, a beautiful face with high cheekbones, and a body that still leaves me at a loss for words. The couples were classic extroverts who caught everyone's attention as they purposefully walked straight across the bar, through the double doors, and into the pool area.

After ten minutes or so I followed through the double doors and noticed a large circle of people gathered around the elevated portion of the group area above the pool. As I strolled toward the circle, the dark redhead started to come into view. Down on the matting, naked, on her hands and knees, she sat on her man's face. He was lying on his back, also naked, while the redhead stroked and licked his lofty erection. She moaned and wriggled, bucking her hips into his face, while at the same time her mouth playfully slurped at his penis.

Next to them, their friends were fully involved in an explicit sex show of their own. The man sat naked on the continuous couch. The woman sat astride his legs, in his lap, facing him. Her arms encircled his neck as she zealously rose and fell repetitively onto his sleek erect penis. The man spread her cheeks, providing onlookers with an even more intimate view as she rode him.

Man, was I was turned on. I needed one hand in a pocket to restrain my stiff penis. My eyes were locked on the redhead and her husband, who were about to complete their oral sex act in unison. Her hips moved in rapid convulsion as her sobs signaled her approaching climax. He tensed his thighs, raised himself slightly, and sighed as the redhead covetously sucked. She didn't spill a drop. Afterward, they used tongues and mouths to groom away any telltale signs of orgasm. Quite an erotic display! I missed the final moments of the second couple's performance. It must have occurred at the same time as the redhead and her man's, I supposed.

One of the couples who had watched the performance left the group area and entered the bar just ahead of me. I had expected them to run back up the stairs to the couples-only floor after the show. They were about my age, well-clothed, well-groomed. If wishes came true, and I had a wish coming my way, I think I'd wish to meet a woman like this lucky guy's wife. He left his gorgeous lady at the bar and glanced in my direction as he walked through the double doors and entered the pool area. I heard her tell the bartender her name: Jennifer. Nice name!

Her facial features were soft and delicate. With large wide dark eyes, an upturned nose with a few freckles splashed across the bridge, and exaggeratedly thin lips, her face reminded me of a fine ivory carving. I hesitated for a second or two and summoned every ounce of courage I had to take the few steps toward her. I offered my hand and introduced myself. She took my hand. A blush quickly filled her cheeks. She looked up from my hand, into my eyes, and quietly, practically in a whisper, introduced herself.

• jennifer

Small talk came easily at first. We didn't talk about the club, or why we were there; we talked about the bright lights of Vegas compared to the small western Canadian town she was from. I was captivated

by Jennifer. Too quickly, it seemed, we ran out of things to talk about. In the silence of not knowing what to say, I closely studied Jennifer's beautiful facial features. There was a hint of anxiousness in her expression, and a wondering look in her eyes. When my gaze fell to her mouth, her lower lip quivered. She looked shy and unsure of herself, searching for a way to say what really was on her mind.

What in the world would cause two people, caught in a place of such flagrant sexual behavior, to be as shy and unsure of themselves as we were? I started pouring my heart out. I told Jennifer of my own curiosities, about the kind of woman I'd want to be with for life. A woman who approved of this lifestyle. I told her of how I longed to live this unrestrained existence with a lover I'd later marry.

Jennifer's face lit up as I exposed my hidden intimate secrets. Soon it was her turn to confide in me. Hesitancy and insecurity vanished. I learned she and her husband had visited the club on half a dozen separate occasions. Jennifer said they frequently entertained the fantasy of a two-male threesome. Every so often their imaginings included three, sometimes even four, males. The reality was she never met anyone who could live up to her, and her husband's, high expectations. The males, she thought, all came across as too insensitive to fit into the images of her fantasies. She wanted to share intimacies. To share, not to be had.

Club visits were a lot of fun for Jennifer, something she looked forward to a few times a year. Her husband normally reserved one of the private rooms in the club on their visits. They loved lying naked, next to one another, listening to the sounds of often kinky lovemaking emanating from the numerous private rooms. That's as far as they ever got. She was blushing again when she told me she'd never had sex with anyone other than her husband.

Every time I think of Jennifer, I feel a lightness of being. Sometimes my heart really does skip a beat. She is the image of the woman I know is somewhere waiting for me. The next time there was a lull in conversation, I impulsively leaned over and kissed her perfect mouth. I didn't plan to kiss her. I just did. Her thin lips parted slightly as she returned my kiss. Physically, my entire body tingled as though I had been hyperventilating.

Jennifer was a dramatically different woman from the shy whispering person she seemed. In less than an hour, she knew more of my sexual secrets than I'd ever told anyone before. I wondered how to ask if I might be lucky enough to fit the standards of her imagined fantasy lover. Feeling I had nothing to lose gave me the confidence to seize the moment. She answered my question by holding my face in her hands and kissing my mouth. Her fragile lips were cool against mine. She whispered in my ear. I was her dream come true.

Jennifer then abruptly excused herself and walked to the end of the bar where she requested a coaster and a pen. She hurriedly wrote a message on the coaster back, passed it back to the bartender and left. I watched as she passed

through the double doors and disappeared from view. She never looked back. The bartender delivered her message. It said, "Give me ten minutes and meet me in the hallway at the private rooms."

Ten minutes seemed like an hour. I was feeling pretty nervous by the time I reached the hallway precisely ten minutes later. One of the doors opened just barely enough to allow the person behind the door to see out into the hallway. It was Jennifer. She quietly called my name and vanished. I opened the door and looked into the darkness. Enough light made its way into the room from the hallway for me to know it was Jennifer who was settling back down onto the bed. I stepped inside the room, closed the door and locked it. A few seconds after my eyes had adjusted to the low light of the bedroom I saw Jennifer and her husband already naked.

I looked up at them from my viewpoint at the base of the bed. Her husband was lying lengthwise on one side, his back supported by a pile of pillows. One leg was hanging over the side of the mattress, his foot on the floor. Jennifer was lying on her side, diagonally across the bed, her head nestled into his chest. Her legs, slightly bent at the knee, lay within reach of my hand. Jennifer started fondling her husband's testicles. I watched as she stroked him, moved her head down close and licked him. Then she turned to gaze directly into my eyes, encircled the head of his penis with her cool thin lips and went down on him. I began to undress.

Naked, I sat up on the edge of the bed and watched as Jennifer tenderly slid the length of her husband's penis in and out of her mouth. She placidly watched me watching her. I imagined, for a second, what Jennifer was seeing. I wondered if the scene lived up to her fantasy images. I was struck with an overwhelming sense of freedom. I wanted nothing more, in that instant, than to act in a manner worthy of a memory I was sure we would each carry over our entire lifetimes: three people in an electrifying threesome fantasy brought to life.

I leaned my chest forward to Jennifer's smooth hard thigh. My hand stroked her face as she went down on her husband. She stopped moving and peered down at me with a dreamy tranquil look in her eyes. Lost in the beauty of her face, I traced the outline of her lower lip with my finger. Soft suckling sounds were coming from her mouth. My fingers glided over the tip of her firm breast. She stayed completely still, savoring the moment and her husband's penis in her mouth, capturing the images, deliberately contemplating every breath, dwelling on each action. My lips found her earlobe.

This was all for Jennifer. It was becoming very clear she wasn't about to succumb to living out her fantasy images in a frenzied grappling manner. As if she were following a practiced choreographed script, she took complete control and led us through what could only have been scenes from her fantasies. Through it all, Jennifer somehow managed to stay solemnly composed.

She casually sat up to rearrange the pillows at the top of the king-size bed. Gracefully, she lay back, half sitting in the pillows. She placed an arm around her husband's hip and drew him up toward her. His right hand held the headboard as he knelt beside the pillows under her head. She reached for my hip. I instinctively knew Jennifer would guide me to kneel on her other side. She held our penises in each of her hands within inches of her sensuous face. Her hands, encircling both penises at the root, tightened and then let up their grip in a steady even rhythm as she languished in the pillows watching us.

My penis was engorged. Silky strands of fluid were abundantly pouring out of me. Holding us firmly in her grasp, Jennifer shifted to get higher up on the pillows. Once settled, she reached under our penises to cup our testicles. In a minute her hands encircled our shafts from behind our testicles as she held our penises to her breasts. For several minutes she gripped us while innocently looking up into our faces. Jennifer remained still and peaceful.

Kneeling beside Jennifer, my penis inches from her face, Jennifer began rolling my testicles through her fingers. As she gently prodded, I became attached to her nipple by a thick strand of moisture. So did her husband. Jennifer made sure of that.

As if on cue, we held our penises in our hands at her breasts. In small circular motions, we painted a slick sheen onto her swollen nipples. The flesh of her breast was cool against the heat of the fluid surging from my glans. It was the same kind of cool I felt earlier from her thin wisps of lips against my mouth. Jennifer continued to roll our testicles and gently poke her finger into the skin behind them, which resulted in a profuse supply of fluid to be brushed onto the lush rise of her taut fleshy nipples.

Once again, after several minutes of silently soaking up the visions, Jennifer settled into yet another in an ever-changing series of fantasy images. She adjusted her body into the pillows, then raised her head, bringing her lips to our penises. She gripped our members just below the head and slid her hands down to the bases. She brought the clenched hand back and then slid down to the base again several times in rapid succession. I had to fight off the urge to let go. Jennifer bent slightly forward and flicked her tongue rapidly across the heads of both our penises. She stopped, partially encircled her lips onto her husband's swollen tip, and sipped his flowing fluid into her mouth. She paused as if to ponder the sensations created by the tang of his essence.

She took me off guard when she turned her face to my penis, held her mouth wide open, and took me in. As she went down, her tongue stretched over her lower lip, the underside was flat against her chin. The inside of her mouth didn't touch any of my penis until the head made contact with the back of her throat. At the instant her throat touched me, Jennifer raised her tongue and flicked

the strand of skin between my testicles. I almost went over the edge for a second time.

Jennifer turned her body in the bed, got onto her knees, and maneuvered us onto the mattress. As she eased onto her back between us, I leaned over to kiss her. Jennifer's husband got up from the bed as her arms folded around me. Her lips, even now, felt cool. My face nuzzled in the nape of her neck while the tips of my fingers lightly trailed up and down her naked body. Jennifer's husband, his eyes firmly fixed on us, settled into the easy chair. Jennifer, so placidly self-composed up until now, began to tremble.

I sat up on the bed and looked down into Jennifer's face. That telltale hint of anxiousness came back to her facial expression. Her lower lip was quivering. She had the same uncertain look on her face as she did when we introduced ourselves at the bar. I stroked her shoulders, then held her face softly in the palms of my hands. She watched me as I glanced reassuringly at her husband. He seemed to sense the underlying feelings I had for his woman. Through my gazes in the silence, I was asking them to trust me. Jennifer closed her eyes, took a deep breath, stretched her arms up into the pillows, and let out a long mellow sigh. Her trembling stopped.

I slid to the floor at the foot of the bed, knelt, hooked my thumbs under Jennifer's knees, and pulled her body down the bed until her legs dropped over the edge on either side of my shoulders. Her eyes stayed closed. I sank to the floor and cradled my face between her open thighs. I'll always remember the sensation of her remarkably cool wetness against my mouth when I kissed her hairless crease. I opened her with my hands. Her inner lips were just like the lips of her mouth, thin with a faint bluish tinge to them. I pressed my lips into hers and sucked her delicate petals into my mouth while at the same time gently pulling them away from her body.

I don't think two minutes passed before I heard Jennifer's "mmmm" sounds building in intensity. When I looked up at her, she raised her head up from the pillows to watch me. I hooked my thumbs behind her knees again and raised them to her shoulders. Jennifer was now more or less balancing her weight on her shoulders, arched in a tight ball. When she just slightly raised her head she could see directly into her dripping center. Looking down at her, as my hands held her open, I pressed my burning tongue deep into her satiny opening. Jennifer, with her hands on the back of my head, pulled my mouth into her. I held my tongue still as waves of an obviously intense orgasm shot through her. Her nails grazed my neck as she locked her ankles against my spine. She looked over to her husband and cried out as I sucked her inner lips into my mouth again and again. Jennifer's legs began jerking in spasms, trembling against my back.

I think Jennifer was still convulsing when she pulled herself away from me, hurriedly retrieved a condom from under the pillows, and handed it to me. I stood at the foot of the bed to roll the condom on while Jennifer rearranged the pillows at the headboard. She lay on her back, looked into her husband's eyes, and opened her legs to his view. I raised myself above her, supported on my arms, my legs between hers. Her hand found my penis and guided me into her. I was penetrating her with my first thrust when I sensed the approaching waves of her second climax. This time her wet membranes turned blistering hot. She raised her knees up to her shoulders as her hips rolled up in powerful thrusts. In full view of her husband she came unhinged. Her hips jerked wildly as spasms after spasm slammed her core. Jennifer was sobbing, gasping for air, as her body convulsed.

It was all for Jennifer. It really was. I felt the first flutters of spasm swell from my insides. So did Jennifer. She thrust her hips at me once more before pulling away just as the first surge of semen splashed into the condom. Her hand milked me as she wrapped her free arm around my neck. She pulled me toward her, kissing my face, my eyes. She licked my lips, my ears. Suddenly, completely by surprise, she whispered, "Please, Josef, you have to go now."

The semen hadn't yet stopped flowing from me when I stood up from the bed. I focused my eyes to see her husband sitting on the bed beside Jennifer, stroking her face. I dressed watching Jennifer and her husband moving about on the bed. He was half lying on her as she lay watching me over his shoulder. Just as I was about to open the door, I looked to see Jennifer with a dreamy half-smile on her face. Our gaze met for one last time before she closed her eyes and lay back in the bed to meet the first thrust of her husband's penis as it filled her vagina. I stood still in the hallway for a few seconds. I could feel her husband's intensity as she cried out in passion. The hallway was full of the sounds one associates with sex acts. Jennifer's sounds were delicious. I walked back to the bar area.

I stayed in the bar long enough to drink a bottle of water before stepping out into the cool desert air. Jennifer's voice saying, "Please, Josef, you have to go now," echoed through my mind. I think I understood their reasoning. It was almost 4:30 in the morning. I drove back to the Tropicana practically oblivious to my surroundings, went straight to my room, and barely managed to get out of my clothing before flopping face first onto my bed. I fell asleep thinking of how beautiful every ivory-carved part of Jennifer was.

It was 1:30 in the afternoon when I opened my eyes, propped a pillow against the headboard, and lay back to contemplate the somewhat unexpected events of the previous night. Yes, I did think I understood their reasoning. By staying as anonymous as possible, in bringing their fantasies to reality, the life they had together seemed less threatened. That had to be the reason for Jennifer's

abrupt way of saying goodbye. Still, I felt a need to call her, maybe meet her for coffee or something.

You see, I told myself, you were right. That's why she was so abrupt. What if she knew my true identity? Would she call me on the phone? How much more of a threat could there be to their relationship? What if I wanted to share my life with someone like her? What would happen if I would do anything to get her? Jennifer's husband wouldn't have stood in my way. How do you care about somebody's feelings if you don't even know their name? Then it occurred to me, her name might not even be Jennifer. I needed coffee!

I stepped into the shower, leaned one arm against the wall and rubbed my face for a few seconds before running the water. Jennifer's faint scent covered much of my body. Her taste was still on my lips. I closed my eyes. I thought of her delicate facial features, her large wide eyes, the way her freckles looked splashed across the bridge of her upturned nose. I thought of her lips, her intriguingly thin lips. In my mind she was going down on me. I saw her mouth not touch any part of my penis until the head made contact with the back of her throat. I came on the shower floor.

In the days and weeks which followed this, my introduction to swinging, I finally had a chance to seriously consider whether this lifestyle was for me. From the first time I encountered the concepts of this lifestyle, I never imagined I'd have my first experience on my own. I'd always believed I'd eventually explore it with a lover. Could I really imagine myself with a lover who would choose this way of life? Based on the experience I had with Jennifer, the answer was yes. Based on the behavior of the couples and singles at the Club, yes, for the most part.

The only negative was the way Gerald and his wife carried on. They were a little too hardcore for my taste. I could never imagine my lover and I, standing at a Spa full of naked men, searching out the one who was best endowed.

Las Vegas was like an enormous Hollywood set. It turned into a huge backdrop for more compelling performances, the ones in my mind. I stayed fully immersed in thought for the rest of the afternoon and into the evening while taking in some of the hospitality the town so generously offers. Scanning faces of the crowds of people I encountered, I hoped I might catch one more glimpse of Jennifer and her husband. I never saw them again. It was as if it was all just a fantasy.

For the entire day, scenes from the night before played back in my mind. Some of the most memorable erotic segments were scenes of Gerald's wife and her accommodating lovers. Don't misunderstand about Gerald's wife: what I watched was an exceptional turn-on. Her determination to be completely impaled by Jake was an extraordinarily erotic show of sexual exhibitionism.

• a private invitation

Waiting for me when I got back to my hotel, later in the evening, was a note from Rob and Gina, the couple I'd met in the bar the night before. The note mentioned the convention information Gina had promised and also invited me to call the noted room number if I were still interested. It was almost eight o'clock.

Of course I was still interested. Gina answered when I called. She asked if I'd had dinner. Neither had they. In her playful way she urged me to meet them at the restaurant bar where we'd met the night before. She told me that wide-eyed and innocent people were always fun to be with.

Judging by her exuberantly sassy manner while we were on the phone I thought Gina had reconsidered her stance on single males... perhaps even considered experimenting, testing her intuitions or something such. Why not? They were probably thousands of miles from home too. It's always so easy to escape the normal constraints of reality when you're that far from home. Not a single person you'll meet knows you. They can't start any rumors, or tell a friend, can they?

Wishful thinking? Maybe. As it turned out, Rob and Gina's only motive was the chance to play the part of teacher and mentor. They admitted getting a thrill out of steering individuals into what Rob called a "coming wave of change." After a drink or two, feeling relaxed and open, I had a comical vision of Rob and Gina as high priests of a swinging cult, lost out in the barrens of Costa Rica or somewhere equally ridiculous. Gina enjoyed laughing... that's when she looked most beautiful.

It was fun to be a student again. I learned more about swinging and the lifestyle in that one night than I've learned in the many weeks and months since. Rob and Gina had been married for five years prior to being introduced to the lifestyle by a college friend of Gina's. When Rob and Gina first learned about off-premise couples' clubs, they were quite intrigued by the idea. Gina's friend, with her husband of course, joined a club and extended frequent invitations to Rob and Gina. They never accepted.

Rob suggested the reason for their long period of hesitancy had to do with the fear of being discovered. There is a stigma associated with swinging, he said. To some, swinging is seen as socially aberrant, even as sexually deviant behavior. Nevertheless, Rob and Gina's intrigue turned to curiosity, then interest, and finally a desire to have a long-anticipated look for themselves. They accepted not only their next invitation, but the entire lifestyle. Rob and Gina gazed tenderly into one another's eyes and kissed when Rob said there was no going back now. The passion flowing between these two was amazing... so erotically uncommon.

Rob and Gina's first off-premise club experiences involved all of the eroticism of a swingers' club, except having sex on the premises, which was not allowed.

They became captivated by the sexually permissive atmosphere of the clubs. Rob loved showing Gina off. He enjoyed watching her on the dance floor in the arms of a man he knew was turned on by Gina. Gina, in turn, felt the same way when she saw an animal lust for Rob in the eyes of some woman.

Rob said his own feelings of lust for Gina were not only validated but infinitely enhanced. The experience underlined just how much of a separate individual Gina was. That certain feeling of familiarity, the one which breeds contempt between people, had never again visited them since their initiation into the lifestyle.

Another reason they participated in swinging was they both had agreed that it would have been impossible for either of them to have stayed sexually satisfied in completely monogamous circumstances.

They claimed the lifestyle added new excitement to their marriage. Swinging for most women, I remember Gina saying, changes their view of themselves, the world and sexual relations. Many people they knew had an identical view of life after swinging. They asserted that viewing each other as individuals was a complete turn-around in their life from the way they viewed each other two or three years before swinging. Their viewpoint made sense to me.

It was plain to see that Rob and Gina were a well-educated, responsible couple who held almost all the traditional values of a couple living in a thriving contemporary relationship. Rob said it so well when he said he and Gina were emotionally monogamous – the rest they merely considered to be a fun and natural form of recreation within marriage. All of the men and women they'd befriended through the years held similar views. Neither Rob nor Gina could think of a single time they experienced even so much as a moment of negativity as a consequence of the lifestyle.

Most of the people they knew at the clubs were educated white-collar professional couples, couples who could be depended on to be perfectly discreet about their activities. Rob was an ophthalmologist, Gina's friend's husband was a psychiatrist. Their immediate circle of friends included a custom home builder, a musician, an author and an air-cargo pilot.

Gina joked that the reason the clubs were so much fun was that the people who thought swingers were perverts were never there. We chuckled, but you could see Rob analyzing what Gina had just said. Then he asked us a startling series of questions: "How many of the people you interact with on a daily basis do you think are the inherently jealous type? How many do you know who seem to thrive on playing destructive social games? How many have a poor opinion of the opposite sex? How many people do you confront on a daily basis who have little or no sense of self-esteem? How many couples do you know who stay together in

miserable marriages?" These, he pointed out, are the very types of men and women you rarely see at the clubs.

Rob and Gina's earliest sexual encounter with another couple was with Gina's college friend and her husband. This unpremeditated first experience followed a night out at the club the four frequented. At the end of the evening, the friends invited Rob and Gina to their home for coffee. Gina and her friend, still caught up in the mood of the club's ambience, selected a few of their favorite CDs and started to dance. "Know anything about spontaneous combustion?" Rob asked. Gina stared into space as if resurrecting images of the occasion in her mind's eye.

Spontaneous combustion. What did I know about spontaneous combustion? My mind flashed back to Jennifer, her husband, and the sensuality we shared. What a clever metaphor. Spontaneous meaning instinctive, involuntary, natural. Combustion. To combust, ignite, or spark. Jennifer! That's what happened between Jennifer and me, spontaneous combustion. Rob and Gina sat back and relaxed as I avidly related the events of the previous night.

Studying their reactions, as my story progressed, I could sense Rob analyzing certain segments. Gina seemed to have enjoyed the part when I spoke with Jennifer, at the bar, after having introduced myself to her. Rob appeared to be greatly amused by my description of events involving Gerald and his wife. By the time my story was finished, I believed they could plainly see how infatuated I was with the swinging lifestyle.

I learned a great deal that night about swinging and swingers. Reluctance to entertain the concept of single male involvement in their relationship, for example, is a point of view Rob and Gina share with most swingers. Gina knew a few couples whose lifestyle marriages were destroyed after single males came into seemingly solid relationships and unintentionally became emotionally attached to the female. The attachment, of course, led to romance. The romance led to sharing an address, to say the least.

What Gina thought made it easy for the women to change their lives was that they had their husband's support in getting to know the single male in the first place. Gina asserted she and Rob had too much to lose to succumb to the single-male threesome scenario. But, she confided, the thoughts of having such a threesome with a much younger male was sometimes very appealing to her.

I though of Jennifer. I could easily spend my life with a woman like Jennifer. Through Jennifer I experienced what Gina feared. This was one of those times I felt Gina and Rob turn into high-priest swinging gurus again. This time it wasn't as funny, it was a lesson. What if Gina was as affected by someone as I was with Jennifer? Uh oh!

They surely were fluent with the language and ideals of the swinging lifestyle. I was amazed by the amount of knowledge Rob possessed. When I asked him about other swing clubs which allowed single guys, he knew of only three: the one in Las Vegas; Dayton, Ohio; and Toronto, Canada. I made a mental note of Dayton and Toronto for future reference. Both cities were a heck of a lot closer to where I lived than Las Vegas.

Following a superb night of dinner, drinks and conversation, we said goodnight, never to see one another again. Three days in Las Vegas was more than enough time for someone to want to stay there. Thursday morning I was on a flight to Puerto Vallarta, Mexico, and ten wonderful days of rest and relaxation.

The contrasts between Vallarta and Las Vegas were astounding. For a while I listened to the ocean and felt as though I were sitting in a vacuum. I caught myself daydreaming, wondering if I would run into Jennifer without her husband in some romantic little restaurant in Old Vallarta. The events of my vacation up to this point had been so improbable, so unbelievable, I actually thought a chance meeting with Jennifer would be the next hand to be played out in the series of astonishing events. That's when it occurred to me: the emotions I was feeling were identical to those of having fallen in love.

Ten days passed by far too quickly. I spent my afternoons relaxing on the beaches of Old Vallarta, sketching and recording memories in a journal. It's become a new habit. I have dedicated two hours of each and every week since vacationing in Vallarta to writing down thoughts relating to my sexual quandary. All of the captured thoughts and drawings are my deepest, darkest secrets. One very special journal sketch is of Jennifer, in the pillows, looking at me for the last time from over her husband's shoulder, as he, on his knees between her spread legs, thrusts his penis into her wet heat. In those days my journal was the only friend I could talk to, on a regular basis, about my innermost sexual secrets.

Three months after my vacation I arranged a Singles Night reservation at the couples' club in Toronto which Rob and Gina had mentioned back when we had dinner at the Tropicana. Singles Night at this specific club was a social event where couples could meet singles, and vice versa, perhaps to make arrangements for future liaisons.

Compared to my exposure to swinging at the club in Las Vegas, this off-premise club experience was tame… but I enjoyed myself anyway. On my first visit, I made a few new acquaintances. On my second visit, I met a very special couple, Jane and Carl.

• **jane** There was a spark between Jane and me from the first dance we shared. Just a spark – not the spontaneous combustion which took place between Jennifer and me in Las Vegas – but a spark nevertheless.

Jane was an extraordinarily energetic, self-assured, spirited woman in her early 40s. If I were to have guessed her age when I first met her, I would have said no more than 30 or 32 years of age.

Carl was a couple of years away from 50, but you'd never have known it – I'd have guessed his age at 35 at the outside. He had the wardrobe, aura and physical appearance of some familiar-looking, ageless musician. Jane's physical attributes were the perfect match for Carl's. She dressed her unquestionably voluptuous body with all of the accoutrements of the flowers-in-your-hair, peace-and-free-love generation. As a couple they were continually the center of attention at the monthly singles nights.

Over the next several months, Jane, Carl and I took advantage of our opportunities to interact. We got to know one another on a few different levels. Jane mentioned one night how different she thought I was from the average single male who was involved in the couples' club scene. Most of the single men I saw were there for one thing only, and many found exactly what they were looking for.

Singles Night, I would later learn, attracted an older and bolder breed of couple. I had sexual opportunities extended to me, by way of some fairly explicit invitations, on at least a dozen different occasions. I bowed out each time. I wasn't going anywhere with anyone without a certain crucial requirement: spontaneous combustion.

Making it with a couple for the sake of making it wasn't what I wanted. I was actually afraid I wouldn't be able to perform if I had taken anyone up on an invitation to be with them after a party. Sex by appointment… the very thought was kinky. If anything of a sexual nature was to take place, it would happen in a natural way, it would happen on its own. My circle of club friends all knew this about me. Maybe this is what made me different than the average guy, as Jane put it.

I never regretted a night out at the club. Jane, Carl and I would invariably find ourselves together, mostly due to Jane's love of dancing. On one of my monthly visits to Toronto, Jane invited me to their annual house party which was to take place on the last weekend of the month. There were a number of invited couples who would arrive on Friday and stay until after Sunday brunch. She teased me by saying, "You never know where you might find a fire, Josef, but I can assure you several will be started. You should come with an open mind and no expectations. Just be yourself."

A few weeks later I arrived at the address, in an obviously affluent Toronto suburb, a little nervous and thinking I might have made a mistake in noting the address during the carryings-on of the previous club party. The imposing two-and-a-half-story English Tudor style home was at the end of a long lane way on a spectacular parcel of wooded lands overlooking the western shores of Lake Ontario.

I hadn't made a mistake: it was Jane who answered the resonating thumps of the heavy brass door knocker.

Strangely, I felt comforted by Jane and Carl's fidgety manner as they welcomed me into their home. There was a shy side to Jane and Carl, and it was showing in the way we greeted one another. Carl seemed relieved when Jane put an arm around me, held her body close to mine, and kissed me on the cheek. The ice was broken.

Jane and Carl's home was incredible. It was exactly divided into two distinct sections. The home contained a party half and a normal-world half, a reflection of the people who were presently enjoying its comforts. The party half of the estate-like structure seemed completely removed from the living area of the home.

The weekend guest contingent of the weekend's festivities soon began to arrive. Jane, Carl and I were chatting on the deck of the indoor pool when the door knocker again resounded. Before seven o'clock in the evening there were eight people in the low lights of the pool deck and its surroundings.

Shortly after the knocker sounded for the last time that evening, Jane and Carl came onto the pool deck to introduce their lifelong friends Rick and Dianne, an attractive couple from the same summer-of-love era.

• natalie

In the excitement of seeing their friends, Jane and Carl neglected to introduce the younger woman who entered the pool area with Rick and Dianne. My first thought was that Rick and Dianne had brought Natalie to introduce to the only other single at the party: me!

Eventually our presence was requested at the formal dining room table for a buffet feast. After all the guests served themselves and were comfortably situated, Jane and Carl made their way around the table introducing their various friends to Natalie and me, "the first-timers."

Jane and Carl's challenge for Friday night was to provide an environment which allowed everyone to familiarize themselves with one another and with the fabulous surroundings. They succeeded quite thoroughly. Carl suggested we have an early night and sleep in as long as possible to ensure we felt rested enough to celebrate right through Saturday until sunrise on Sunday morning. The real party, Jane said, would start with dinner at 6:00, after which an additional twenty after-dinner guests were scheduled to arrive between 8:00 and 9:00. For the balance of Friday night, love and sensuality were occasional topics of conversation as seven couples and two first-timers enjoyed a strictly social affair. Well, maybe not quite so strictly social for the two first-timers....

Natalie and I eventually connected with one another and enjoyed each other's company as we would probably have in any social circumstance. Taking Carl up on his invitation to feel right at home, I did. I asked Natalie if she would

like to share a glass of wine with me in the hot tub. She didn't say yes right away; instead, she asked if I had seen the second or third floors. I told her I hadn't and she explained that her bathing suit was in her assigned room. Excitedly, she grabbed my hand, rushed me out into the main foyer and ushered me up the staircase. "You have to see this," she said.

To the right, at the top of the staircase, was Jane and Carl's amazingly fabulous master bedroom – a room with twelve-foot ceilings, eight-foot window lengths, hand-hewn beams, two fireplaces, several couches and love seats. Partially concealed by a rock wall made up of ledges and potted plants was their bedroom suite. Natalie left me standing in the hallway gazing into Jane and Carl's room while she quickly ducked into her assigned quarters.

The room was easily 40 feet in width and length. In the windowless quarter, on the left side of the bedroom suite, was an open-concept bathroom, walled with ceramic tile and glass block. His and hers showers were visible from behind the smoked and etched glass doors which separated the wet area from the living space of the room. To the right of the showers was a hot tub area; behind them was the type of redwood door one would associate with a sauna. Just inside and to the right of the double door entrance of the master bedroom was a round wrought-iron staircase leading into the attic. From the bottom of the staircase I looked up, through the attic's glass ceiling, at the crescent moon in the night sky… just as Natalie reappeared.

Incredible! Not the surroundings, but Natalie. Her body shone with the glow of an even golden tan of nude beach caliber. Natalie wasn't a least bit shy. Beneath her thigh-length embroidered robe she wore nothing at all but a black sheer thong. Her open robe barely covered her small firm breasts. With her hair tied back her eyes looked larger and for the first time hinted strongly of Asian ancestry. She smiled when she noticed the attention I paid to her body and choice of eveningwear. First class all the way! Then, looking toward the round staircase, up into the attic, Natalie said, "I wonder if that's where it'll be?"

No matter how I begged her to tell me what "if that's where it'll be" meant, she wouldn't say anything further. She didn't bend. If I really needed to know, Natalie teased, she was sure Jane or Carl would be only too happy to explain everything if I were to ask. Well, I did have the chance.

I left Natalie on the pool deck to retrieve my overnight bag, still in the trunk of my car. When I returned with my things I was kind of stuck because I wasn't yet assigned quarters for the weekend. Jane rescued me when she noticed me returning from outdoors with my baggage. She apologized for forgetting to show me to my place for the night and escorted me up the staircase to the second floor.

To my surprise, Jane walked through the double doors of her master bedroom suite and continued up the cast iron stairway. On the way up I asked Jane if she knew what Natalie might have meant when she looked up to the attic and said "I wonder if that's where it'll be?" She didn't answer my question directly. Instead she asked if I could wait until Natalie and I had a chance for a chat, in which all would be explained. Before Jane returned to the party, she mentioned she also had something she wanted to ask me after I had a talk with Natalie.

I stood in the quiet sanctuary of my temporary accommodation. The moon shone brightly through the wide expanse of skylights facing the southeast as I studied the plush environment. I was in a room approximately twenty feet deep by thirty feet wide. Several couches and love seats were arranged around an audiovisual entertainment center, making up one side of the area. The other half of the available attic space was very sparsely decorated. I wondered what Jane wanted to speak to me about.

In the center of the sparse part of the room stood a medieval-looking piece of antique furniture. It was a heavy headboard piece intricately carved with images of birds, animals, flowers, all living entities. A cross section of our global panorama of living things, of life itself. It was a wonderful piece of heirloom-quality artistry. Attached to the headboard was an ornately embroidered purple velvet upholstered bench. About nine feet long, it wasn't quite wide enough to pass for a single bed. A pillow propped against the headboard suggested it might be my place for the night. Later that night I would find myself unable to fall asleep on that bench, knowing what was in its future and its past.

When I got back to the first floor I scanned the room for Natalie. It was my turn to be animated with excitement. I picked a breathing bottle of California vintage, along with two glasses from the buffet table, and followed through on my earlier invitation to have a dip in the hot tub. Natalie was a very sophisticated young woman. You could plainly see she was quite used to showing off her allover tan. She radiated an uncommon zest for life.

Natalie and I chatted as we lounged. We sipped away our wine in the comfort of the hot tub until we needed a dip in the pool to cool our bodies down. After we dried and wrapped our bodies we were back at the buffet to fill plates with a selection of assorted goodies. I asked Natalie to guess where my quarters were. When I told her, she got up with her plate and said, "I've just got to see this." She was gone before I had a chance to pick up my plate and stand. I climbed the staircases back to my room to find Natalie lying against the pillow on the bench looking up at the moon.

Natalie's voice was different. She asked if I had spoken with Jane yet about any sexual aspects of the party on Saturday. I didn't answer right away. Earlier, Natalie asked me to talk to Jane about the meaning of her statement, "I wonder if

that's where it'll be." What did Jane mean when she said she needed to talk with me later? It was obvious something was up. I poured wine into two glasses, handed one to Natalie, and sat on the bench beside her. I asked Natalie to be frank and tell what she knew about the sexual aspects, as she called them, of Saturday's party. She blew my mind!

Natalie grew breathless. She spoke quietly. Her own words took her breath away repeatedly. The look in her eyes was the same one I'd seen before, in Jennifer's eyes, that certain look which suggests vulnerability. In near-whispered tones, between deep breaths, she showed me the true dimensions of her hot-blooded lust for fantasy. I could feel a sudden rush of heat rising from her body as she disclosed the party theme guidelines...

• **natalie's fantasy** Close your eyes and imagine this. You are at a party in the midst of dramatically extravagant and sexually inspiring surroundings. By 8:00 or 8:30 in the evening, 38 people are present. The 37 individuals you see before you have all agreed to be players in a fantasy game which you control.

You mingle in a crowd of uninhibited pleasure-seeking couples while secretly noting the most sexually appealing persons among them. You then choose, from the 37, as many individuals as you'd like to participate with you in bringing your fantasies to life.

This was precisely the plan Natalie was going to follow on Saturday night. She would mingle, choose and disclose her choices to Jane. She would then leave the room while Jane notified the men and women Natalie had chosen. Natalie was to be waiting, blindfolded on a bench, exposed to the sexually creative will of the men and women she had selected.

The meaning of "I wonder if that's where it'll be?" was explained. Of course! The bench! I could hear the lust which burned in Natalie by the way she used her voice as she spoke of what was to come. Overwhelmed, I stood up and looked down at her. Her flesh was covered with fine perspiration. Her breathing was rapid and visible, her eyes wide. She was positioned on the bench as though she were a jungle cat about to pounce on living prey. Did I know what spontaneous combustion was? Oh my....

On an impulse, I asked Natalie to lie back on the bench. She stretched her arms toward the headboard and raised her legs onto the bench. In doing so, her robe fell open to reveal her naked chest. Her nipples hardened each time she saw me focus on them. In a deliberately slow step, I wandered from one end of the bench to the other, from one side to the other. For some reason I felt like I needed to see her from all perspectives.

It wasn't the sight of her naked body which created the pleasurable sensations I savored. Natalie's unspoken granting of permission to examine her body so intimately had aroused me tremendously. At first, Natalie silently watched as I walked back and forth above her. After a while she closed her eyes and seemed to slip into a state of meditation.

I loved the way heat quickly grew and rose from within her, the way her chest heaved in a long moan when she closed her eyes. Were visions of what awaited her dancing in her mind? How could they not be? Natalie then unexpectedly sat up and flashed her wide smile. Enough! We agreed we couldn't take any more. A swim? A dip it the hot tub? One thing was certain: Natalie looked as though she had just stepped out of a sauna.

It just doesn't seem fair, when I think about it now, how quickly Friday night flew by. Far too soon it was after 1:00 in the morning. By the time we returned to the great room, Jane, Carl, and their friends Dianne and Rick were the only people present on the first floor. Everybody else had said their farewells.

To my surprise, Natalie stayed only five minutes before she too retired for the night. On her way upstairs, in a dreamy-eyed state, she joked about not being sure if she was leaving because she needed sleep or because she was going to pass out from the sensations gushing through her body when she thought of what the evening promised. As she left the room, images of Natalie, minutes earlier, on the bench, covered in sweat, moaning, flashed in a strobe light staccato in my mind. She was indeed the centerpiece of the weekend's celebration.

A short while after Natalie's farewell, Dianne and Rick said goodnight, leaving Jane, Carl and me the only ones still up. On the way up to our quarters, Jane suggested the three of us could have a sauna in their room. Carl passed on the idea but encouraged Jane and me to carry on if we wished.

When he closed the double doors of their suite Carl walked to the glass doors of the wet area, onto the ceramic floor, and casually disrobed at the showers. At the entrance of the wet area Jane reached behind her to undo her dress. She asked me to please not feel uneasy about being naked because it would make her self-conscious of her own state. Her dress fell beside my clothing, in a pile on the floor. Naked, we walked past Carl and entered the sauna.

Jane had absolutely nothing to feel self-conscious about. Sitting across from me, in the well-lit enclosure, she looked extraordinarily young and beautiful. Carl, she said, felt perfectly at ease and not threatened by me in the slightest way. In fact, she eagerly went on, Carl had grown fond of something he called my "gentle manner" in the months since we first met.

Jane apologized for not letting me in on the details of the weekend's celebration. After the way I described my experience at the swinger's club in Las Vegas she said she was absolutely convinced I would rather have enjoyed finding

out for myself. She was right. When an opportunity arose, I asked Jane to please tell me more about Natalie.

Rick, Dianne and Natalie shared the same kind of relationship Carl, Jane and I had. Natalie met Rick and Dianne more than a year ago at an off-premise club. A few months after first meeting, they got to know one another intimately during their club's biggest event of the year, a week-long Caribbean cruise. According to Dianne, Natalie's sexual initiation into the lifestyle came during the cruise. The experience left her with much the same kind of follow-up lifestyle involvement as my own. That's about all Jane knew. Natalie, she said, wasn't looking for something to happen, she was waiting for it to happen.

One night, their memories still fresh, Rick and Dianne told Natalie the intimate details of a particular party at Carl and Jane's home. Hearing the story changed Natalie: she later told them she had constant intense fantasies for months after learning the story. Eventually, every time she fantasized, her fantasies would begin with her lying down on a bench.

Before Jane and I left the sauna she sat next to me, unexpectedly put her hand on my shoulder, and looked into my eyes. She seemed to tense a little when she asked me to consider a proposition. She and Carl wanted me to consider a threesome encounter with them. They didn't expect an answer right away, I should just consider the possibility.

I'd thought about Jane and Carl in sexual ways, but, because I just didn't expect a mutual sexual attraction, I never pursued the issue. It was very flattering to be regarded as desirable by a couple who were continually the hottest, most irresistible couple at the singles' night parties. I interpreted Jane's proposition as a compliment of the greatest magnitude, and I said so as I hugged her body against mine.

I must not have been the first person who, after learning its secrets, had difficulty in sleeping on the bench. Before we said goodnight, Jane said I'd more than likely have a problem and would probably have better luck in falling asleep using one of the couches. I did have difficulty but enjoyed every last minute of my sleeplessness. I imagined what Jane must have been feeling when she was lying blindfolded on the bench. What would it be like to be surrounded by a circle of gentle individuals to be massaged, kissed, and licked to orgasm?

For hours, I lay still, eyes closed, my imagination running wild. I conjured intricate visions and sounds of pure unrestrained lust in a continuous stream of fantasies. Jane, laid out on the bench, in the middle of a circle of men and women, blindfolded. Two women, on their knees, from the sides of the bench simultaneously suckling Jane's nipples. A third woman, on her hands and knees between Jane's spread legs, making loud wet sucking sounds from between them. The woman turns her face to look at me. It's Dianne!

Like in some ancient forgotten ritual, six individuals come to the medieval bench as if to celebrate an exorcism of Jane's sexual inhibitions. Two men take positions on either side of the bench at the headboard and feed their penises to a blindfolded Jane. She fondles their testicles as, first, she takes one penis into her mouth and then the other. Occasionally, Jane's lips make loud smacking sounds as she insatiably sucks both penis heads into her mouth before returning her attentions to completely engulf the penises one after the other. A third man kneels behind the upturned backside of the woman between Jane's legs and enthusiastically pumps his penis into her sopping vagina. A voice asks Jane to stand up beside the bench.

Jane pulls away from her lovers and stands up trembling in anticipation of her wildest fantasies coming true.

After disengaging themselves from the tangle of arms and legs, all rise to stand with Jane. One man then lies down on the bench, his firm erection pointing straight up into the air. Five pairs of hands, men's and women's, lift Jane into the air above him to calmly and gently lower her puffy vaginal opening onto his bulging erection. The hands holding Jane rock her body back and forth, bringing Jane to the brink of orgasm several times before pulling her away and denying her pleasure.

Blindfolded, Jane sees only through her mind's eye. Each of the men takes a turn on the bench while the others, again and again, help to bring her close to the edge without crossing over the line. Jane grows increasingly ravenous, to the point that she is freely pleading for release. Her pleas are finally answered. Seven physical entities, seeking their individual carnal pleasures, writhe in unison like one enormous undulating amoeba. The sounds I imagined seemed to move further and further away as the sandman slowly won the battle for my consciousness.

The sun wasn't up but nobody told the birds. Wow! Try sleeping late on an unusually warm and sunny spring weekend in Southern Ontario. I lay, in a state halfway between sleep and consciousness, imagining the number of ways anyone could be sexually serviced by three men and women at the same time. I was pretty sure I had envisioned at least half of the potential number of combinations by the time the sun started to rise over the lake.

Sharing a morning routine with a very attractive married couple who happened to be into recreational sex will endure as a fun memory for years to come. Our nakedness really wasn't an issue after the way we'd conducted ourselves the night before. That weekend I learned how much joy could be found in something so simple as being naked with highly sensuous people in a non-sexual context. It really is all about feeling completely happy with your physical self, your body.

When we eventually clothed our bodies for the day and arrived onto the first floor, the sounds of people awakening from their sleep on the second floor were just starting to be heard. Toronto was only 25 miles down the road, it was a

gorgeous day, it was early. Try as I might, I couldn't find a reason not to take an early Saturday morning drive down the highway.

You know, to me, there's an almost metaphysical air surrounding individuals who live in a constant state of high sexual arousal. It's visible, to some, in an aura of colors. When I occasionally think I see these auras, they become visible in varying shades of the colors deep blue and purple. As I turned around in the driveway and looked back at Carl and Jane's home, there was a purple rainbow-like arc of color glowing above the whole front facade. Purple, the color of rapture and passion.

The drive down the lakeshore road to Toronto gave me a breather, a chance to put new events into proper perspective. First, Natalie and her blindfold game. Obviously, I wondered if she would choose me to be one of her anonymous lovers. Extremely pleasurable pulses of sensation spread from the base of my spine through my entire body while recalling sounds and visions of Natalie's hedonistic conduct on the bench the previous night.

Just who was Natalie, anyway? She seemed to want her personal life to be totally separated from the swinging lifestyle part of her life. I knew nothing about her beyond the fantasy desires she'd described. I had the notion we were living with very similar views and ideas regarding these lifestyle issues.

Unexpectedly, Natalie intrigued me in a way which brought up defensive responses in me. I didn't want to go through another six months of the same feelings I had after my involvement with Jennifer.

Nine months had passed since my jaunt to Las Vegas. It took six months before I was able not to think of Jennifer for a single day. If I were to have met Jennifer, under different more innocent circumstances, and she was single, I'm convinced we would have fallen madly in love at first sight. Jennifer knew it too: isn't that why she said, "Please, Josef, you have to go now"? Didn't she fall in love at first sight when she told me I was a dream come true? My first time wasn't a sharing swing experience. My first time was the result of an impassioned sexual desire for a certain woman, Jennifer. Was I was alone in having had fallen in love at first sight, or did Jennifer feel the same way about me? Had she gone through a period of longing for me the way I had for her? The thoughts struck me with some impact.

At times I thought of how my first visit to an on-premise club would have been had I not fallen under the spell of the woman who said she wanted to share intimacies. Oh, Jennifer! The memories now seem like no more than vivid fantasies. Thinking back on the advice Rob and Gina offered, back in Vegas, I profoundly understood Gina's reluctance to indulge in a fantasy she admitted was sometimes appealing to them.

Natalie was anything but the stereotypical single woman one would find in a swing environment. To begin with, she was only 23 years old. Rarely is a woman attracted to the swinging lifestyle before age 30 – except the occasional woman who is in a bisexual relationship with a swinging couple. These facts were evident at all of the monthly singles' night parties I've attended. Even more rarely does a very young woman become absorbed by as uninhibited and complex a sexual adventure as the one on which Natalie was about to embark.

Rob and Gina mentioned – and I have since read scientific explanations of the phenomenon – that physiological changes in a woman over 40 may lead her to explore fantasies of wild group sex. Apparently, as a woman ages, her testosterone levels steadily increase. Testosterone is the hormone which governs sex drive, and as it escalates, a mature woman's body becomes capable of experiencing heights of sexual enjoyment far beyond the normal limits of a single monogamous encounter. A few – and Gerald's wife comes to mind – become sexually insatiable. Natalie was anything but ordinary.

As I headed along the elevated expressway which separates Toronto's skyscrapers from the shores of Lake Ontario, *Once In A Lifetime* by the Talking Heads played on the car radio. The song eerily fit into the day and my frame of mind. Driving by the C.N. Tower on a weekend like this three years ago would have been a daydream. It was hard for me to believe that only three years had gone by since the days of my initial infatuation with the concepts of erotic couples' clubs.

Yes, I'd considered. Part of what made thoughts of a threesome with Carl and Jane a delicious turn-on was Jane herself. All it would have taken is for the three of us to find ourselves in the right place and time and I was convinced the chemistry which existed between us would ultimately influence sexual behavior. In my mind, at this late point, I also knew I wouldn't hesitate for an instant.

Another reason Jane's proposition was so tempting was the fact I'd already included Jane and Carl in sexual musings. Several times, since making their acquaintance, they had been with me while my eyes were closed in the shower. I wondered what they looked like while making love, what their kinks were, what experiences they might have had. When I imagined our fantasy threesomes, the sounds I imagined Jane making, in response to the pleasure Carl and I provided, sent me over the edge onto the shower floor on each occasion.

On the road back, I intentionally tried not to think of Natalie. I guess you could say I wasn't too successful. My pulse raced when I thought of the way she might later lie blindfolded, her arms stretched up above her head, one leg draped over each side of the bench. My mind embroidered the image: with her feet on the floor, her back arched up from the bench as she suspended her hips in the air, her body now completely exposed, open, waiting. The closer I got to Jane and Carl's,

the more stirring, at times even dizzyingly vivid, the images became. I was calmed only when I thought of how intensely the anticipation of the evening's purpose must have been affecting Natalie. I couldn't begin to imagine!

Pulling back into the driveway of Jane and Carl's lakeshore estate, I had a strong sense of consciously departing reality, a sense of escaping, of floating. I had no idea what might have been taking place inside the home, or of what I was about to walk into. I was a bit anxious but knew it was all for nothing the second Jane answered my knock. She was stunning. What a memory! A delicate sprig of baby's breath in her hair, a long flowing hippie dress with at least a hundred buttons running from the top to the floor, she looked as thought she had just stepped out of the '60s. I didn't expect Jane would put her arm around my neck and passionately kiss me on the mouth when she welcomed me back, but that's precisely what she did. Before excusing herself she directed me to the pool where everyone else had gathered.

One of the most uncanny memories of my weekend at Jane and Carl's was how laid back, composed and unassuming people were. Virtually everyone was relaxing in the spa area, lazily enjoying the congenial surroundings. You'd have never guessed, from first impression, the hedonistic pleasure-seeking nature of these folks. On the surface they looked like a large group of people enjoying nothing more than a social get-together. The setting looked so enticing I decided to change into swimwear and join in the nonchalantly self-possessed atmosphere of the pool area.

When I walked into my upstairs quarters I didn't expect to find anyone there, but I did: Natalie. She had been arranging a few items around the headboard of the bench area. She noticed my arrival even before I had stepped off the staircase. "You were supposed to have asked me to come with you... thanks a lot," she said with a kidding pout.

There were two newly placed floor-standing candelabras at the headboard of the bench. Natalie was replacing the last of the red candles with a purple one just as I stepped off of the stairs and into the loft. The only solution to this major trauma of a problem, I answered her jokingly, was to go back out for a second drive and have lunch in Toronto. Natalie couldn't get to her room for a change of clothing quickly enough. A few minutes later we found Jane in the kitchen and told her of our plans. She reminded us we'd be expected for dinner at six and we'd better not dare be late.

• **time with natalie** The first few minutes of the eight hours we spent together were the toughest. I believe what made those few minutes difficult was a strong sense of having stepped into the real world once the front door had closed behind us. The time must have been awkward for Natalie too,

because we sat in the car practically silent for several minutes before Natalie asked how I had slept the night before. It was as if her question opened a floodgate. Before we had reached the C. N. Tower in downtown Toronto, Natalie knew the details of most of the fantasies I had imagined while I settled on the bench trying to fall asleep.

A few times, as I spoke, some of what I was describing seemed to come to life in Natalie's eyes as she listened intently. As my sketches progressed, a barely perceptible sheen of sweat began to form on her upper lip. She was gazing out at the road straight ahead but I could see she was looking past what lay immediately ahead of us. She was busy painting images in her mind, using my words as a brush.

Natalie trembled when I portrayed my earlier visions of two men taking positions on either side of the bench to feed their penises to Jane. Her nostrils enlarged when I detailed how she tasted one penis and then the other before slurping them both into her mouth. I described how two women suckled Jane's nipples while a third made wet sucking sounds from between Jane's spread legs while yet another man, on his knees behind the woman who was sucking Jane, pumped his long wide penis into her from behind.

I thought it a little eccentric when Natalie started to giggle out loud, but the source of her amusement very quickly explained itself the moment I followed her gaze to the area at the bottom of the steering wheel – my lap, to be exact.

Everything about the weekend so far seemed like a fantasy. Jane and Carl's home, the cause of the weekend celebration, my first ride down the highway to Toronto, and now, with the mysterious Natalie by my side, the first time view of Ontario from the top of the C. N. Tower. Neither of us had ever had a chance to take a ride up to the top – with its spectacular view of the mist rising up into the air above Niagara Falls fifty miles away – before today.

A little later, sitting in a seafood restaurant across from the Tower, we found ourselves to be in almost identical circumstances regarding our personal involvement in recreational sex. Both of us were young, single, we'd had one so-called lifestyle experience to date, witnessed several, and we were both the centers of erotic intrigue to an older couple who had recently made their ambitions known to us. The only difference was, in Natalie's situation, it was the female, Dianne, who had overpowering desires for another female, Natalie.

Up to this point in their swinging experiences, neither of the couples, Jane, Carl, Rick nor Dianne, had participated in anything other than married couple sex with people in roughly their own age group. I thought of Jane in a very tender way as Natalie confided how Jane feared being rejected by me. She was an extremely self-assured woman in her own element but was not ready to accept the fact she could be sexually desirable to someone barely more than half her age.

I had no idea of Jane's lack of self-confidence or of her true age. I did know she was one of the most desirable women I'd met at the monthly singles parties, and judging from last night, certainly one of the most desirable of the weekend houseguests. I was quite surprised to hear of her uncertainty – but not as surprised as I was when Natalie confessed to me her own infatuation with Jane.

In the months since her sexual initiation into the lifestyle, Natalie had grown increasingly curious about female-to-female sexuality. Her first swinging experience came at the hands of two couples who were all bisexual. It was frantic: everyone did everyone, as Natalie put it. The only act she didn't participate in was to provide another female with oral sex.

In the sexual fantasies which followed her first encounter, Natalie said she began to occasionally imagine herself going down on another woman. In Jane, Natalie finally found a focal point for her fledgling bisexual desires. She never expected to be sexually attracted to a woman, let alone a woman in her forties, but, after having met Jane, her once occasional imaginings were now occurring on a regular basis.

Before we left the restaurant Natalie reached across the table, took my hand in hers, and said she hoped what she was about to say wouldn't spoil the positive feelings which existed between us. Natalie wasn't going to choose me to be a part of her bench fantasy. If it was any consolation, she went on, she wasn't planning on selecting Jane either. She hoped Jane, Carl and I could somehow find ourselves intimately together and she didn't want to stand in the way. Natalie didn't allow me a chance to respond. Still holding my hand, she got up from the table and said, "Come on, Josef, enough of this. Let's go sightseeing." We walked out of the restaurant arm in arm.

The sights and sounds of the marvelous, world-class city that is Toronto made the afternoon literally fly by, to the point where we found ourselves having to rush to get back to Jane and Carl's in time for dinner. We arrived back at Jane and Carl's exactly in time to merge into the procession of guests heading up the main stairway. It was as if we hadn't gone anywhere – as if we'd just decided, together with everyone else, that it was time to change into evening attire. I left Natalie in the upstairs hallway on her way to her room and opened the doors to enter the master suite. As I walked up the round cast iron staircase, my steps grew progressively slower with each consecutive stair. At the top, I froze in my footsteps.

The moment I stepped onto the third floor could be compared to actually having stepped across a threshold into another world – a world of hedonistic make-believe. These days it spooks me, sometimes, when I'm daydreaming, how just recalling specific incidents of the weekend's revelry sends me across that very same threshold. The fantasies I used to have seem out of focus, murky, obscured.

Now my fantasies are actual memories which even inspire my senses to recall specific fragrances, sounds, tastes and visions.

In a stream of sunlight flooding through the skylight, leaning back against the headboard of the bench, stood Jane, completely naked. She had one foot on the floor, the other up on the bench, leaving her legs very spread open. With both hands, she grasped Carl's penis to barely insert the tip past the hairless lips of her opening. Carl, in front of her, his left knee on the bench, kneaded Jane's flesh as he held her small buttocks in the palms of his large hands. His head lowered as he suckled first one nipple and then the other in a sensuous succession of wet kisses. So electrifying was the sight of Jane's remarkably smooth, deep crimson, almost translucent vaginal opening, I was compelled to wander into their space for a closer look.

Jane acknowledged my presence with a look totally devoid of any noticeable expression whatsoever. With his penis now in her vagina, she pushed away from leaning on the headboard with one hand and wrapped her arm around Carl's neck. Supported by Carl, she wrapped her other arm around him, and encircled his waist with her legs. He turned, shifted and sat on the bench for a second or two, then, as he stood up with Jane tightly holding onto him, his penis penetrated her to the hilt.

Carl continued to knead Jane's bottom, methodically easing into her with a succession of soft prodding thrusts, while she sat in his hands as he stood. Just as I was certain they were about to share orgasm, Carl, denying the ecstasy of release, deliberately withdrew his penis and calmly settled Jane back down onto the bench. They sat for a few moments, very casually catching their breath, studying me as if what I had just witnessed lived in my imagination only.

Neither Jane nor Carl said a word. They simply sat at the edge, side by side, an arm around each other's waist, the other hand palm down on the bench. They seemed to be waiting for my reaction. Without anyone having spoken a word, they silently gazed with an expression on their faces was as if they were pleading with me to earnestly consider their threesome proposition. The thought crossed my mind… but I didn't get a chance to ask. If we'd have had more time, I think we well may have shared a similar experience, but Jane suddenly suggested that a threesome shower might be a lot of fun before readying ourselves for dinner.

Carl and Jane both appeared younger than most people their age, and they also displayed an uncommonly high level of energy. I mentioned to them, on the way down to the master bedroom spa, how I thought they looked absolutely fabulous while absorbed in their display of lovemaking. Jane contended that what I had walked in on wasn't lovemaking so much as it was a calculated teasing, of bringing one another to a state of high arousal which, she said, ultimately left them feeling relaxed and endlessly more adventurous in sexually motivated party

settings. To this day I continue to wonder if this high level of sexual energy could be somehow responsible for having kept them so young and vital in appearance.

My biggest disappointment of the weekend was how quickly the hours flew by. The evening passed by so swiftly that my ability to recollect some of the evening's escapades are, quite frankly, rather muddled.

- **the tension builds...** The instant I walked downstairs into the great room, I noticed a hard-to-ignore intensity among the guests. The previous evening, Friday night, had been entirely different – everybody had been laid back and unassuming. But tonight, it was as though someone had thrown a hidden switch somewhere. Dressed in their finest party attire, people were examining one another as if to ascertain whether or not they were sexually attracted to anyone. Several men and women inspected me so closely that I felt naked, and very alone, as they pored over my every physical characteristic.

Natalie had yet to make her entrance into the great room from her upstairs quarters. When I noticed Natalie's friend Dianne at the bar, I wandered over, poured myself a glass of wine, and joined her and Rick in a game of trying to guess which individuals Natalie would later choose to include in her bench fantasy. A hush fell over the room the moment Natalie walked in. Everybody stopped what they were doing to focus their attention onto her.

Natalie looked absolutely sensational. She knew she was the center of attention and smiled confidently while making her way to join us at the bar. She rose on tiptoe, kissed my cheek, hooked her arm in mine and held my hand as if we were a couple. Suddenly, with every eye in the room on us, I didn't feel so alone any more.

Natalie and I sat side by side, often hand in hand, over the delectable catered meal everyone so evidently enjoyed. Admiring eyes doted on her every move. Her gray-green eyes sparkled when she'd notice an individual gazing in her direction. Now and then I saw her closely watching someone as if making up her mind about whether or not they might be suitable for her purposes. I wished we could have exchanged ideas and opinions, but it was a little difficult to do while seated in the midst of so many who were appearing to be hanging on her every word.

I attempted to make up for the lost opportunities after dinner, when all of the guests enjoyed an hour or so of relaxation in the great room. My curiosity was piqued. I was interested to know whom of the individuals present intrigued Natalie enough for her to choose as participants at the bench. Instead of a straightforward answer, she turned the question around and asked me who I would select if I were in her place. Her whole manner changed, as if she were genuinely awed, when I told her she would be at the top of my list. Natalie stared into my eyes as if to ask,

"Are you telling me the truth?" A few moments later she looked as though she found her answer, smiled, and kissed me lightly on the cheek. My curiosity remained. She never offered an answer to my question. Instead she took my hand, squeezed tightly, and excused herself, leaving me sitting on the couch to wonder why.

Within the hour, new people started blending into the environment. Several of the overnight guests, including me, had changed into swimwear to take full advantage of the pool and hot tub. Carl and Jane's dinner parties, I'd later learn, were near-legendary in the Toronto swinging community. Nobody had yet turned down an invitation. By 8:30, all of the twenty invited after-dinner guests had arrived.

For the most part, the after-dinner invitees were a younger group than were the friends of Jane and Carl's who had stayed overnight. They were unquestionably more brazen as well. Up to this point in the evening, paradoxically, modesty had prevailed. Either the new guests didn't know they would be in a pool party setting and didn't bring swimwear with them, or they just plainly didn't care if they were seen nude or not. Two dauntless young women bared themselves and casually mingled with the others in the spa and the great room areas, without so much as a thought of jumping into the pool.

Jane and Carl continued to play the part of perfect hosts. One at a time they escorted the overnight guest couples, beginning with Natalie, around the room, introducing everyone to the new after-dinner group of folks. As Natalie made her rounds, I intently studied her body language trying to predetermine who she might later choose to accompany her to the third floor. The regard I paid was noticed during several separate introductions.

Once Jane and Carl finished introducing her, Natalie told me that she knew exactly why I had been regarding her introductions with such rapt attention. In true Natalie form, she again asked me who I would select if I were in her place. Finally... a chance to satisfy my curiosity, a chance to compare evaluations.

My first guess was solely based on the way Natalie had reacted to one of the nude women, Brenda, and her husband Ron. I was half right and quickly learning the rules of this fantasy game as we went along. Selecting one half of a couple didn't mean both would be invited to participate sexually. Natalie agreed with my choice of Brenda but not Ron. Ron, as any half of one couple chosen, would be invited to be present, but only as a spectator. Unselected halves of couples could, if they so chose, observe their mates from the other half of the loft space which accommodated couches and love seats.

Brenda, a voluptuous brunette of about 25 years of age, was unquestionably the most exotic-looking creature at the party. She was around five feet five or six, with a most remarkable shining thick mane of waist-length hair. Her large breasts

were obviously natural, unmarred by the telltale scars left behind by augmentation surgery. Both her nipples were pierced in three places to accommodate gold rings of varying sizes. The top ring was small, the middle slightly larger, and the third larger yet. Other obvious piercings visible at first glance included several in both ears, a small delicate golden nostril ring, and an even finer piece of gold at the corner of the eyebrow opposite the nostril ring.

According to Natalie, Brenda's most interesting body jewelry, adorning sites not readily available to view, included tongue and clitoral hood piercings. Natalie further confided that Brenda had been introduced as being kinky and very bi. I teased her by saying the tongue piercing must have been the deciding factor to influence her choice. She responded with a poke to my ribs.

Another person I thought Natalie would choose was Kevin, the husband of Brenda's nude counterpart. Once more, I was correct. Natalie said she was fascinated with Kevin, a ruggedly handsome, well-built, tall black man in probably his late twenties or early thirties. With Kevin, she said, she could have the chance to live a fantasy which she was convinced most white women entertained at some point in their lives.

After making a few incorrect guesses, I wondered about Rick and Dianne, her club friends. If she wasn't going to choose Jane or Carl, would she choose Rick and Dianne? I guessed she would. Again I was correct.

By this time, it was my turn to be introduced to the after-dinner crowd which, I'd later learn, mostly consisted of Jane and Carl's intimate friends. As we made our rounds, they both appeared pleased to introduce me as their close friend. I must say it was very flattering to be regarded as such by their long-time acquaintances.

Jane and Carl had made their previous introductions in a far more time-efficient manner than had they during my round in their company. Jane evidently had mentioned me to most of the folks I met. The introductions ended, in scripted sequence it seemed, with Jane, Carl, and me standing on the pool deck in company with the last two couples I'd been introduced to, Eva, Chaz, Anne and David.

It only took a few minutes in their company before I became mesmerized by the way these six individuals interacted with one another. All three couples somehow came across as having, at some past time, shared sexual intimacies between each other. Collectively they seemed to possess a level of energy quite unfamiliar to me. It could well be that this was the level of energy which had kept Jane and Carl younger in appearance than their years dictated.

Natalie continued to remain the focus of attention while people entertained themselves between the spa area and the bar in the great room. Jane and Carl hadn't yet gotten to a point where they could relax without the burden of any further responsibilities concerning the entertainment of their guests. There was

one lone obligation left: Jane had to notify individuals who Natalie would soon select to entertain her fancy at the bench. She constantly glanced over to Natalie as if awaiting a designated signal, and the moment she noticed Natalie walking alone in the direction of the staircase, she hastily excused herself to follow her to the third floor.

In Jane's absence I was overcome by sexual arousal in a way I hadn't experienced on any previous occasion. These new feelings of arousal were completely unrelated to my normal levels of excitement. Until tonight, highly charged erotic environments and situations used to provoke me into a state of erection, a sometimes embarrassing circumstance. But now, I became very aware of an increasing core of heat at the center of my body. My taut testicles were gradually receding into that heat. My penis, unrestrained, every so often brushed against my loose silk boxers, becoming sensitized to a state only a heartbeat away from the beginnings of erection. Just breathing became a laborious task.

Chaz, David and Carl more or less segregated themselves from Eva, Anne and me by standing as a group a few feet away. The additional fifteen couples could be counted between the downstairs spa area and the great room. Virtually everyone occasionally glanced at the entranceway Jane was to walk through on her way back from the third floor. The air was heavy with anticipation.

Eva put her hand on my shoulder to ask if I was "still here": unconsciously, I had ignored her as she spoke to me. "I can see for myself why Jane thinks you're so sweet," she flattered me. I was looking into her eyes from inches away as she let her gaze fall to my mouth. Her hand moved from my shoulder to cradle my chin. Eva tilted her head as if she were going to kiss me… instead, she seductively licked her top lip and smiled before she just as suddenly took her hand away from my face. She held my gaze as her other hand rose to cradle Anne's chin. She fixed her eyes on Anne, angled her head, and audaciously french-kissed her mouth.

A hum filled the room as Jane finally appeared at the top of the main staircase. The first thing she said when she rejoined our company was to comment on how warm it had become on the first floor. Everyone present was responsible, I'm sure. How could anyone have remained cool and unaffected?

• **invited to watch** Jane announced that she'd be circulating through the pool area to inform the couples who'd been invited to the third floor. Then a surprise – a strange request, really. Natalie had requested Jane to direct me to the third floor. I was to quietly make my way no further than the top of the cast-iron staircase, stand for a few minutes, and then leave. Staying quiet was essential. Natalie wanted me to see her one more time but she didn't want to know exactly when I'd be there.

Maybe the other couples who weren't privy to Natalie's request thought I was first to be selected. They might have observed me closely to determine my suitability for inclusion in some plan at a later time. I didn't know. All I know is every eye in the place was on me while I tried to remain calm and casual as I strolled by.

I struggled to hold onto my composure as a distinct warm throbbing sensation, emanating from deep in my middle region, took total control of my senses. The throbbing originated just above the interior side of my tailbone and traveled to the tip of my penis, where each palpitation ended in a fireworks-like starburst of sensations. The sensations created by each burst were even further enhanced when they exploded against the soft touch of silk. When I walked up the stairs of the staircase, my penis, sticky wet, bumped pendulously against my inner thigh with each step.

Natalie was reclining on the bench. Her naked form rested on a large dark cushion propped against the headboard. Blindfolded with an elaborately laced piece of fabric, her body shone in the glowing candlelight. Her wrists were bound above her head, fastened to the headboard, her legs unrestrained. Remaining stealthily silent, I stood transfixed by the visions and sounds of Natalie's gorgeous heaving body.

Her imagination must have been running wild. Her breathing was loud and urgent for several seconds at a time. Twice she squirmed as if to avoid someone's mouth about to suck her nipple. When I turned to retreat, I made a slight sound which belied my presence. Natalie made "Oh" sounds as though she were having an orgasm. A few moments of living in a real-life daydream and I had to leave. Why?

It was indeed very warm on the first floor. Warm and ever so much more quiet than when I departed a few minutes before. Jane was returning from her notification rounds when I rejoined our group. She told us there were eight people selected out of a total of 13 couples. All had consented and were willing to abide by the rules of conduct in the loft. Natalie, as it turned out, had selected five men and three women with which to make her fantasies come true. What an erotic sight they made as they quietly walked *en masse* from the pool area and up the main staircase! I wished I'd somehow been allowed to stay in the loft, over on the couches or somewhere, anywhere!

To say Eva was the most forward of the group of individuals in my company would be an understatement. She and Chaz were wine connoisseurs who delighted in expensive vintages. Eva was a little high, but only to a point of letting go her inhibitions before anyone else present on the first floor. Her scantily clad body was becoming progressively less covered as she draped her few items across the back of a rattan chair. "Come to the hot tub with me, anyone?" she asked without

a trace of modesty. I was the last of our party of seven to undress and immerse my body in the warm effervescent water.

Eva was responsible for starting the chain reaction of activity which followed. Four couples, two at a time, headed upstairs for the privacy of their quarters. One couple bared themselves and entered the pool. The four remaining couples graciously took into consideration the circumstances before them and yielded to the comforts of the great room.

Naturally the conversation centered around Natalie, her choices, and guesses about what she must have been experiencing at that precise moment. I didn't know about the other guys but our discussion had an intensely arousing effect on me. It became especially so while Jane disclosed details of her own personal encounters on the bench. Eva and Anne nodded their heads in agreement when Jane described the experience as a totally overwhelming and all-consuming sexual awakening. Both gestured their agreement once again when Jane said normal sexual intimacies where far more exciting since her discovery of how much carnal pleasure her body was capable of enjoying. I presumed, from their knowing looks, they too had the chance to have surrendered their sexual inhibitions on the bench.

Meanwhile, as Jane continued to relate her story, Raymond and Sandi, the couple in the pool, became unquestionably overtaken by the spirit of the evening. Raymond was sitting on the deck of the shallow end, his feet dangling in the water. Sandi, in plain view of all in the hot tub, shamelessly got into position between his legs to begin fellatio. She had no sooner started her act when a tall blonde woman walked onto the pool deck from the confines of the great room. She promptly peeled her clothing, jumped into the pool, and swam in the direction of Sandi and Raymond. In a few moments she also fellated Raymond from a position between his legs, immediately adjacent to Sandi. They passed his penis back and forth as though they were sharing a popsicle. Jane stopped talking. We sat in silence and watched, as my thoughts once again returned to Natalie and the bench.

We stayed in the hot tub until Jane excused herself and quickly returned with a stack of towels. "Come on, you guys," she said. "Let's go up to our bedroom." We followed Anne, Jane and Eva up the main staircase, through the doors, past the cast-iron staircase, and into the luxury of the master bedroom. Carl more or less guided David, Chaz and me to the couches and chairs which had been moved into the area.

While the guys made themselves comfortable, Eva and Jane placed their arms around Anne's waist and directed her to the bed. They eased her onto the bed, fluffed pillows under her head and lay down on either side of her. With Anne on her back, Eva placed her left leg over Anne's left thigh while Jane mirrored her actions on her right. Together they moved to spread Anne's legs wide open using

theirs, as they rubbed their smooth vulvas against her thighs. While Eva kissed and suckled her left nipple, Jane licked Anne's swollen areola in a circular motion, periodically pausing to suckle at her jutting right nipple. At the same time, their hands moved sensually over Anne's entire body, their fingers trailed over her breasts, her stomach, down onto her thighs, where they finally met between her outstretched limbs.

Eva was first to kiss Anne deeply and passionately on her mouth. Jane then took Eva's place before the three of them, together, licked and painted each other's mouths and lips with their tongues in a lustful three-way french kiss. I thought I could hear my heart thumping in my chest as I adjusted my towel to better conceal my erect and oozing penis. From that point on, everything which took place happened as if in slow motion.

Jane and Eva's fingers worked Anne into a frenzy. Jane shifted down between Anne's thighs and lowered her face, taking Eva's fingers away from Anne's center region. A few moments later I heard Jane's licking and lip-smacking sucking sounds as her tongue visibly swirled against Anne's hairless moist folds.

Eva rose from Anne's side, held onto the headboard with both hands, put her knees on either side of Anne's head and squatted, placing her vulva directly onto her waiting open mouth. Jane plunged her tongue in and out of Anne while at the same time Anne's tongue, in unison it seemed, slithered in and out of Eva's glistening pink void.

"Come for us, baby. Come! Please come for us," pleaded Eva as she bucked her hips against Anne's face to meet her darting tongue, her sucking mouth. Jane was now flagrantly lapping at Anne, whose entire body began to shiver and quake. Eva, sensing Anne's approaching orgasm, quickly dove to the bottom of the bed where she raised Anne's legs off the mattress to make room for herself beside Jane. Anne held her legs with her knees at the sides of her breasts and raised her head to watch as two mouths feverishly licked and sucked the very breath from her. At the precise moment Anne cried out in orgasmic ecstasy, I heard Natalie's own cries of passion coming from the upstairs loft.

Anne looked frazzled as she removed herself from the tangle of arms and legs on the bed. She sat at the edge to regain her composure while Eva and Jane kissed and licked clean each other's lips and mouth. It was Eva who was next to lie down in the pillows. Anne placed herself between Eva's legs while Jane rose to the headboard and more or less duplicated the scene Anne had just experienced.

Eva used her fingers to hold Jane's vagina open, which allowed her long, pointy, serpentine tongue to wriggle into Jane's exquisite depths in a less restricted fashion. She was as adroit in enjoying the taste of a woman's sex as she was ardently deft in providing fellatio. Eva was the first individual I'd ever known to be completely free of inhibition. Jane's sexual excretions coated Eva's tongue, then

her lips, and finally flowed out of Jane in such quantity as to completely cover her chin and cheeks.

"Go with Anne," she sobbed as she pushed Jane to position at Anne's side. Both women buried their faces between her spread legs. Their tongues licked in a swirling motion, their lips sucked, they kissed one another and much of Eva's exposed puffy inner lips at the same time. Then, with an loud guttural rasp, Eva chanted, "Eat me. Oh... eat me hard." When she sensed an approaching orgasm she got uncharacteristically nasty, I thought, screaming, "Ohhhh... so good. Eat me. Eat me. Eat my cunt!" She surprised me with that.

Bucking and gyrating uncontrollably as Jane and Anne continued to "eat her cunt," her cries seemed to inspire the group with Natalie, who could be clearly heard by us all.

Eva! She was insatiable. Her appetite for lesbian sex was voracious. She rode the waves of two prolonged body-flailing orgasms and she still couldn't get enough. It became obvious these three women had played sex games before tonight. Jane knew exactly what Eva asked for when she moaned, "Janie, please. NOW. Do me now."

Chaz, Carl and David seemed to take Eva's words as a cue for the next scene to begin. They stood, dropped their towels, and walked toward the women, who readjusted themselves on the bed. Eva lay very still in the center, breathing calmly for the first time since sitting down on the bed. Jane angled her upturned bottom toward one side of the bed but maintained full access to her focus of attention between Eva's spread thighs. Anne shifted to the same position on her side of the bed. Carl and David stepped behind their respective wives' upturned bottoms while Chaz kneeled beside Eva's head, making his penis available to her. I could only sit and stare in wonderment as Eva's hand encircled Chaz's stiff penis. She brought her head forward and pressed the purple shining head against her lips. She tasted him as the others watched in silence.

For me, it was like watching a play. In the next scenes, I watched everyone as they studied Eva in her phenomenally stimulating performance of oral sex.

"Mmmm..." she'd moan on the way up after she took Chaz's seven, maybe more, inches of wide turgid flesh all the way down to his pubic bone. Eva's enjoyment was visible and audible. The way she smacked, slurped, moaned, gurgled around it when it was in her throat, you could tell she worshipped Chaz's penis. Either she adored it or she was, in fact, an exceptional actress. I didn't know how Chaz could take it and restrain an orgasm at the same time.

By now, of course, I was ready to climb the walls. I never realized it could be possible but I had reached a point where I could no longer sustain an erection. My testicles felt swollen and even somewhat sore, tender. The fluid oozing from my flaccid penis flowed much more freely than when I had been erect. Each trickle

was like a mini-ejaculation which sent the same kinds of rushes up my spine I usually experienced at home, in my shower, ejaculating onto the floor. Nowhere near as intense as one of those orgasms, mind you, but definitely identical, and pleasurable to a point beyond description.

"Janie. Please baby." Eva managed to say around the deep purple glans at her lips. At that particular cue, it seemed, David and Carl began to slowly penetrate their wives from behind. Eva went back to swallowing Chaz while Jane and Anne began again to lick and kiss each other and whatever of Eva they could manage to suck in at the same time. From the upstairs loft, at least four people were raucously caught in the throes of either losing themselves completely or crying out in orgasmic bliss.

When Eva's mouth came all the way up on Chaz's shaft she sporadically paused to catch her breath and chant. She repeated, "Ohhhhhhh... cock! Mmmm... cock," several times before resuming her feat. I thought it a little weird, but I could understand her turn-on.

David and Carl's penises were buried in their wives to the hilt, but they weren't thrusting. They silently stood, one foot on the floor, the other on the bed, and firmly pushed their testicles against the moist velvety openings they were nuzzled against. Both were intently watching Jane and Anne as they kissed and sucked at Eva's middle.

"Oh Fuck me Janie. Please fuck me. Please Janie," panted Eva. I hadn't noticed, but Jane had been working her hand into Eva's vagina. Up until this time I had no idea she had been doing so. I couldn't really see anything until Jane and Anne raised their heads when Eva asked to be fucked. That's what the others were so intently preoccupied with. Now I understood.

"Oh Fuck... Fuuuuck... Fuuuuuuuuuuuuck," screamed Eva as Jane began to narrow the diameter of her hand, folding her thumb inside the four fingers already buried to the knuckles. Anne applied a thick layer of lubricant from a bottle on the nightstand onto the exposed remainder of Jane's slight hand before she gently traced the outline of Jane's closing hand with her fingers. Jane held her own hand still as Anne slipped her fingers along the side of her hand and into Eva. Anne continued to apply lubricant onto Eva's considerably swollen ring of flesh. Then she hooked her finger and painstakingly coaxed open the taut circle of muscle.

Eva's vaginal lips had become thick and bloated to the point of having turned red, blue and gray in color. The only time Eva wasn't yelling "cock," "fuck" or "cunt" was when Chaz's penis was too deep in her throat.

• **frenzy** A million things were going on in my head. Upstairs, downstairs, the guest accommodations, everywhere you could go in this home, was filled with the cries, even screams, associated with multi-partner

sexual activity. Despite having surrendered traditional sexual mores, I thought the individuals who indulged themselves in this fervent unorthodox sexual conduct did so in a very loving, gentle and sensitive fashion. To a person, they all seemed to put the pleasure of their partners above their own.

At the same moment Jane's hand was engulfed to the wrist by Eva's body, Chaz let out moans which signaled his impending orgasm. Carl and David began pumping their organs in and out of their wives, using the same rhythmic motion in which Eva was fellating Chaz. It was as if Jane's arm was the metronome everyone followed. One by one they worked themselves toward the common goal of simultaneously climaxing. Exactly like in the visions of my earlier fantasy, Jane partaking in multiple-partner sex, I saw six separate physical entities writhing in unison like one enormous undulating flesh-colored amoeba.

Eva implored Jane to fuck harder as Jane enthusiastically rocked her body back to meet Carl's now forceful thrusts. Her brow wrinkled heavily. Her body tensed as she threw her head back. I could hear the noises of Carl's penis slipping in and out of Jane's soaked vagina. Jane sobbed sighs which emphatically signaled her approaching climax. Her arm, deeply penetrating Eva's writhing body, started to quiver and shake. Anne, whimpering, pitched her body back to meet David's plunges as her mouth continued to suck greedily at Eva's upper folds of satiny flesh. David's head shot up to make him appear to be looking into the sky as he paused to deeply inhale cool air into his lungs. He looked as thought he was struggling to keep himself back from being first to come.

I'm not sure if it was Chaz or Eva who toppled over the edge first; I believe it was Eva because of how the blood-engorged fleshy circle of reddened muscle pulsed around Jane's wrist. Her stomach muscles tightened with each pulse, each flaring beat, as she frantically rubbed her clitoris with the fingers of her left hand. At the same time she just as frantically worked to swallow Chaz's penis whole. Her entire body heaved as Chaz held her head and pressed his fully lengthened organ all the way into her throat. Her body continued heaving while she purposely contracted and expanded her lips around the flesh of his pubic bone. Chaz practically folded in two as he cried out freely, shooting deep into Eva's throat with each convulsing surge of orgasm.

Jane, Anne, Carl and David's bodies exploded in simultaneous climax before Chaz had gotten over the final throes of his ejaculation. Eva had again set off a falling row of dominoes, it seemed. One after another, the six collapsed and crumpled onto the surface of the bed. Eva, still on her back with her legs against her chest, gripped and held Jane's arm still. Motionless and passive, they rested for a few minutes before everyone attended to separating Jane and Eva.

From the third-floor loft another tumultuous crescendo cut the stillness and echoed throughout the space around us. Natalie's familiar cries were the center

of my attention. She was crying out her delight, although her voice was muffled in a way that suggested she was performing oral sex at the same time she was being brought to orgasm through intercourse. I closed my eyes, sat back in the couch and listened to determine which sex Natalie might have been orally playing to.

The minute I closed my eyes, the mini-ejaculation feeling shot through my penis again. Each beat of my thumping heart now diminished the unpleasant and intense hurt in my pelvic region. The images I saw in my mind's eye were of Natalie, on her hands and knees, between the legs of voluptuous Brenda, the pierced brunette doll. Natalie's sounds seemed to come from behind clenched teeth as if she might have been pulling Brenda's clit ring back. A man's orgasmic cries were in sync with Natalie's, in time with the sounds of strong slapping thrusts. Brenda's cry was as if Natalie pulled her clit ring too far from her as she rocked back and forth to meet the penetration of the man on his knees behind her upturned bottom.

The hiss of a shower being turned on interrupted my lustfully creative musings. Jane and Eva stood in the stream of water for a minute, looking through the wall of glass separating them from the others. With David's encouragement, Carl and Chaz helped him to raise Anne's body onto the center of the bed. David caused me to cringe a little by lying between his wife's legs and going down on her. She instantly began to moan as if she would come again, and when Carl kissed and licked the nape of her neck, her earlobe, and wetly kissed his way to her breast, she did. At the same time, Chaz, who had been kissing and licking her breast opposite Carl, licked and kissed his way up to repeat Carl's attentions on his side of Anne. David held his wife wholly open with the fingers of both hands. There was no mistaking what he was up to: it was all over his tongue and lips.

It only took a minute or two. They had hardly laid her down when Anne cried out in a piercing blare which silenced everyone within earshot to the point that the only sound you could hear was that of the water hissing from behind the glass wall. Jane and Eva said something to one another, smiled, and went about soaping each other's back. Anne, David, Carl and Chaz paused to regain their composure, then joined Jane and Eva in a communal shower.

Feeling somewhat out of place in this post-orgasmic sexual atmosphere, I thought I'd to go back to the first floor and submerge my body in the hot tub. The available showers were now in demand throughout the house and I was kind of happy to see that. I was also pleased to see the pool area free of the sexual activity which had been going on earlier. I needed a break.

But I didn't get one for very long. At first I believed Eva and Jane must have also had the same urge to enjoy the soothing waters of the Spa. I thought so because, without hesitation, they headed in the direction of the hot tub as they walked onto the first floor. It wasn't the water they came for.

They entered the water, both pushed me up to sit at the side of the tub, then Eva started to swallow me into her throat while Jane held my face in her hands and kissed me on the mouth. I have yet to come as effortlessly as I did that night. She went down on me, paused, then, when I felt myself completely engulfed down to my pubic bone, I erupted. Jane sucked my tongue into her mouth as spasm after spasm propelled my sperm into the wet heat of Eva's heaving throat. "Mmmmmm," she moaned while finally finishing me with her hand, my glans just inside her lips, her tongue swirling in clockwise then counterclockwise sweeps. She didn't leave a trace.

"I hope you feel better, darling," said Eva and casually stood up, as if nothing had happened, and left the hot tub in favor of a swim.

Jane pulled me back into the water and stayed beside me, her arm on my shoulder, her fingers raking my hair back from my face. Her naked flesh sent tingles of pleasure through the skin where her body touched mine. Her breast, stirred by the bubbling jets, brushed the side of my chest. When she held my penis in her hand, I quickly found myself fully erect, as though I hadn't subsided at all.

"Come with me, Josef," she whispered in my ear. I was dumbfounded. I couldn't do anything but take Jane's hand when she stood and offered it to me. I got out of the Spa, grabbed my towel and submitted totally to Jane's lead.

"Let's go rinse the chlorine off," she said, ushering me up the staircase back toward the second floor. Carl, Chaz, David and Anne were at the top of the stairs, about to come down, before we were halfway up. I wondered for a split second how Carl would react to the sight of his naked wife leading me to his bedroom.

Jane stopped, let the others find their way down, momentarily leaving us alone with Carl. "If I manage to get back before you've left, may I come to the bedroom?" he asked looking to us both for an answer. Jane turned to me with a questioning look. Astounded by their unconstrained manner, "yes" was all I could say, all I wanted to say.

Jane and I decided on a sauna until the last of the guests had finished showering. We took turns massaging one another's shoulder muscles and chatted about Eva's recently acquired insatiable appetite for fisting. We rinsed off the chlorine, as Jane had suggested, and dried ourselves at the wall-mounted hot air blowers. Jane quickly walked out into the alcove to close the suite's double doors before again taking my hand, this time guiding me to the bedroom portion of the room.

We sat on the couch closest to the bed and continued our sexually stirring chat. Jane asked me to describe my recollections of the interaction between the three couples that I'd just witnessed. She listened intently as I tried to describe not only what I saw, but how responsively my body had reacted to the visions as I took

them in. Her wrist being gripped by Eva is a mental image I'll never forget – and never fail to be turned on by.

Jane was becoming overtly titillated and dwelt on my every word as I described her hand invasion of Eva. She stopped to ask if I would please lie on the bed to continue my story. I sat on the edge of the bed while Jane stretched out on the couch, leaned her back against the soft arm cushion, and crossed one ankle over the other. Listening intently while gazing straight into my eyes, her hand rose to her breast to roll her swollen nipple between her thumb, fore, and middle fingers. When her other hand moved to the sensitive area between her legs, I lay down and continued my narration while Jane skillfully brought pleasure to herself. We were abruptly interrupted by the sound of the opening double doors.

"Hi guys. Hope you don't mind me crashing your party. Carl did say I'd find you here," said Natalie in an unexpectedly upbeat manner. She looked ravishing, full of energy… not at all like you'd expect a person who had just had sex with eight people to look.

"Wow! I walked in on something, didn't I? Oh, I did," she asked and answered herself.

Jane stood up from the sofa, took Natalie's hand and attempted to draw her to the side of the bed. Unexpectedly, Natalie resisted. Instead, Natalie took control of the circumstances. She pulled Jane's arm quickly toward her. The maneuver caused Jane to spin on one foot and to be thrown directly into Natalie's open and waiting arms. Natalie and Jane were eye to eye, their naked bodies tightly against each other, almost as if they were dancing.

Just as suddenly as Jane found herself in her arms, Natalie's mouth was at her lips. Up until this point Natalie had remained upbeat and playful, now she turned serious in her passion. Her long slender tongue unhurriedly licked at the line separating Jane's lips as if she were performing oral sex at her nether fringes. Her arms were holding Jane firmly against her while she kneaded the hard flesh of her buttocks. When Jane reacted by sucking Natalie's tongue in and out of her mouth, as if feigning fellatio, they moved together toward the open side of the king size bed. Natalie stood at the side, pulled down on Jane's shoulders from behind, and laid her in the middle of the cool linen bed covering and pillows.

I could feel the heat from Jane's body between us as Natalie leaned over her to kiss me. She sucked my tongue into her mouth and practically used it like a leash to bring me to Jane's face where we met in a three-way kiss. Actually, the kissing was more like a three-way licking and sucking of tongues, lips and ears. Then slowly, deliberately slowly, Natalie kissed her way down Jane's neck and lowered her lips over her breast. Her cheeks hollowed as she drew Jane's hardened nipple into her mouth. Taking Natalie's lead, I descended onto Jane's other breast.

Our hands met between Jane's thighs before Natalie began slowly, more or less tentatively, to kiss her way down to where our hands were.

My most remarkable memories of the weekend are of how aroused I was capable of becoming. Each period of arousal, over the course of the weekend, was more intense than the previous level. This time I was as close to being out of my head, as the cliché goes, as I thought possible. The sexual energies were so intense, so abundantly potent, I closed my eyes and saw myself floating while weightlessly tumbling through space. With each sound, each texture, each fragrance, I remember wondering how anyone could deny themselves such lush pleasure for the sake of something called monogamy.

Natalie looked lost as she marveled in Jane. Her damp probing lips shimmered in the candlelight when she occasionally paused to study Jane's face. I kissed and licked my way down Jane's body toward her belly, to be met with Natalie's sultry kisses on my mouth. Influenced by what I had seen earlier, when Jane and Dianne simultaneously went down on Eva, I shifted my body down the bed and nestled in beside Natalie. Our tongues and lips then greedily competed in bringing Jane to orgasm.

Once Jane had come down from the heights we were able to take her to, I thought Natalie would have had enough of performing orally. I was wrong. The experience was, she told me later, a personal exploration of her sexual boundaries – and Natalie wasn't letting this opportunity go by. Jane was her first. She plainly hadn't had enough.

I stretched out and lay on my side beside Jane's warm body, just above Natalie's face, and watched as she licked and suckled Jane's bulging pinkness. Jane made soft whimpering sounds as I trailed my fingers lightly down from her face to Natalie's, stopping on the way to caress and kiss her sensitive breasts. When I continued down, Natalie opened her eyes to stare directly into mine. She never let up on the wet flicking sounds her tongue made as she strove to coax yet another climax from Jane. My fingers outlined the corner of her lips, her ears, her entire face, as she licked. I leaned toward her and kissed her face from the temple and then down to her ear. She responded to my soft breathy kisses by rising to her hands and knees while she continued to work feverishly between Jane's legs. The way she positioned her bottom in the air I knew exactly what she wanted from me.

Natalie cries were muffled in the wetness of Jane's sweet musky flesh, as I penetrated her from behind. My own desires seemed secondary to the act I participated in. I wanted nothing but to provide Jane and Natalie with the ability to live, even if only for a few minutes, within the bounds of their fantasy worlds. At that moment I wanted only to provide for their every sexual desire.

With my eyes closed, I was overwhelmed by that weightless tumbling sensation again. I felt as though my the tip of my penis was really Natalie's flicking tongue, as if Natalie wasn't between Jane and me at all. I imagined having an orgasm. Spasm after spasm would send my semen up the shaft of my penis, through Natalie's body to spurt out the imaginary tongue and into Jane's trembling body.

Reality slowly came back into perspective when I opened my eyes to see Jane rolling her head from side to side on the pillow, gasping for breath. There wasn't, needless to say, a tongue at the end of my penis. Natalie's sudden urgent rocking movements plunged my penis to the limit of her quaking heat, then withdrew until I almost left her body, and then threw herself back at me one final time. Her mouth left Jane as she too cried out while gasping for her breath. Her vagina clenched and relaxed in such powerful pulses that, in essence, she totally milked me of all remaining vestiges of my orgasm.

We didn't collapse on the bed. It was the strangest feeling. Instead, we seemed to catch ourselves in the light of our present time and space. Natalie glanced over her shoulder at me while swinging her leg over Jane's body to sit on the bed and simply look at us. Jane drew her legs toward her and folded them under her as she sat gazing back and forth into our eyes from the base of the headboard. I remained on my knees.

My soaking penis had remained practically erect despite the fact that only moments before I had achieved a tremendously intense and gratifying orgasm. Powerful feelings of freedom, which seemed somehow to merge with the earlier sensations of tumbling weightlessly through space, made me feel as though I could have sustained my level of energy far into the light of morning. Oh how I wanted to!

I really don't know how long I stayed on my knees before Natalie, her eyes fixed on my penis, reached out and rolled my testicles in her hand. Jane leaned toward me, gripped my penis down where the shaft meets the body, and brought my glans to her lips. I watched as she looked up into my eyes. I somehow ended up on my back, Jane between my legs going down on me, while Natalie lay holding her face over mine, covering my mouth with licking wet kisses. I closed my eyes and surrendered to the now-familiar floating sensations.

To this day, I don't know if Carl had been sitting silently observing us as we played or not. Feeling a presence enter our space, I quickly opened my eyes to catch a glimpse of Carl raising Jane's hips toward him at the base of the bed. As he wholly entered Jane in one fluid motion, she let out the unmistakable sounds one could only associate with a woman receiving immense pleasure. The head of my penis vibrated with a certain frequency, a certain note of the throaty tones she made, as she held me in her mouth. Again, I closed my eyes and floated away as blood surged into my erectile tissues.

Carl's way with Jane was enthralling. He would slowly and deliberately push himself into her and hold her tightly against him. Carl repeated this about ten times while Jane very calmly suckled on just the head of my penis. Then, for the next ten or twelve thrusts, he very forcibly slammed toward her to practically impale her on his penis. During these spells, Jane would force her throat to open to accept me.

On each thrust of her mouth, with each of Carl's stabbing lunges, her cries grew louder, vibrating through my glans. The sounds would start when just the glans was in her mouth and continue until Jane was silenced when the head of my penis met her throat muscles. She paused and pushed, which forced her throat to open to accept all of me. Her entire body heaved without so much as a wisp of air escaping through her lips before my penis slid completely into her throat.

Jane's body heaved three or four times before she came up to the point in her throat where making sounds was possible again. She rested by suckling and responding gently to Carl's gentle probing pushes, but grew increasingly loud and eager to swallow me whole with each of Carl's successive pummeling spells. I looked forward to the suckling breaks because I selfishly wanted this pre-orgasmic state to last as long as possible. I was on the verge of stepping over the edge every time Jane took me deeply into her mouth.

With the next plunge into Jane's throat, just as I thought it was all over, Carl gently eased into her on his next thrust. Jane suckled as Natalie rose from her position, stood right up on the bed, placed her legs on either side of my body, and squatted, suspending her vagina immediately above my mouth. This shook me a little. I thought of how I cringed when I saw David go down on Anne after filling her vagina with his semen. Very tentatively, I licked her flared lips at the same time Jane clenched my penis in her hand and started sliding her mouth and hand, in unison, methodically up and down my length.

Jane knew exactly when to stop. Each time I thought I'd come with her next action, she stopped to simply hold my glans between her lips. Carl must have chosen to watch Jane because he stayed still in her for the longest time as she repeatedly brought me to the brink, then stayed still and just suckled: the calm before the storm.

Eventually, Carl resumed his forceful lunges into Jane. I started to feel as though I had departed my body altogether, as though I had no control or influence on what was happening whatsoever. Carl began to make the sounds of a man about to spill his seed as Jane, not to be denied, opened and opened until I was entirely engulfed by her throat. When I felt the tingling sensations signaling the first spasms of orgasm, my hands opened Natalie and I kissed and licked her without premeditation. It was an automatic response. I didn't think about my

actions at all. At that particular moment in time I wanted nothing more than for Natalie to come over the edge with us. I would have done anything to include her.

Carl cried out just a second or two before Jane's body convulsed in orgasm. She didn't pull away from me. Instead she continued to wholly swallow me. When my first surge splashed into Jane's throat, my mouth filled with my own semen oozing out of Natalie's convulsing center. With her every orgasmic spasm, more and more of my semen spilled out of her directly into my accepting mouth.

Each time Carl forcefully, almost savagely, plunged himself into Jane, she responded with gulping movements in her throat as if she were drinking my cum. With each surge of semen into Jane, I reacted by spreading Natalie, placing my mouth entirely over her vagina, and pulling her sensitive fleshy petals into my mouth. I reveled, no, wallowed, in the all-consuming ecstasy of ejaculation while weightlessly tumbling through space as I savored the essence of my own life.

For the first time in my existence, I felt total sexual realization, a sense of being positively satiated. Together, Jane, Natalie and Carl collapsed onto the bed. My arms folded around Natalie. I held her body close against mine as we soulfully kissed each other's panting mouths.

I don't have any idea how long the four of us had carried on. About all I remember, at that point, is looking out the window to see the sky in the east, beyond Toronto, turning blue. Natalie and I fell asleep, our arms and legs intertwined.

The hissing sound of water slowly crept into my consciousness to awaken me. I opened my eyes to the sight of Natalie soaping her body while standing just away from the stream of water in the shower. She was oblivious to the fact she was being watched. A sadness crossed over me. We would very soon be going our separate ways. I didn't want to lose her.

• **bliss** In the several months since Jane and Carl's house party, Natalie and I have grown inseparable in the time we have available. Either Natalie visits me or I drive a couple of hours north of Toronto to spend time at her apartment on weekends. Long weekends are especially rewarding. The miles between us make things difficult but we make up for them in our time together.

The first time I drove up to stay at Natalie's for a weekend, despite the circumstances under which we met, we did the things two people getting to know one another would typically do. A walk, a bite to eat, a movie, followed by a late dinner and yet another walk filled with getting-to-know-you conversation. She seems so wholesome!

Natalie lives, and had lived, her life with her little secret. None of her friends know. She's absolutely discreet with her sexuality. We share that one special

secret. Natalie and I visit couples-only night on a monthly basis. The experience of a couples-only environment is far superior to the singles nights I was accustomed to. Now that I know the difference, it's calmer, not as competitively frenzied an atmosphere as singles night often seemed.

We haven't had any real chance to attend any large parties since Carl and Jane's. I'm not quite sure how we would react to an invitation at the home of someone new. We believe the experience at Jane and Carl's was so perfect that anything else would take away from the impeccable memories of the weekend we met.

That's not to say we're born-again traditionalists or anything such. Natalie and I have cruise reservations for her club's annual Caribbean Cruise event. We've also become fascinated with the notion of spending a week with 70 to 80 other couples at a lifestyle resort in the Dominican Republic.

I'm sure we'll continue to explore our rich fantasy lives in our future days together. Natalie's friend Dianne mentioned she couldn't wait for next year's celebration at Carl and Jane's. It will be our first party as a couple.

As the weeks pass, I feel more and more connected to Natalie. She's become a person I feel I've known all my life. It's like she's always been a part of me. I live most of my days knowing, inside, that I've fallen for her. Natalie's strong and caring sensitivity strongly suggests she might feel the same way about me.

Here's to the future!

breaking the ice

How do couples break the ice? After all, initiating a conversation about sexual desires outside of a conventional marriage can be interpreted as a terribly destructive message. To some men and women, hearing a lover talk in these terms can be a traumatic, relationship-damaging event. Even if both partners turn out to be receptive to the idea of fantasy exploration, there exists the common fear that opening up a dialogue may be heard as, "I don't love you any more," or "You don't turn me on like before."

It's imperative that you be in a loving, trusting and mature relationship prior to entering into any discussions dealing with the subject of fantasy sex. Do you love your partner, or are you coming into this lifestyle with the hopes of saving your relationship? Many do come with hopes of saving a faltering marriage. They, unfortunately, find out the hard way. If you're not in love with your partner... forget it! This is not an activity for you.

Either love your partner without condition, or find a partner you can. Being in love is the most common denominator among successful members of any lifestyle community. Strange as it may seem to some, the members of this particular lifestyle are truly in love with one another. According to them, not only has the recreational sex lifestyle been responsible for removing negative dynamics surrounding issues of power and jealousy, but it's also helped them to see their lovers as individuals, not as possessions.

With very few exceptions, new couples are surprised to learn that the rules which govern traditional lifestyles are more strictly and honestly adhered to by the members of the recreational sex community than they had expected. Many will tell you recreational sex supports rather than disrupts so-called *monogamous* relationships as they exist in today's society.

How do couples justify detaching from the conventional moral values of traditional marriages? Generally, swingers view the sharing of sexual intimacies as

a recreation. The recreational sex lifestyle does not interfere with any of the basic values of traditional marriages. It only infringes on the issues surrounding sexual exclusivity.

• **sharing fantasies** How have people introduced this sensitive, often hard to discuss subject?

Reesha & Arty. One of the most erotic occasions in my personal experience was the very first time the subject of another person or other people joining us in our bed was discussed. Over the course of our years together we have always been very orally expressive. It seems natural now, looking back, during an evening while taking turns expressing ourselves in oral terms, I looked up into Reesha's eyes and asked, "Have you ever imagined two tongues licking you like this, both at the same time?" Reesha just cooed and closed her eyes as I showed her what *"like this"* was all about.

Asking that simple question, and continuing my attentions, certainly must have given her something to think about... because a little later she looked up into my eyes and made a statement of her own.

While I watched Reesha fill her mouth with me, our eyes locked. Reesha stopped for a few seconds and said, "I'd like to pass this back and forth as though it was an ice cream cone I was sharing with someone... like this." Then Reesha talked me through what "like this" was all about.

Laying and cuddling in the afterglow, we expanded on our thoughts as they pertained to others joining us in our lovemaking. It was such a turn-on we ended up making love a second time. That was the first time we flirted with these lifestyle ideas.

Marny & Lee. Lee says, "Marny and I were sitting in an outdoor cafe on one of those sticky summer nights, you know the kind we get here. We were enjoying a cool Caesar salad and a little red wine when I suggested that Marny play a game with me. I would try to pick out people that I thought Marny would be sexually attracted to. Marny told me later that what turned her on more than anything else was watching me eyeing guys.

"Can you imagine the hours of conversation made possible by those few minutes of playing a simple game like this?

"We had been together as a couple in a committed relationship for three years and this was our first step into the lifestyle. We didn't know it was our first step, but looking back, we agree this game opened the exchange of ideas which ultimately lead us to sexual experiences with multiple partners."

Marny says, "I remember that night, and yes, I was turned on seeing Lee eyeing guys, trying to pick out guys that I found attractive. I would have thought, back then, that most guys who bring up the subject of fantasy sex want to find themselves in a threesome with two women. This, I thought, was kind of a change from the norm. I saw Lee watching guys and got turned on at the thought of my Lee, another hunk of a guy, and me in a threesome.

"Later that night, after we enjoyed a very memorable evening of sexual play, I guess I sort of got carried away with these threesome thoughts. I told Lee of how turned on I became when I thought about not only being in bed with two guys, but, two guys who were going down on each other in a hot 69 while I held them both in my hands. Lee told me that if I was willing to go down on another woman, he would go down on another guy. Years went by and all we ever did was talk about our threesome fantasies. We've been tempted on numerous occasions but have never met what we would consider a perfect couple. We crave meeting a couple one day who are untouched by swinging, novices who think like we do, before we'd ever make a move from fantasy to reality."

Joanie and Peter. Joanie says, "I believe we more or less tripped across the idea of swinging. Peter is the most unselfish, giving, imaginative lover I've ever had. I lost my virginity when I was seventeen and had at least twelve or fifteen flings before I met my first husband.

"Marriage was something I grew to despise, and it wasn't very long after I married I started having sexual flings with guys I'd meet. My actions were directly attributable to the lack of attention, abuse, and all the rest of the crap I was getting at home. Nobody could have made me believe that I'd be single after only two years of marriage. To be exact, it was 25 months, three weeks and two days until we parted company.

"I'm getting a little off the track here in trying to tell you that I know the difference between a sex partner and an imaginative, sensitive, caring lover. Life with Peter, right from the first day we met, has been what can only be described as exciting and fun. I guess I was the one who had the idea of a threesome first, but I didn't dare say anything as I didn't want to risk damaging our relationship by saying what I was feeling.

"Despite my many sexual adventures, having sex with multiple partners never even crossed my mind until the night that changed us both. It was the night we celebrated our first year together. A romantic candlelight dinner, a roaring fire, Dom Perignon champagne... it was so good. But I had no idea of how good dessert was to be.

"Peter asked if he could tie my wrists and ankles to the corners of our bed. Never having experienced bondage, and being the adventurous person I am, I

readily agreed. What happened next came as a complete surprise. Peter tied a soft black velvet blindfold over my eyes and then seemed to vanish. Except for the crackling of the fire, off in the other room, there wasn't a sound to be heard. I don't know how much time went by until, for just a brief second, I felt something soft brush against my breast. A minute or two later I felt Peter quickly lick the inside of my thigh. Then again, silence, nothing but the crackling of the fire.

"This theme was repeated over and over again, a hand, a finger, a tongue, I didn't know what sensation I'd feel at the next touch. I wasn't even absolutely certain that Peter was alone with me. I could feel him between my spread legs. At least I thought it was Peter. In one sudden thrust, he pushed his penis into my wet pussy, and, just as suddenly, he was gone. Two or three minutes later, I felt his penis, still wet with my pussy, brush lightly against my lips, but just as I opened my mouth to accept it, gone again.

"My mind was reeling. Was Peter alone? Was someone staring at me? There was an unfamiliar hardness pressing at my dripping pussy. I moaned as a hard slick object was gently inserted. It didn't take me long to guess it was a sex toy, a long wide vibrating dildo. Again I felt his penis brush against my lips but this time, when I opened my mouth to accept, it wasn't taken away from me. Oh... it was so good. I could go on telling you the story for hours.

"Anyway, I wish I could have seen my face when the blindfold finally came off. The sun was up and neither of us had climaxed. Finally freed, we wrapped our arms and legs around one another and I experienced the most memorable, slow and sensuous lovemaking experience of my life. We melted into sleep and stayed in bed until late in the afternoon. I can remember how Peter laughed when I told him that I felt as though, just that morning, I had finally lost my virginity.

"That evening of lust was the main topic of conversation for many evening to follow. I told Peter of how I thought that there were two people touching and licking me. He asked me if I had ever had more than one sex partner at once. When I said no, he asked if I'd ever thought that I would like to. I lied, telling him that I'd never had that thought. Maybe I was afraid of Peter thinking I was a slut for thinking of having sex with more than one person at a time. Although our sex life remained the best I'd ever known, my lie seemed to have put a wall between us, and it wasn't until a few months later I admitted my lie. Once I did, I realized the wall existed only for me and to talk honestly was to take that wall down, brick by brick. That was our turning point."

Nancy and Jay. Nancy says, "I remember, as if any one of us could possibly ever forget, the only time my husband Jay and I had sex with another couple. Mark and Donna are our closest and dearest friends of more than 25 years. The four of us had always been intimately involved with each other's lives since early

high school days, and I must say, they're the only couple we know who are just as in love with one another as Jay and I are.

"On the weekend in question, Donna arranged an intimate dinner party for just the four of us to celebrate Mark's news of a major career promotion. As they lived in another town, we took an overnight bag and planned to spend the night as was usual for us. Mark's promotion included a transfer to the west coast… so the dinner part of the evening was happy, but at the same time there were hints of a slightly sad goodbye.

"After Donna's superb dinner the four of us lounged in the living room reliving some of the happy times we shared not only between us, but the good times with our parents, our children, the friendships that came and went. Donna and I weren't alone when we had tears in our eyes as we recalled some of both our happiest and most heartbreaking memories in common: seeing our kids grow up, the death of Donna's mom, the untimely departure of her oldest sister, our wedding days, the birthdays of our youngsters. Twenty-five years held memories of more love and caring than I've ever heard of four people sharing. I'm convinced that it was the love we shared which made the evening unfold in the way it did.

"When we eventually said goodnight and retired to the guest bedroom, I certainly would never have guessed Mark and Donna would be waking up in the same bed Jay and I were to finally fall asleep in. That's just the way it was. As far as spelling out every intimate detail, use your imagination, I'll never become well spoken enough to even attempt putting into words the beauty of what took place. What we shared that night was not lust, but rather pure unconditional love."

• **personal ads** For many years, countless numbers of couples have lived out sexual fantasies by locating like-minded couples through either answering an advertisement or placing their own ads in a couples-seeking-couples publication. Swing clubs and organizations offer little appeal to individuals wishing to remain altogether discreet about this aspect of their sexuality. Specific estimates of the actual numbers of men and women who have met through placing or answering an ad will forever remain unknown.

The next time you visit your local bookstore, one with an adults-only section, take a firsthand look at the kinds of magazines offered. You will more than likely find at least a half dozen publications dedicated to issues surrounding recreational sex. Select one that is pertinent to your geographical area and take it home. As you work your way through some of the personal advertisements you will see ads representing the entire fantasy spectrum. First-timers, "soft swingers," voyeurs, exhibitionists seeking voyeurs, bi men, bi women, bi couples, all the way through to hard-core swingers.

A number of publications publish pictures of couples together with their text ads. These are favored by many readers: we all know what we like from a visual standpoint, now it's just a case of motivating a visually appealing advertiser by sending them a photograph which may entice them into a first meeting. A favorable reply obviously indicates physical compatibility.

You may come across an ad or two that you feel you'd like to respond to. Talk with your lover, and if you both agree, respond. Sending someone a note to find out more about them doesn't mean you're sending out an open invitation. You can always change your mind. Who needs the levels of frustration you might experience if you don't at least follow through on a thought, on a desire? Following through may do nothing more than draw you into openly and honestly discussing your most intimate sexual fantasies.

Once you have read through some of the ads contained in one of the many swingers' publications available, you should be able to compose your own personal ad. This can be a very erotically stimulating event which will likely lead to an evening of outstanding sexual intimacies. Visualize an evening with your lover, a romantic candlelit dinner, a glass of vintage wine. Imagine being a participant in an tender dinner discussion to examine how best to compose your personal "couple seeking" ad. After dinner, write your own versions of ads you believe one another would find interesting. I guarantee your sexual batteries will very soon become overcharged.

Placing your own ad has advantages over answering ads. Many new couples are intimidated at even the thought of sending their pictures and phone number to a total stranger. Placing, rather than responding, is just one way to overcome this specific apprehension.

The ad you write should be sincere, honest and to the point. Most effective ads are in the range of a total of 50 words. The following examples of well-written genuine ads are shown as they appeared in various swing magazines.

Very attractive couple, 30s, seeking bi female or select couples for sensual encounter. We are anxious to find special partner(s) for our first-time experience. We are professional types and we are both very fit and athletic. No single men please.

Attractive couple, 43, non-smokers, social drinkers, easygoing, enjoy life. Seeking couple for same-room activities without swapping. Enjoy nudity, lingerie, toys, movies and especially massage leading to watching and being watched. Long term friendship important. Couples with children welcome to our rural retreat. Can travel within reason or entertain.

Married white couple. She 5'1," 110lbs, 33, very attractive, classy lady, dark brown hair, nice figure and squeaky clean. She enjoys stockings, garters, heels, and providing oral pleasure. Seek two attractive, well hung would be a treat, black males for some good fun. He 43, 5'7," 150lbs, will participate. Photo appreciated and returned with SASE. Will travel.

First ad. Classy white couple, both very attractive. She early 40's, brunette, 5'8," 125lbs, excellent body shape, very hot and horny. He late 30's, 6', 200lbs, physically fit, always horny. Both straight. Enjoy oral, toys, movies. Very discreet and clean. Seeking friendly couples 30-45 of similar description to share erotic encounters with right couple. No pressure, no drugs. Social drinkers and smokers okay. Meet socially first. Send photo and reply.

Happily married couple, both bi curious, smokers, light drinkers. She 29, 5'2," 116lbs, brown hair, eyes, nicely built. He 36, 6', 180lbs, blue eyes, the greyish look, 7" without a doubt. Looking for clean couple, age (19+) not important, nor race. Photo will get replies, photo need not be nude. Absolute discretion.

As in these examples, never include a home address or your telephone number in print advertising. Think, for only an instant, about what could happen as a result of such information finding its way into the wrong hands. Mailboxes are available in many drugstores, shopping malls and quick print shops, as well as in the post office. Rent one. Just because you are honest and sincere doesn't mean everyone is.

Many publications have a system in place by which your identity is held in confidence. Your ad will more than likely carry a code number identifying you to the publisher, who will then forward replies to you. You can be assured your identity will remain confidential with leading magazines.

Don't be surprised at meeting real people, folks who look and think just like you or your next door neighbor. Keep in mind that everyone is new to the lifestyle at some point – the other couple may or may not be as new as you, but they certainly were once!

a fantasy fulfilled:
alex and samantha

For many years my husband and I have fantasized about inviting another woman to share our most intimate times with us. Although we've discussed our fantasy frequently, I've always been reluctant because I didn't know if I could watch my own husband having sex with another woman without becoming fiercely and destructively jealous.

One day, after many months of discussion, I decided to secretly place a personal ad in the publication that Alex sometimes brought home. It took a couple of weeks before I started to receive a few responses. Judging from the snapshots accompanying the short notes and letters, I thought we would forever be destined to do nothing but talk about the subject. There is no way I'd have anything to do with any of the women who responded to my ad. Just as I made up my mind that my advertising efforts had been fruitless, I received a response from a young woman whose picture restored my faith in advertising. I quickly read the woman's letter, picked up the telephone, and called the number she had given.

We had an interesting, not to mention sexually stimulating, conversation for more than an hour. It became clear, from an intellectual perspective, that this was one bright woman. As we chatted she quite capably drew emotions and feelings out of me until I found myself admitting my secret desires to make love to a woman. I made a date with Lori to come over and finally make my utmost fantasy a reality.

I didn't tell Alex about my plans. Instead, I waited right up until the day Lori was expected to visit. When Alex phoned on his break that day, I told him about the ad I had secretly placed, and that I'd made a date with a woman who looked and sounded like someone he and I would love to meet. It was easy to hear in his voice, and by the way he was breathing, he was rapidly becoming very aroused by the idea of what I had arranged.

Lori was supposed to come over around eight, and as I prepared our apartment for company I couldn't believe how the anticipation of what may happen made me shiver. At five-thirty Alex called again to tell me of an unforeseen situation at work. He wouldn't be able to come home until at least nine o'clock. I told him it wasn't a problem and that I felt comfortable enough to entertain Lori until he got home. After putting the finishing touches on our apartment I showered and dressed myself in a pair of new jeans and a body-hugging top.

• **womanliness** When the doorbell rang promptly at eight, I was a bit surprised by my nervousness as I opened the door. There was no reason to have been as jittery as I was – Lori was warm, gentle and altogether composed. The picture she had sent us showed an attractive woman, but in person she was breathtakingly beautiful.

When I welcomed her to come inside, my voice sounded shaky and nervous as I looked into her eyes. Again I had to control my feelings, admitting this time that I was indeed nervous... after all, here was a beautiful woman who wanted to have sex with a man and his wife. This so turned me on that I could only look on in admiration and with a burning need to provide her the means by which she could live out her desires.

Lori was gorgeous in her tight black jeans, suede cowboy boots, and a brilliant red silk T-shirt. A heavy gold, ruby-encrusted necklace adorned her long sensuous neck. Rubies dangled from her pierced earlobes. As she walked into the apartment, admiring it, I found I couldn't keep my eyes off of her silk top with her protruding nipples rising in it. After mixing a couple of vodka tonics, we sipped at them as our conversation slowly turned into a discussion about our secret sexual needs and desires. She was more than a little surprised to discover my husband Alex was one of only two lovers in my lifetime.

"You mean you've never ever even so much as lovingly hugged a woman before?" she asked in disbelief. I shyly shook my head, confirming her thought. "Oh, you're sweet," she cooed. Our eyes locked, a twinkle in hers. Smiling broadly she put her drink down and took mine from my hand. Seductively licking her lips, she leaned toward me and kissed my mouth. Lori was sweet-smelling, sweet-tasting and delicate as our tongues touched within our open mouths. All I could manage was a sigh as I responded freely.

I started to feel like I was an actress playing the lead role in a "love at first sight" movie. We put our arms around each other, her soft breasts rubbing against mine. I ran my hands slowly and softly up her arms and then gently cupped her breasts, my fingers spread wide. I was amazed at their softness, at the full, firm, pliant lushness. Our lips still locked together, tongues swirling in and out of our mouths, we urgently helped one another remove our tops and jeans.

I can barely remember what happened next, except before I knew it, I was tenderly pinching and twisting Lori's nipples, watching with excitement as they grew bigger and harder. From this point on I started to feel confident and sure of myself in this unfamiliar situation. Oddly, it seemed, there weren't any feelings of unfamiliarity on my part. Lori made me feel as though I had been making love to women all of my life.

Lori leaned over to tongue my breast. I moaned out loud in ecstasy and drew her face closer to my body. We both fell back on the couch and she ended up lying on top of me, rubbing her exquisitely supple body softly against mine. Then she sat up and leaned back away from me, displaying her body in an incredibly suggestive way, her breasts triumphant on her slender, well-defined torso. Lori was presenting herself to be explored and fondled. I affectionately placed my hands under the heaviness of her breasts and moved my face towards them, sucking one nipple while squeezing the other gently between my wet thumb and forefinger.

"Ooooooh," she whispered, "you make me feel so good." We eagerly helped each other slip off our panties, my hands feeling their way over Lori's hips and thighs, all the while wondering if this is what Alex feels when he undresses me and traces my curves with his hands. Her pussy, covered with soft silky red hair, looked so inviting I leaned over and kissed it wantonly while wriggling a finger between her swollen labia. She grinned as she gazed down at me and asked, "You like this, don't you?" I responded, "Oh, Lori, I love this."

We kissed again, but even more passionately this time, rubbing thighs, bellies, and mounds together as our mouths sucked each other's breath away. As if we shared one mind, we simultaneously got up from the couch and walked toward my bedroom, our arms encircled around each other.

Lori sat me down on the edge of my bed and took her breasts in her hands and pushed them towards my mouth. I had never felt so turned on as I squeezed and stroked Lori's soft, silky flesh. I clasped her thigh between my legs and rubbed my pussy against her knee. I started to shiver and have orgasms, small ones, over and over, while I was moaning, totally consumed by pleasure. When I had licked her nipples, she took her breasts away from my mouth, pushed me back onto the bed and lay down next to me.

She rolled over onto her stomach and asked me to skim across her bum with only my fingernails. I did as she asked and loved the way she wriggled beneath my touch. "Put your hands underneath me and rub my clit," she asked. She moaned and pushed herself against my exploring fingers. When I looked up I saw that my husband suddenly standing in the doorway watching us. Lori and I were so absorbed in our lovemaking that we had forgotten about Alex altogether.

• alex's arrival

Talk about an extremely awkward moment! I didn't know what to say. Then I looked down at our bed. Lori and I must have made a delicious sight. She had her firm round ass up in the air, and I had rolled over onto my back and was lying with my legs spread wide open.

"Hi," Lori said, smiling at Alex. She didn't skip a beat. Lori slipped a finger into my wetness and said to Alex, "Your wife is a doll, why don't you take your clothes off and watch us for a while?" Alex answered her by starting to take his clothing off, not once taking his eyes off of our naked bodies.

I moved my hand down to Lori's fingers to encourage her further penetration. It quickly became obvious she had something else in her pretty little head. She moved up to my face licking my mouth, moving from my mouth to my throat, shoulders, all the while sucking, licking, and teasing. She finally moved to my breasts, where she centered her oral attentions on my nipples. My hand gently persuaded her head down along my body. She put her fingers on my lips, and I kissed and sucked them in a frenzied manner as her mouth licked its way slowly down my stomach onto my pubic mound, where, at last, she buried her head and licked me lustfully.

I felt as though I had been waiting for this moment forever. Lori shifted her body, moving her wet pussy closer and closer to my mouth. At the same time I felt her flicking tongue enter my wetness, she placed her vulva over my mouth. I deliberately breathed in her sweet scent and started licking and kissing her with the same energy with which she was expending on me. Lori responded by spreading her thighs, making her innermost folds completely accessible to my mouth. Her sweet juices mixed with my saliva to flood my mouth. The next sounds I heard were her moans and cries intermingled with my own as we convulsed and climaxed at exactly the same moment.

Lori then drew her head away from my quivering pussy. I looked down to see Alex moving in to enter me. While Lori was lying down next to me I spread my legs, allowing Alex to tenderly push himself into me. Lori was all over our bodies, her mouth sucking at my nipples, one hand fondling Alex's testicles, the other stroking the sides of my swollen full pussy. Alex leaned over without interrupting his strokes and kissed Lori, his tongue deep in her mouth.

My memories of the rest of the night are hundreds of images which will forever live in my mind: Alex and I kneeling on either side of Lori, both of us sucking on her nipples, our fingers crowding her vagina, Lori fondling my clitoris and mouthing Alex's penis as I licked her, Alex taking Lori while I knelt behind him, mouthing his testicles. Finally, the three of us in a chain while I deep-throated Alex, Lori pushed her tongue into me, and Alex licked at Lori's savory center.

Lori, Alex and I had many other exciting sexual sessions together until Alex's business transferred us to Ontario. We have since had other women join in

our lovemaking, but none of them have yet to compare to my first female lover. I keep hoping that one day soon, finally, we'll meet a woman as exciting as my sweet Lori.

getting started

• responding to personals

DO follow the advertiser's instructions: If you are asked for a picture, send one. If the ad asks for a detailed letter, write them a detailed letter. BE HONEST. Tell them you are new to this kind of play. They were new once and I'm certain you will hear back from them. Many who have been initiated into the lifestyle would love to help you start out.

DO respond only to ads that describe situations you would be prepared to follow up on: for example, if a couple's ad states that they are both bisexual and want to meet a couple that are, at minimum, bi-curious, don't respond unless you are both prepared to experiment with the activity being sought out by the advertiser.

DO expect that an ad will provide an accurate description of the couple and their desires: If the ad sounds as thought it were placed by a "hard-core" couple, it probably was. Don't expect a "play couple." Don't expect to change someone's mind about what they are looking for. Again, what you see is what you get.

DO beware of prostitute singles and couples: Don't respond to ads which seek out "generous" people or ads which ask for a "token" be sent (unless, of course, you're OK with the idea of forming a commercial relationship). These are terms used by "Play for Pay" singles and couples.

• the first date

Finally, either by answering an ad or by placing your own ad, you establish contact with an individual or individuals who seem to be ideal partners. What now?

The best advice would be to do what you'd ordinarily do when you go out for an evening with another couple... movie, dinner, drinks... whatever. On your

way to your date you may experience butterflies, or have second thoughts and apprehensions. All of these emotions will confuse you – and when they do, think of how you felt on your way to meeting your lover for the first time. What you probably felt, and are feeling once more, is excitement over what may take place, the anticipation of the evening. Adrenaline is causing this state. Don't confuse these feelings with guilt or a similar emotion – guilt would have already kicked in far in advance of this point.

Your objective is to get to know this other couple or person. Relax, be yourselves, enjoy the conversation, just have fun. If the chemistry is right, things will unfold in a very natural way... after all, you are all there with the same intent in the back of your minds.

Let's say the chemistry *is* right. What now? It's all up to you. Either invite them to your home, a hotel room, go back to their home... whatever. At this late point the worst that can happen is to get "no thanks" for an answer. Nothing wrong with a no, is there? You'll never get a yes answer if you don't ask.

Experienced couples, out for a first date, will more than likely have prepared an overnight bag containing a change of clothing, toys, oils, etc. You need not be shy. Be a little bold. Suggest that they feel free to freshen up, and slip into "something a little more comfortable." From there, perhaps watch an erotic flick – my favorite is "9 1/2 Weeks" with Mickey Rourke and Kim Basinger. It's an incredibly erotic movie which will, more likely than not, sexually motivate four like-minded people. Or, if you're all into it, a more explicit video will definitely add some excitement to the evening.

Now, picture the scene: candlelight, perhaps cocktails, comfortable loose clothing, four sexually aroused individuals. If you need to ask what to do from this point forward, check your pulse to see if you are still alive. I'd suggest sitting with your lover and lightly kissing and fondling. From there... have you ever seen a snowball rolling down a hill?

opening pandora's box:
the dark side of swinging

There are many hidden risks associated with the lifestyle. The last place you'll ever hear of the dark side of swinging is from swing publications, clubs or governing organizations. The two of us have witnessed and heard enough so-called "dark side" experiences to unequivocally understand the meaning of a rather cryptically phrased piece of advice concerning swinging.

The advice was:

"It can be the most beautiful experience you may ever have, but it can turn into the ugliest memory you'll carry with you for the rest of your life if you're not careful."

We tell you these stories, not to frighten you, but to make you aware of some of the genuine possibilities for personal and relationship distress you might encounter in the swinging lifestyle. In our experience, such unhappy stories are unusual but certainly not unheard of.

• jeff and susan

This couple got into the lifestyle in the late '70s and early '80s, the days of Plato's Retreat in New York City. Their relationship crumbled after seven years of heavy involvement in the scene. After nine years of marriage, Susan discovered she was a lesbian trying to live her life as a straight married woman. The person who was most surprised to learn of her lesbian tendencies was Susan herself.

As one half of a couple open to fantasy sex, she was overweight and not someone the average person would describe as being at all desirable from a sexual perspective. Her dissatisfaction with married life was something she lived with. She knew all too well something was not right, but not knowing what it was made her do nothing but pamper herself with food. Susan's self-esteem was practically nonexistent.

Since leaving her heterosexual lifestyle and Jeff behind, she looks fabulous and is happily living with a female lover. Jeff was devastated. He has remained single and fills his days with his job and the responsibility of bringing up his and Susan's three children. Jeff is of the opinion that had he not insisted on their involvement in fantasy sex, Susan would have remained a part of his and his children's lives.

• frank and cindy

Cindy was the instigator in introducing Frank to the swinging lifestyle: her insatiable sexual desire motivated her to work on him until he finally broke down and agreed to open up their marriage. They had been married for only fourteen months before involving themselves in threesome sex, always with another man. Frank had been under the impression their threesome affairs would, at some point, involve another woman. This was not to be the case. What Cindy wanted was threesome sex on her terms only. She would fly into a furious jealous rage if she even so much as saw Frank talking to another woman in non-lifestyle social situations.

Frank is currently serving a five-year prison sentence for causing grievous bodily harm. The charges resulted from Frank discovering his wife in their bed with two of the men that Cindy would regularly call on for participation in threesome sex. After physically removing the men from their home, he flew into a blind rage and beat Cindy within inches of her life. Frank was originally charged with attempted murder but pleaded guilty to the reduced charge of causing grievous bodily harm.

It turned out Cindy was carrying emotional baggage as a result of being sexually abused as a child. She has since left the swinging lifestyle, undergone intensive psychotherapy and is looking forward to Frank's release from prison so they can get on with their lives. Frank remains undecided about whether or not he will reunite with Cindy.

• kris and christine

This couple was married for more than six years before their initiation into the lifestyle. Kris and Christine almost immediately discovered their bisexual tendencies. They had lived completely heterosexual lifestyles and were fascinated and surprised by how attracted they were to the same sex during their first foursome experience. For the first few years of their time in the lifestyle they resisted these newfound bisexual urges, or so thought Christine. Secretly Kris began seeking out same-sex partners without her knowledge or approval. He has recently tested positive for HIV. Chris has so far tested negative; she has left the relationship.

• **fred and veronica** This couple became totally immersed in the swinging lifestyle very early in their relationship. Everyone they knew on a social level shared their sexual interests. Swinging was Fred and Veronica's lifestyle, period.

As would be later disclosed, Fred came from a childhood background of violence, alcoholism, abuse and squalor. The youngest of four brothers and two sisters, he became known as the charming cute kid from "the wrong side of the tracks." Fred was a high school dropout who, through his charming nature, good looks, and hard work, aspired to a position of power in the trucking industry. He was the sole member of his family's six offspring who managed, in spite of his upbringing, to make something of his life.

Veronica was from the other side of the tracks. Hers was a background of love, wealth and respect. When Veronica met Fred she was, to use the oldest of clichés, swept off her feet. Within three months of meeting, Fred and Veronica became husband and wife.

Many of the classic indicators of an abusive relationship went unheeded. Veronica stayed completely submissive as Fred verbally abused and humiliated her, especially when the opportunity availed itself to do so in the presence of company. She said nothing as Fred slowly turned her away from family and friends. Veronica remained silent as Fred berated and blamed her as being responsible for every mistake and bad decision he personally made. One minute he would be the charming handsome Fred, the next, a raging stranger whom she feared.

Veronica was a highly educated person who knew exactly what was happening in her life with Fred, yet she didn't take action. Wanting to prove her parents wrong in their criticism of what they called her recklessly impulsive decision to marry Fred, she chose to succumb completely to Fred's every wish and desire. His power over Veronica promptly led to her involvement in swinging. They had known one another for less than six months.

Fred and Veronica approached swinging with a zeal and commitment very few would ever consider. Over the next dozen years, neighbors would speculate on how Fred's upscale home appeared as if it were a weekend retreat. Upwards of two dozen cars would arrive on Friday evening only to leave after the supper hour of Sunday night. It wasn't until Tina, at eleven the oldest of their three daughters, was overheard by a schoolmate's mother as she talked about what was taking place during these weekend retreats, that children's agencies quickly moved in. The daughters were removed from the home, and an investigation began, documenting what had been taking place during these weekend get-togethers.

What had been taking place within the home was obvious. Investigators were flabbergasted. The home contained two orgy rooms with a various assortment of chains and instruments of sadomasochism, an eight-person hot tub, a library of

over one thousand explicit home sex videos, and numerous sex toys, dildos, plugs, swinging contact magazines, etc. What was disturbing was that everything was so blatantly out in the open.

Tina and her sisters were raised in this cult-like swinging environment. Fred had isolated his family to such a degree that not even next of kin, let alone neighbors, would dare knock on the front door of their swinging haven. Although the youngsters may have observed every sex act imaginable, it was never proven that they had actually participated. The couple separated. Veronica is piecing her life back together and working very earnestly to regain custody of her daughters.

Fred and Veronica's story is included to underline once more that swingers do come from every walk of life. Contrary to pamphlets distributed by some swing associations and clubs, not all of the people are "some of the nicest people you will ever meet."

• **elliot and marcy** Twenty years of love and marriage went out the door when Marcy left Elliot for a man with whom she fell in love. Elliot and Marcy married in their early twenties and enjoyed a successful family and working life. It was Elliot who first thought it might be fun to look into the swinging scene. They met a couple through an ad in a contact magazine and undertook a swinging affair in which both couples remained exclusive to each other for more than two years. With time, Marcy started to get together with Will, the male half of the other couple, without the knowledge of Marcy's husband or Will's wife. These meetings led to the eventual breakdown of both marriages.

• **richard and madeline** Richard, a highly motivated and successful businessman, and his wife Madeline had involved themselves in several brief swinging affairs very early in their marriage. They had enjoyed same-room encounters with large groups of like-minded couples. During one of these parties, entirely unknown to them, they were videotaped in compromising situations with several different couples and singles. This videotape would haunt their lives for years after it fell into the possession of an unscrupulous couple who blackmailed Richard and Madeline.

The couple were parents of five children and very well-known and well-regarded in their community. They paid several tens of thousands of dollars to keep the video from family, friends and business associates. The nightmare ultimately ended with Richard going to the police. Fortunately, they escaped the disastrous consequences relatively unscathed. The pair responsible for their problems, a West Coast couple, were arrested and imprisoned for trafficking in large inventories of cocaine.

• dianne

Countless numbers of single women have become involved, over the years, with the swing scene. Dianne is one such woman. Openly bisexual, Dianne primarily involved herself with married couples where the female had interest in exploring bisexual curiosities. Her prime sources of contact were several national swing publications in which she regularly advertised. Dianne became intrigued by one particular response, which included photographs of a mysteriously intriguing and remarkably attractive couple.

After several months of correspondence, using the mail, Dianne finally agreed to drive several hundred miles to meet her new friends. She rode around in circles trying to locate the rural address for a considerable period of time. When she finally drove back to the nearest populated area, a gasoline station attendant provided her with specific directions in the form of a hand-drawn map. The couple's home turned out to be at the end of a half-mile long lane completely hidden from the roadway by woodlands. Finally she found the blue mailbox as shown on her map.

By the time she had driven her car to the end of the narrow lane, Dianne knew something was not right. She got out of her car and stood on the driveway without closing the car door. Several rusted hulks of cars were scattered about the derelict-looking property. From amidst the squalor, surrounding the main building, a snarling Doberman lunged at her, restrained only by a length of chain.

Frightened by the dog and the appearance of the property, Dianne reentered her car and started the engine. She froze momentarily as the front door of the dwelling opened and a man emerged from within. She was gripped by fear as she hurriedly locked the car doors and slipped the transmission into reverse.

The remaining few minutes of Dianne's ordeal were spent in utter terror. She went on to describe this male individual and his actions in a way which brought to mind the movie "Texas Chainsaw Massacre." As she looked over her shoulder, driving in reverse, a barefoot, grotesquely misshapen man climbed onto the hood of her car begging her not to leave. Dianne remembers screaming in fear for her life as she slowly made her way along the narrow lane. The man's pleas turned angry as his toothless face peered in at her. By the time she got back to the main road, the man was slamming his fists against the windshield screaming profanities, foaming at the mouth. He finally got off of the hood just as Dianne slammed the gear shift into forward when she ultimately reached the roadway.

This unfortunate incident went unreported to police officials. Dianne sensed her story was sensational enough to warrant extensive press coverage. She feared the repercussions of exposing her family and loved ones to her sexual preferences and history. Dianne gave up advertising through contact magazines, choosing instead to meet potential lovers through her membership at an on-premise swing club.

• bob and tracy

Bob and Tracy had been members of an on-premise club for several years. Choosing to remain monogamous in their involvement, both were initially drawn into club membership for the purpose of watching others involved in sexual acts. They were what are known as voyeurs. Many couples join recreational sex clubs for no other purpose than to satisfy their voyeuristic curiosities. Conversely, many join simply to gratify their desire for exhibitionistic behavior. This segment of the swing society, couples who delight in having others observe as they involve themselves in explicit displays of lovemaking, are known as exhibitionists.

Bob and Tracy, over the course of their years long club involvement, made a move from voyeurism to exhibitionism. This change in interest is not an uncommon turnabout. The next step they took in their development was participation in what is known as "soft swinging." Soft swingers are very sexual, but will only go so far as to participate in teasing, touching, massaging, and possibly non-completed oral sex play with new partners. Tracy's newfound enjoyment was to be caressed and fondled by new friends while she and Bob made love.

During one of the biggest events of swinging's calendar year, Valentine's Day, Bob and Tracy were in the company of several couples in an area designated for soft swinging activity. Feeling the effects of having consumed far more alcohol than usual, Tracy excused herself and left Bob, who stayed in the soft swing area.

Located a few steps down a short corridor was a room known as "The Tank." The tank was set aside for, to use the vernacular of the day, "gang splash" action. A gang splash is when one woman carnally takes on multiple numbers of men. Tracy staggered down the corridor, only managing to get as far as the entrance to "The Tank," when she sensed she was going to pass out. She was completely oblivious to her surroundings when she entered the tank, collapsed onto the matting and passed out from the effects of having over-indulged in alcohol.

Bob, in the meantime, remained in the soft swing area as several men subjected Tracy to various sexual acts. Some time later, Bob was seen walking around the complex asking friends and acquaintances if they had seen Tracy. When he finally found her, still passed out in the Tank, he fell to his knees in tears. He gathered her semen-filled and -covered body into his arms and, crying bitter tears, carried her into the shower room.

Bob and Tracy's is a dreadfully shocking true story, once again, of circumstances which should have resulted in criminal prosecution. (Sex with a drunken person constitutes rape.) The swinging lifestyle includes many tales of traumatic criminal occurrences which remain unreported due to people's fear of being exposed as swingers.

• jim and mary

Jim and Mary who were married for eight years before entering into the lifestyle. From very early in their relationship, Mary had always possessed a certain inquisitiveness toward the topic of men with large penises. She wasn't interested in men as much as she was engrossed in the fantasy of having sex with a man who had a large penis. At six inches in length, Jim was neither over- nor under-endowed, and was quite contented with what Nature had given him. Jim willingly fed Mary's curiosity with videos he would search out at the rental store. Watching videos of men with large penises engaging in oral or vaginal sex never failed to provoke a powerful chain reaction of sexual excitement. Mary's fantasies added a certain spark to their sex life.

Eventually, Mary's curiosity, together with the couple's inherently adventurous nature, led them to membership at an off-premise couples club. Jim and Mary moved slowly, enjoying all of the secret thrills the lifestyle has to offer short of a full swing with another couple. They enjoyed the softer side of swinging. Life as they knew it as a couple changed when Jim and Mary met Paul and Heather.

Mary knew she had found what she was longing for the very first time she and Jim got together on the dance floor. Paul and Heather weren't into threesomes, foursomes or soft swinging. If anything were to take place between these two couples, Jim and Mary would have to reevaluate their expectations. Paul and Heather were a full swing couple with a one-on-one, behind-closed-doors, see-you-when-you're-done kind of attitude.

During Jim and Mary's nighttime pillow talks, Mary persuaded Jim to try a get-together with Paul and Heather. She had succumbed to her desires of being taken by a man with an oversized penis.

On the night of their first of several full swap encounters with Paul and Heather, Mary and Paul were in the master bedroom adjacent to the guest room which Jim and Heather's occupied. Mary became so boisterous when Paul penetrated her that Jim actually got up from Heather's arms and walked into the hallway out of concern for her well-being. Heather stopped him from entering the master bedroom, reassuring Jim that Mary's sounds were inspired by lust rather than pain. She quickly convinced Jim; Mary was simply responding to being penetrated by Paul's extremely substantial proportions.

Jim and Heather returned to the guest room but were entirely distracted by Mary's vociferous and frenzied reaction to Paul's attentions. Mary was noisily telling the world how immense, how wonderful, how gratifying Paul felt inside her. He and Heather, Jim later admitted, became so distracted they merely went through the motions of a sexual encounter. Jim was so desirously turned on he couldn't wait to get Mary home and into bed. But wait he did… all night. By the time they were halfway home, Mary was fast asleep in the front seat of the car. The night sky in the east was quickly turning blue.

The morning following their first full swing sexual encounter, Mary carelessly, without thinking for a second of the possible consequences, described the episode as having been "the best sex I've ever had in my life." Mary didn't mean for what she said to hurt Jim. When she later thought about the words she had chosen in reference to her encounter with Jim, she understood how someone could be hurt.

It wasn't until the third or perhaps fourth encounter with Jim and Heather that the two couples felt comfortable enough after a sexual session with each other's spouses to interact with one another while naked. Gathered in the downstairs den, illuminated by only the small jets of gas flames in the fireplace, they consumed fluids and fruits, consciously aware they needed to replenish energy levels so they could prolong the night's excitement.

Mary's poor choice of words didn't have an immediate impact on her husband. On the next overnight fling at Paul and Heather's, the couples began the evening by socializing in the dark and mysterious ambiance of the downstairs den. About an hour into the evening, in total spontaneity, the four began undressing one another's bodies. Once undressed, Mary got on her knees between the two men, reached and hooked her thumbs over the top of each shaft and let her hands gently cup the testicles of the men standing before her. Both very quickly became aroused.

Mary brought the heads of their members to her mouth. Looking up into the faces which studied her, she licked and kissed first one and then the other. Opposite Mary, Heather lowered herself onto her haunches. Staring into Jim's face, Heather took Paul's penis away from Mary to perform fellatio. She purposely held her husband in such a way as to most advantageously show off the dimensions of his penis in concert with her serpentine skill in performing oral sex. Mary simply watched as if awaiting her chance to outdo, to outperform Heather's accomplished technique. Left standing alone, Jim lost his ability to maintain an erection. Mary's words, echoing from the past, seemed to taunt Jim with every vision of his wife's total submission to Paul's massive organ. "The best sex I've ever had in my life... the best sex I've ever had in my life." For the next hour, Jim sat in a chair, motionless, and watched as his wife enjoyed the attentions of the man who was responsible for "the best sex" she'd ever had in her life.

The ensuing hour was indeed filled with images of a woman enjoying the best sex she'd ever known. Jim knew Mary's opinion was right.

Heather completed her artful session of fellatio on Paul by amazingly managing to engulf at least seven inches his enormously thick ten-inch penis. She gazed into Mary's eyes, as if to challenge her into a deep throat competition. Jim could just stare in disbelief. Heather appeared to be very well versed at how to show a man what he'd like to see without having to ask. She was remarkable.

Heather reached to Mary and helped her up from her hands and knees. She embraced her boldly for a moment and then guided Mary to a sitting position on the love seat. Mary's eyes closed. She took Paul into her mouth as Heather slipped onto the floor between Mary's legs... Mary's first touch from a woman. She lasted two minutes.

Moments later Mary was on her hands and knees in front of the love seat. Paul, on his knees behind her, raised her hips and placed her slick opening on the head of his penis and gently pushed into her a little at a time. Heather, sitting on the love seat, placed her hands on the back of Mary's head and pulled her toward her center. Mary went for it. Paul rocked back and forth in a gentle sensuous rhythm as Mary's moans mixed with the wet sucking sounds of her mouth grew louder and more intense.

Jim could only sit and watch. Mary was ravenous. For moments at a time she seemed lost in lust, disconnected from everything but her insatiable carnal desires. She showed him the person he wished he could have been. Jim felt as though Paul and Heather were purposely ruining Mary by showing her heights of pleasure which could never be found within the realities of their once traditional married existence. In the decade he had known her, it hit hard for him to face the fact he had never taken her to the limits he watched her explore.

Jim became so depressed and despondent that he seriously considered a costly surgical penile extension procedure. Jim believes he might have followed through had he been able to convince a single surgeon that a penis six inches in length could be considered to be too small, so small in fact that the medical community should intervene. Jim wasn't successful in his search.

Their experiences created some emotional walls and bridges for Jim and Mary to take down and cross. Somewhat bewildered, they left the lifestyle for a "breather" as Jim called it.

• **andre and angela** Andre writes: "It changed my life. I wanted the lifestyle in the first place. It's only me I can blame. I basically talked Angela into it. She was always reluctant. Our ten years together were okay, I mean, they saw some fairly steep ups and downs. At one point we even got to the point where she grew to despise me. I didn't make that part up. She told me how much, how deeply she despised me, for a period of our marriage, only after knowing me for fifteen years. Somehow we stayed together and worked at making things better.

"Anyhow, after what I'd call 'hard work' talking her into it, we ended up at an off-premise club. Most of the people there, to tell you the truth, could never appeal to me on a sexual level. But, every time we went, there would be two, maybe three, women who I knew I could get with. I felt like I'd do anything to get

there. They were what I'd call absolutely luscious. Every time Angela would show up on the scene, that's as far as it ever got.

"I got really pissed off about that. I carried it with me out of the club and into our living room. Anytime I felt unhappy, it was Angela who I thought made me that way. Angela was always in the way.

"Yeah, it changed me. All I ever got out of it was frustration. I think the problem was that she really wasn't into recreational sex in the first place. I didn't know how much I loved her until I was single again. I'm still trying to figure out why I wanted to be a swinger so badly. I've never really come up with an answer."

• **wayne and lynette** Lynette writes: "My husband Wayne and I have been involved in the lifestyle for a little over a year now, but we didn't become involved because our sex life was monotonous or dull. Not in the slightest. It was and is ever more intriguing and gratifying as the years rush by us. I think we became interested as a result of curiosity inspired by XXX videos.

"We were teenagers when we met, in our early twenties when we married, so, after several years of monogamy, we inevitably began to question what it would be like to be with other people. I believe this curiosity over what an extramarital sexual encounter might be like is one all married couples go through. Some, as we do, love each other enough to share their innermost thoughts, no matter how intimate. Others keep such wonderings a secret… one which eventually works against them.

"Having open minds, we seemed destined to stumble across the concept of swinging, and we did. The idea struck us only as a way we could test what it would be like to share a sexual experience with someone other than each other.

"We worried over many of the same fears and apprehensions I'm sure many before us have had. We talked to a number of experienced couples before we actually became initiated ourselves. One of our major concerns was, believe it or not, jealousy. Neither of us knew how we'd react to seeing the other in a sexual situation with another person. Many of the folks we spoke with said jealousy wasn't an obstacle. After carefully considering our own reasons, we decided to give swinging a chance. If we did become jealous we both wanted to work to combat those feelings. We felt jealousy and possessiveness should not be an issue in the trusting and loving relationship we were very consciously working toward.

"The crowd who told us that jealousy wouldn't be an obstacle were right, at first. We fully submerged ourselves in swinging. We had talked about our fantasies for so long that when we did become involved, we couldn't get enough. After our first sexual experience we abandoned our traditional lifestyle and became altogether promiscuous. We found ourselves with a new couple every weekend, on many occasions we even had two couples in a week.

"Several months went by before Wayne and I sat back and discussed our shared experiences. I was surprised when Wayne told me his opinion of swinging agreed so closely with my own. The reality of having intimacies with new people didn't live up to the thrill of the fantasy. This truth in common didn't keep us from our chosen lifestyle. What kept us interested was our enjoyment of the variety and the excitement of wondering what a new couple were like in bed... then, instead of just wondering, going ahead and finding out.

"The sexual exchanges we shared weren't that memorable. Disappointing, really. Each episode with a new man emphasized my Wayne's warmth, tenderness and responsive nature. I quickly discovered, through others, how fortunate I was to have met and married the man of my dreams. This never occurred to me before our swinging involvement.

"The promiscuity we were living with started to get boring. All of the advice we'd sought out regarding the issue of jealousy turned out to be true. The series of physical adventures we had made us realize the physical act of sex on its own didn't create any feelings of tenderness or love for the partners we shared.

"We left promiscuity behind and carried on an exclusive affair with two couples with whom we had emotional ties and often socialized with as family units. Then an unexpected thing happened. Both of us fell in love with a man and his wife.

"Jammie and Stephan moved into our neighborhood. Wayne and I, given our lifestyle, noticed them right away. How could we not? They were absolutely gorgeous. We immediately started having sexual fantasies about them. The moving van was still in their driveway when we talked about inviting them over with the hopes of seducing them into swinging.

"We politely invited them over one night and were ecstatic there was such an instant and positive rapport between us. Within a few weeks we felt more intimate with Jammie and Stephan than with anyone but our oldest friends. One evening, oddly enough during a discussion with Jammie about jealousy, I hinted we had participated in group sex. They both expressed their own interest in the subject. Over the weeks which followed we gradually told them about our swinging involvement, with details of a few of the more memorable experiences we had shared. Our coffee table discussions must have been the center of many of Jammie and Stephan's bedtime chats. All on their own one evening, Jammie and Stephan asked if we would be interested in having a foursome with them.

"We didn't know it could have ever been possible, but nevertheless, Wayne and I fell in love with them at the same time. It was real love. Love which drew out of us the same emotions which were present way back when we first fell in love with each other. Not only did I fall in love with Stephan, I also fell in love with Jammie. Wayne was perplexed. How was it possible for both of us to be falling in

love with a man and his wife at the same time? These tender emotions hadn't ever surfaced in earlier swinging experiences. Confusion abounded.

"Our lives changed drastically. We did everything together while at the same time, without even being aware of it, we alienated all of our friends, family and acquaintances. The sex we shared was pure, uninhibited and physically intense. There were days when Jammie and I would have sex while the guys were at work, or when I would have sex with them when my husband "wasn't into it," or he would have sex with them when I would go to bed early. We could not keep our hands off of one another.

"Then, it seemed to us suddenly, Jammie and Stephan would explain they were busy when we called to get together. Instead of seeing them every other day as had been our habit, they progressively withdrew until we only saw them every two weeks or so. Jammie would say they wanted to spend more time with their children, were busy fixing up their new home, or they were getting to know more people in the neighborhood. This was all perfectly straightforward, of course, but even though Wayne and I realized we had, in a way, taken over a part of their lives, we were hurt.

"We did our best to hide our feelings of jealousy, even from ourselves. But when we learned from the grapevine that Jammie and Stephan were seeing other couples for sex, we couldn't ignore our feelings any longer. We were furiously jealous! When we were alone we kept imagining them in bed with couples we knew. It was just horrible.

"I'm certain we could have remained friends with Stephan and Jammie if we could only have found a way. There wasn't anything we tried which worked to dull the intensity of the distress caused by our feelings of jealousy. Wayne and I began withdrawing from the friendship. We just couldn't find a way to handle the jealousy. We wanted them all to ourselves. Both of us hated the notion they could want to have so much as a friendship with anybody else.

"After much discussion and many sleepless nights, we decided to entirely retreat from Jammie and Steph and the whole swinging scene. We're always hoping, after a sustained period of time, we will be able to carry on a conventional friendship with them. We found we don't know how to carry on a real love relationship with another couple.

"As for the swinging, we don't ever want to share ourselves again. It just doesn't have the allure it once did. What a long, weird trip it's been.

"It's been worth it, though. It has made us what we are and we love each other more today than we ever thought possible. Our experiences have left us, beyond a question of doubt, wiser, less vulnerable, and stronger in mind and spirit."

• **"she"** It's only been a decade or two since issues of partner abuse, and the damage it does, have been identified, discussed and become a social taboo. Our observations and personal exposure to these matters strongly suggest there are many individuals involved in swinging who have never had reason to examine this moderately upsetting social reality. Following is a paraphrase of a "chat," from one of the many Internet chat rooms which cater to swingers, in which we participated:

She: I would like to talk to a woman or a couple who are experienced swingers.

Us: Care to chat?

She: Well, we swing sometimes but if I'm not in the mood for it he gets really mad at me.

Us: What does he do when he gets mad?

She: He calls me names. And if I don't want to have a guy come over to our house and have sex with me, he gets really cold with me.

Us: Do you ask him to find guys for you?

She: No. He asks me to find people, guys and women.

Us: How old are you? How long have you been married?

She: We are both 39, been together 9 years.

Us: I don't know what the problem might be yet, but so far, here's what more than twenty years of experience screams at us: This sexual recreation thing is supposed to be fun! People are the only living things on the planet that have sex for fun. If it's not fun, stop it until it is again. There is nothing you can do otherwise...

She: I'm feeling really scared and upset. He threatens to cheat on me if I don't do threesomes with him and the guys he finds.

Us: This swinging thing is all about relationship building – first build *yours*. Then, when you have your relationship ticking along just the way you want it, you're both strong enough to venture out and have some fun in this lifestyle. Until then, you should stay away from non monogamous sex altogether. *"You do me and who I bring home or else I'll cheat on you."* That sounds just awful.

She: I enjoy swinging, but I don't think it should be our whole life. I like to get to know people first. He says if I need to get to know someone first, what I really want is romance, as if I were having an affair.

Us: I'd put my foot down and take control of the situation if I were you. This is all about being equals.

She: We had a threesome with a guy I knew from online. He said I didn't have sex with him, I was making love to him and in his mind what we had was an affair. He videotaped us and made me watch it over

and over again. He kept saying. "Look at yourself. You were making love with him." I went through hell over it.

Us: Unless you get help he's going to continue to take you down the dark road you are on until YOU change it. YOU have to get strong.

She: I go to counseling about it.

Us: Does he go to counseling with you?

She: No. He doesn't see any need for him to go, just me.

Us: Sounds to me like he doesn't love you and you want to prove to him that you do so you'll do anything. Right out of the pages of what I've read about abusive behavior.

We went on to give this woman some checkpoints she could use to help her reach a decision about her situation and what she could do about it.

- *Was your partner abused as a child? Was one of your partner's parents abused?*

- *Is your partner prone to irrational jealousy? Does s/he try to prevent you from spending time with friends and family? Does s/he accuse you of flirting with others when there is no grounds for the accusation?*

- *Does your partner try to control your behavior – by getting angry when you don't follow his or her advice, by controlling when you leave the house and when you come back, by controlling your money? Are you afraid when your partner becomes angry with you?*

- *Did you and your partner fall in love with each other very quickly, before you really got to know each other very well?*

- *Is your partner trying to isolate you from your friends, family, work and other sources of emotional and financial support?*

- *Does your partner blame you, or someone else, for his or her mistakes? Does s/he feel that life is unfair and that someone is out to get him or her?*

- *Does your partner take offense easily at perceived insults and attacks? Is s/he easily angered?*

- *Is your partner cruel, teasing or overly demanding toward children or animals?*

- *Does your partner enjoy mock violence in play (striking you, holding you down, etc.) without checking with you first to see if that's OK with you? Does s/he try to manipulate you into sex by using sulking or anger?*

- *Does your partner insult you, put you down, or embarrass you in public in ways that are hurtful to you?*

- *Does your partner insist on rigid traditional sex roles?*

- *Does your partner have very rapid changes in mood – sweet one minute and angry and hurtful the next?*

- *Does your partner break, strike or throw objects to frighten you or to harm things you value?*
- *Does your partner ever physically restrain you from leaving a room, push you or shove you? Has your partner ever struck you without your consent?*

Us: I think many of the patterns of abusive behavior were there all along. Now, with swinging, this person has you exactly where he wants you because you *can't* talk to anyone about it. Well, do. Take control by talking with your counselor.

She: But can I tell my counselor that we're into swinging?

Us: There was a time in our lives when we had to get a little help. When our sexual behavior was brought into the session, the advice was to fix our relationship first, then we'd have a look at our sexual desires. When we finally did discuss our sexual desires, our analyst (we were both there) told us our sexual preferences were up to us. She neither condemned or approved of our ideas. She said something to the effect that it wasn't unhealthy as long as we made the choices we did from a happy perspective. Not saying anything to your counselor would be like going to the doctor with a broken arm and being treated for a bloody nose.

marie: in over my head

After a monogamous marriage of more than twelve years, and two and a half years of stepping out of the limits of monogamy as a couple, my husband and I have once more become monogamous in our relationship.

We were in our mid-twenties when we married, and for seven years we consciously buried ourselves in our careers until I happily found myself playing the role of expectant mother. What a wonderful part to play out in real life. It was a spiritual time, a connecting of souls, mine and the new one being created within me. I gave up my career to become full-time mom to my delightful and beautiful baby girl.

Four years later, Jenny was off every morning to preschool, and I found myself at home totally alone. There was an unfamiliar clarity of mind which I hadn't experienced since university days: finally, I had time for no one but myself. It seemed as though many more than four years had passed. It dawned on me that since Jenny came into our lives, I had never spent any time alone. Either my husband Brent was with me or the three of us were together. Oh, there was the odd time I'd be alone for a few minutes while Brent took Jenny to his mom's home while we were getting ready to go out, but for most of those early years I had never had a single day all to myself. It truly was a most wonderful feeling.

Once the novelty of having days to myself wore off, I took out a membership at a co-ed health and fitness spa. My body really did need some attention. Both Brent and I, lulled by the good life, had separated ourselves from the ways we used to live. In our earliest days together we used to work out at the gym quite regularly. Sometimes we'd even meet at the club at lunchtime for a quick workout, or meet after work and spend hours on the treads, bikes and Universals.

Brent and I tried to revisit those days to pick up where we left off, but the day-to-day realities of his successful business became too demanding. He just couldn't find the opportunities to slip away to the gym during the daytime hours.

When Brent did find the time on a few occasions, I know he was feeling uncomfortable. As we worked out in front of mirrors, it was plain to see the good life had consumed our bodies. Both Brent and I were noticeably withdrawn and unsure of ourselves in this environment of physically active and fit people.

It was during my twelfth week of visits, after a lot of pain for gain, when I began to see reflected in the mirror the person I used to know. My physical appearance once again resembled that of the person I was before Jenny was born. I had the best of both worlds: motherhood and the physical appearance of a woman who hadn't had her first child yet.

As the weeks went by, I found my time at home rather boring. The weekends were different: Brent, Jenny and I occupied ourselves with wonderfully wholesome outings. A Saturday afternoon spent picking apples at old-fashioned country orchards, a Sunday wandering through the Metropolitan Zoo, a country fair, an air show… we always had fun doing something special. Monday morning would arrive and it seemed the only day of the week which was tolerable. I occupied myself with all the cleaning and washing that had to be done after our active weekend outings. It was no effort at all and I was always done in time for a two-hour gym visit before picking Jenny up and heading home.

Tuesday through Friday were kind of hollow. The house would be empty at 8:30. By 9:00 the breakfast dishes were done and I had another day to myself. I started to use my late morning hours pampering myself with hot oil baths, experimenting with different hairstyles, manicuring, pedicuring, waxing, which lead to getting carried away with a razor one particular morning. What a mistake! By about the third day after shaving my pubis, I thought I'd die at the gym. I was so bristly that I swore my vaginal folds were being seared by the friction created by some of the exercises in my routine. I spent the entire following morning tweezing away each and every dark dot of hair from between my thighs until I was perfectly hairless, supple and very, very sensitive.

Routine was quick to settle in. Eventually, Tuesday became the day I would tweeze all of the new hair growth from my intimate area. After my ritual I would apply a special warming oil which I picked up at the lingerie shop for this very purpose. Afterwards I would always snuggle back into my bed. I would get comfortable and start daydreaming, fantasizing and more often than not, masturbating. Closing my eyes I regularly found myself fantasizing about a black man from the gym. I didn't know his name, but while at the gym as he worked out, I tried to stay unnoticed, fascinated by his glistening black flesh. While I lay in bed I would imagine this black young hunk on his knees at the foot of my bed, his mouth between my legs, licking my smoothness, his soft lips sucking and tasting the moistness there. I would inevitably climax when I imagined him getting up from his knees and lowering his shorts to reveal his exquisite pitch-black penis.

There were, on my part, some feelings of guilt associated with my Tuesday sessions. I would pick Jenny up from preschool and head home to a normal evening of preparing supper and getting everybody ready for another day. When bedtime came and we snuggled after turning out the lights, Brent always seemed to pick up on the sexual energies that had been present in our bed just a few hours before. And so it was that Tuesday nights were set aside for "duty night," as Brent kiddingly called it.

As much of a routine as Tuesday nights had evolved to, the way we had sexual relations slowly became just as routine. Kissing and hugging would eventually lead to Brent guiding my head down toward his penis. After five or ten minutes of fellatio, Brent would mount me in the missionary position and ten minutes later find his release, fall asleep and leave me to lie with eyes wide open, entangled in my guilt.

It was terrible, lying there sexually unfulfilled. I thought the problem was being brought on the new fantasy world I was creating. After one "duty night," as I lay listening to Brent's snores, I started thinking about our years together. In particular, I started thinking over the ways in which we had had sexual relations. The way we made love today was much the same as it had always been, save for one obvious exception: in the early days Brent would delight in performing oral sex on me for prolonged periods of time. Unfortunately this behavior only lasted for a year or so after marriage. Could it be I was so busy in those early days I never so much as had a chance to notice that Brent was no longer performing this wonderfully fulfilling sex act for me? I can't say I missed his oral attentions during our sexual exchanges. In reflection, it seemed I always set my own needs aside to make sure everything was exactly the way Brent would have wanted things to be.

It was after one of my Tuesday routines when, on a whim, I left home for the gym far earlier than I normally did. The gym's juice bar had an outdoor patio where I decided I'd spend part of my early afternoon. There was, after all, the possibility of my secret fantasy man dropping by for a glass of fresh cold juice. I wondered what I'd do if he did walk out onto the patio. Could I find the courage to say hello and introduce myself?

Comfortably seated on the patio, I started pondering my sexuality. Past conversations with some of my more intimate girlfriends and workmates resounded through my mind. There was my friend Patty and her story about meeting a guy with a ten-inch penis and how consumed by oral sex she became. Sylvia and her neverending Monday morning depictions of her weekend threesome experiences, and Tamara's tales of exploring bisexuality. The fact that my sex life was monotonous and bleak compared to theirs had never, until now, crossed my mind. The ways Brent and I had relations had been quite satisfying to me up until the last several

weeks. Here I was 33 years old and feeling truly vibrant and lustful for the first time in my life.

It was on the juice bar patio one Tuesday afternoon that I met an intriguing young woman who would have a profound impact on my life. I had seen Audrey at the club on many occasions, but she seemed to always be on her way out as I was arriving, so we never had the opportunity to say hello to one another.

• audrey

Audrey was an exceptionally high-spirited 29-year-old woman, married, without children. We instantly became friends. We started meeting at the gym at arranged times to work out together, and then, weather permitting, we'd enjoy each other's company on the juice bar patio. One day, after completing our gym routines, we were off to the showers when Audrey noticed how smooth my pubic area was. She asked me how I managed tolerating the annoying stubble which she said was the worst part about shaving pubic hair. Audrey was somewhat astonished when I told her of how I escaped that dreaded consequence.

The next time I was to see her naked, I noticed she too had rid herself of personal hair. I mentioned this to her while we lounged on the patio. Audrey told me of how aroused she had become while baring herself and blushed deeply when revealing how, afterwards, she had gotten back into her bed and satisfied herself. It was my turn to be astonished. Strangely, I wanted to hear more. I admitted to Audrey my day for my own personal care was Tuesday mornings and that I would seldom stay away from getting back into my own bed when I was smooth and oiled. It was just such a turn-on to lie back and slip into fantasy for a few minutes out of a week, I explained.

Audrey told me of how her husband Jared had a problem keeping his hands away from her at bedtime, how he would outline her intimate contours with his fingertips while falling asleep, how she sometimes awoke to find Jared's face between her thighs, but most of all, how delighted she was that I told her my secret. On the day of this unusual conversation, Audrey said something about being in a hurry because Jared was to meet her at home and she did desperately want to be there before he arrived.

Audrey left me sitting on the patio to a significantly memorable series of thoughts. Then, a startling realization. Brent had never so much as commented about my personal grooming choice. Had he even noticed? I felt what I thought was a wave of sadness. Or was it hurt? Thinking about it later, it may even have been a wave of anger. The one thing that was certain was I was confused.

My fantasy episodes started becoming more and more explicit and frequent. As I lay in my bed I envisioned all manner of sexual exploration. To my amazement I began to include Audrey and Brent in my fantasies. These visions of the three of

us having sex would bring on the most intense orgasms I had ever attained through the act of masturbation.

After one of my fantasy episodes I called Audrey to ask if she would like to meet me for lunch at the club. She said she was tired of the juice bar patio scene and asked if she could pick me up and take me out to a downtown restaurant owned by friends of Jared's and hers. Readily agreeing, I hurried to make myself ready for our lunch date. Within an hour we were sitting at a table in a charming little bistro in the black section of town.

Audrey's friends, as it turned out, were a very attractive interracial couple who made us feel at home and special the moment we walked through the door. After being seated at a window table, surrounded by lush potted ferns and ivy, we exchanged some small talk with Jon and Marrilee before being served a most wonderfully prepared meal.

After lunch, feeling especially relaxed and somewhat playful, I asked Audrey if Jared was still turned on over her intimate grooming. She just smiled and thanked me again for sharing my secret with her. It was then I broke down and started sobbing. I told her of how I was feeling being taken for granted, how I wasn't certain Brent even noticed I was hairless. I didn't stop. I shared with her everything that was on my mind. I told her everything: the way Brent would push me to go down on him, how he'd get on me and finish only to end up on his side, snoring away, while I lay beside him in a state of total abandonment. It felt good, in a way, to get it off my chest.

Audrey just listened, letting me get it all out. Then, after picking up the check, she said, "Come on, Julie, let me show you how to fix all of your problems."

We drove to (of all places, I thought) an adult XXX video store. Audrey asked me if we had ever watched erotic videos. I could tell she didn't believe me when I told her the only time that I knew they were in my home was on one occasion when, after one of Brent's football parties, one of the guys left a copy of Linda Lovelace's *Deep Throat*. Audrey chuckled, saying something about it being an "oldie."

When we first walked into the video store, I expected to see dirty old men in raincoats standing in front of racks with their hands in their pockets. Instead, in this brightly lit and tastefully decorated interior, were several women and a couple of men browsing through racks and racks of adult videos. Audrey suggested a few titles and gave me a crash course in how to select erotic videos, something about trying to find ones that were shot on 35mm film. She also advised me to read the covers to find films which were produced by women, or, at minimum, to choose films shot by female cinematographers.

I didn't understand what Audrey was trying to get at when she asked me what I'd like to see. She asked me several times, and I still didn't get it until she

blurted out loud, "Sheesh ... what do you fantasize about when you get back into bed on Tuesday mornings?" It was a little difficult for me to respond, but finally I told her I thought a threesome film might be fun to watch. After selecting a video for me, Audrey asked me about the state of my intimate apparel collection. I told her what I had and she said that she knew of a little shop we should go to.

It was my turn to chuckle. Audrey took me to the very lingerie store I used to shop at. This was a fun afternoon. I felt like a little girl playing dress-up with a friend. Audrey's tastes in intimate apparel were a little more daring and exotic than mine. but I let her talk me into purchasing a few items which she chose for me.

On the way back to my place, Audrey suggested we stop at a grocery store to purchase the ingredients for a gourmet Italian dinner along with a couple of bottles of vintage wine. What a little schemer. What a wonderful little scheme.

The afternoon slipped by so quickly we had to rush the shopping trip to collect Jenny from pre-school. Once back at our home, I invited Audrey to come in. We occupied Jenny with her favorite kid's TV show and retreated to the kitchen. Audrey started filling me in on how to change Brent's attitudes towards our intimate exchanges. Even though it was clear to me what Audrey had in mind for us, she painstakingly went through exactly how this evening of change was to take place.

In a condensed version, the evening was supposed to flow like this: After Jenny's bedtime I was to prepare an out-of-the-ordinary pasta dish, pop the corks on the rare French wines and linger over dinner, after which I was to ask Brent if he felt like having a shower with me. Then I was to dress in my sassy new lingerie and finally retreat to the family room to watch the video Audrey had selected for us. She asked me when I planned this special evening, and I told her there couldn't be more a perfect day than today.

Audrey called me first thing in the morning to ask how things went. There was a problem in talking with her on the phone because I couldn't stop giggling. It felt strange to be telling my friend how lustfully torrid my evening hours had been. Tantalized, Audrey arranged a time we could chat later, at the club.

Describing my night to her was much easier in person than it was on the telephone. I could see Audrey's face showing me her interest in my story. When I started recounting events, from about the time Brent and I got into the shower, her face started to gradually take on a beautiful warmth. By the time I was describing how Brent so tenderly soaped and rinsed my shivering body, the beautiful warm glow of Audrey's face turned into an obvious blush.

Looking back now, what a wondrous time I had leaning against the wall in that shower. Brent was on his knees, water cascading down his cheeks, holding one of my legs up on the side of the bathtub as he licked and sucked on the

smoothness between my legs. That was the first of many orgasms that night, and I felt I owed every cherished one of them to Audrey.

Audrey's breathing began getting noticeably rapid as the sexual descriptions began arousing even me. I couldn't get any further and blurted out, "Come on Audrey, let's go have a shower and work out... in that order." She just smiled and followed me into the locker room.

As we walked the treadmills, Audrey's next to mine, she asked me if I enjoyed the video she had selected for us. I bluntly told Audrey there was one part in the movie which was almost right out of my Tuesday morning fantasies... the part with a couple in bed, she on her back as he lay beside her deeply kissing her mouth. She stopped kissing and looked to the foot of the bed, where a black man had approached and lowered his shorts to expose his glistening pitch-black penis. The three had blistering hot sex.

• **audrey understands** Audrey then shocked me profoundly. She told me she knew I would love watching that specific scene from the very first time she met me. Jared, she said, came home from the gym and, on several different occasions, told her about a cute redhead at the gym who used to think she was getting away with sneaking a lustful look at his body.

I was dumbfounded. Feeling guilty for coveting another woman's man, I didn't know what to do or say. Audrey sensed this right away and dropped another bombshell. In an affectionately sexy tone, she said, "Don't feel bad about it, Julie. I'd love to watch you with Jared. To be perfectly honest with you, I'd love to have you all to myself too."

I didn't know what to do or say. Shocked, I left Audrey at the treadmills, went to the locker room and quickly put my street clothes into my bag. I left the club in such a hurry I was still wearing my workout gear.

I stayed away from the club for the next few days, not quite certain about how I was feeling about what happened. I knew it wasn't anger which caused me to leave as abruptly as I did. A few days later I knew I left the club to hide my embarrassment.

During my Tuesday morning routine, I wondered if Audrey was doing the same thing I was. Recollecting how affectionately she gazed into my eyes while listening to the particulars of my night of lust with Brent, I began to feel badly about responding to Audrey's playfulness the way I had. Was it her fault I noticed a black man with a sexy desirable body at the club? Was it her fault I would deliberately sneak looks at his black skin, all the while thinking I was too clever to get caught? I think not.

By the time I put my tweezers away and jumped into the shower, I was feeling dreadfully guilty. Making up my mind I would go to the club and apologize

to Audrey for the way I had treated her, I couldn't resist the urge to jump back into my bed. Laying there, Audrey's words repeated themselves over and over in my mind. "Don't feel bad about it, Julie. I'd love to watch you with Jared." Imagining his smooth brawny body next to mine, I climaxed at the mental image of my milk-white fingers encircling his black manhood. Why had I felt so embarrassed?

I remember how my body still tingled from my climax as I hurried to get to the club with the hope Audrey was there. As I walked onto the patio Audrey noticed me and, without hesitation, waved me over. It was nice to see the wide suggestive grin which seemed ever-present on her face.

I didn't know what to say when Audrey's first words to me were, "Hiya! Seen any good movies lately?" I merely chuckled and shot back, "Yes, and you were in them." We humorously traded barbs back and forth, which made me feel entirely childish for my behavior of a few days before.

After our workout I invited Audrey over for tea. Brent was at work and I did have a few hours of free time before needing to pick Jenny up. I thought it'd be interesting, not to mention erotically stirring, to talk with her without the threat of a stranger overhearing us. I knew only too well that sex would be the main topic of our conversation. I was right! Audrey asked if our sex life had improved after my evening of lust with Brent. I told her our sex lives had improved dramatically. Audrey went on and on, drawing out as many intimate details as she could. We were both succumbing to sexual arousal.

I asked Audrey if Jared was still showing his approval and interest in her new grooming methods. I could feel myself becoming warm and flushed as she described the last time they made love. Noticing this, Audrey asked me if I was okay. I said, trying to be cute about it, "Oh, it's nothing a cold shower wouldn't help me out of." She just smiled and said, "Okay, let's go have a cold shower, I'm getting a little carried away myself."

I didn't know what to do. I was just kidding around but Audrey was dead serious. She stood up, came over to my side of the table, took me by the hand, led me into the bathroom and started undressing me, all the while, that cute sexy grin of hers on her face. She then climbed out of her own clothes and together we got into the shower. Losing all of my inhibitions, I gave my body over to her completely as she gently soaped and massaged me.

She really meant it when she said that she wanted me all to herself too. After our shower, we ended up in bed, where Audrey showed me just how much she wanted me. That was the first time I had ever had another woman perform oral sex on me. It was outstanding. Audrey seemed quite willing to orally bring me to orgasm and be satisfied without so much as laying a hand on her own private parts. Not since first discovering sex had I climaxed so intensely, so entirely.

Before leaving, Audrey left me with a videotape, saying that I should watch it with Brent. Oh!... Brent... Jenny... I had forgotten about everybody and everything I was responsible for. I rushed around the house to tidy up a bit and drove off to collect my dear daughter.

Part of me wanted to tell Brent about what had happened earlier that afternoon. I came close to telling him during several lulls in our after dinner conversation. What if I turned him off? What if he felt as though I'd cheated on him? Worse yet, would he accuse me of turning lesbian? I decided to say nothing of the incident.

After Jenny was in bed and the dishes were done, Brent and I adjourned to the family room as we usually did. We were snuggling on the couch when I remembered the video Audrey had left with me. I asked Brent if he'd like to watch another adult sex flick, to which he just smiled and said he would love to.

The first video which Brent and I had seen was tame compared to Audrey's latest offering. This particular film was raunchy. The main character was a redheaded woman who I thought looked very much like me. One at a time, she took on four hunky-looking black men and concluded by taking on three of them at the same time. Seeing these scenes left me highly aroused and willing to experiment.

Brent and I had tried anal sex on a few occasions in our early years but I can say neither of us were really turned on by the practice. This was going to change. After the movie, while we made love in our bed, I gently eased Brent down on his back and went down on him. Brent was in ecstasy as I gently took as much of him into my mouth as I possibly could. When he was completely aroused and on the brink of orgasm, the images of the woman with three black men taking her reran themselves through my mind. I stopped sucking, and leaving a thick coating of saliva on his penis, I pulled myself up to put a knee on either side of Bent's hips. Slowly I lowered myself until Brent's penis was at my anus. In one lunge, Brent was completely inside me. In just seconds I felt his spasms as he released his fluids deep within my bowels.

When the phone rang, at about ten the next morning, I knew who would be on the other end of the line. Audrey suggested we take a drive to Jon and Marrilee's for brunch. She explained she had promised to return the video that she had lent me. As we sat and chatted after our brunch, Audrey told me all about Jon and Marrilee. It turned out they were very close friends of Jared's and hers, and I mean very close friends. Audrey went on with stories of how they met, and about Jared's and her introduction to group sex with Jon and Marrilee. She talked of the parties they had attended in their younger years, about how she got into having sex with women, and of her love of black men.

We were having fun, both of us, playfully giggling and trading sexual stories back and forth. I was picking up on Audrey's casual manner calling a cock a cock, a cunt a cunt, and an asshole an asshole. I'd always been embarrassed to use language like that, but listening to Audrey talk dirty turned me on.

When Audrey asked me about the latest video she had lent me, I told her of how horny I got when I saw the redhead who I thought looked like me sucking one black cock with a second in her cunt while a third fucked her ass. Audrey giggled and agreed she thought the woman staring in the film looked exactly like me. That's why she thought Brent and I would definitely enjoy that particular movie.

I asked Audrey if she could lend me another movie showing numbers of black men with one white woman. To my surprise she excused herself and went into the back of the restaurant. When she sat back down at the table, she slid another video cassette across the table towards me. She mentioned this particular video was rather special.

• the home video

"It's a home group sex video Jared, Jon, Marrilee, and a few other friends are in," she said casually. Then, with her ever-present coy grin, she added, "Why don't we go over to your place and watch it?"

The first frames of the video showed Audrey lying on a bed covered with bright red satin, naked, running one hand over her breast as the other lightly skimmed across her pubic area. The camera panned in for a closeup of Audrey's face. Out of the corner of the frame an exceptionally large ebony penis slowly edged its way toward Audrey's mouth. She cupped the testicles of the anonymous member, wrapped her other hand around the thick black shaft and sucked and licked the strangely shaded head .

"My goodness, is... is... that... J-Jared?" I stuttered.

"No hon, that's Jon. Marrilee loves watching me suck Jon while she tries to go down on Jared."

As the camera panned back again, four people instantly came into view. Audrey was propped up on pillows sucking Jon, while at the side of the bed stood Jared. Marrilee was sitting on the edge of the bed, mouthing only the tip of Jared, watching, as Jon's penis slipped deeply into Audrey's mouth.

At first I didn't believe my eyes when I saw Jared's penis. It was just a little longer than Jon's, but it was twice the diameter! I held my breath as Marrilee's lips slowly encircled Jared's stiffness. Audrey must have noticed the change in my breathing as she moved closer to me. Her sweet smell and the images of Jared, Marrilee and Jon on the TV screen became overwhelming. I wrapped an arm around Audrey's shoulders and drew her in towards me. Having her lying next to

me on the couch while watching her with the others on the screen gave me a sense of actually participating in the sex play taking place on the video.

I closed my eyes, took a deep breath, and slowly began to caress Audrey's breast. As I gently squeezed her hardening nipple, Audrey's hand reached for my own breast. Opening my eyes to the screen I saw the four images shifting positions. Audrey, still propped up on the pillows, held both penises in her hands, her tongue licked the heads. Meanwhile Marrilee lay on her stomach with her mouth feverishly engaged between Audrey's legs. Again, closing my eyes, I let my hand wander down to the spot that Marrilee was now noisily licking. I wasn't sure if Audrey's moans were coming off of the screen or out of her sweet mouth.

The camera panned in for yet another closeup of Audrey's face as she held the two penis heads in her open mouth, all the while stroking the length of both. Occasionally I could hear Jon gasping while she took him alone deep into her throat.

Once more the four images shifted positions; this time they moved onto the floor next to the bed. Jon sat with his back against the bed. Audrey, with her legs straddling his hips, took in the entire length of his now glistening licorice-colored dick into her visibly moist vagina. Jared was on his knees behind Audrey applying lubricant onto his swollen black penis. I could hear Audrey's loud lustful moans as Jared first gently pushed just the head of his penis into her back opening before sinking his whole wide length into her. Marrilee, meanwhile, sat on the bed's edge, legs spread wide open, urging Audrey to lick her wet folds as a young blond hunk entered the picture and placed his penis into Marrilee's waiting open mouth.

When I saw the closeup images of Audrey tenderly licking Marrilee's open folds while being filled in her ass and pussy at the same time, my entire body was covered in goose bumps. Audrey noticed and said, "Come on, Julie, please, I can't watch any more. Let's turn it off for a while."

Without saying a word, we both got up from the couch and, holding hands, walked to the VCR to shut it down. Standing close to one another in the silence, I gazed into Audrey's eyes and said, "Come with me." I guided her into my bedroom and literally pushed her down onto the bed. Our clothing quickly found its way to the floor as I arranged pillows for Audrey just as they'd been arranged in the video. As she lay back onto the pillows, the images of Marrilee on her stomach between Audrey's legs ran through my mind. Tentatively stretching out between her legs in the same manner, I spread her, moved my face in and licked. Her sweet musky juices, I thought, were mildly reminiscent of an overripe mango.

In what seemed far too short an introduction to cunnilingus, Audrey arched her back, pressed herself into my lips and climaxed. Spasm after spasm electrified her body as I licked and savored her sweet secretions. I was so spellbound by the

newness of it all I didn't know when to stop. Audrey became very sensitive and not being able to handle any more sensations, had to push me away from her expended pussy. As I felt her hand pushing at my head, I looked up to see her flushed face gazing down at me. "Oh ... please stop, I can't take anymore, please Julie, no more, no more... ohhhhh," was all she could manage to say.

It was when we were dressing I realized I hadn't had an orgasm with either Brent, the last time we had sex, or with Audrey this afternoon. I couldn't wait for Brent to come home. As Audrey left, my mind was busily running through my agenda for this evening.

Finally, when Jenny was in bed and we had a few hours to ourselves, I enticed Brent into the family room to watch the rest of the video Audrey had left. Not wanting to let Brent know I had seen the beginning of the video, I rewound and once more sat through Audrey's impassioned performance. I had mentioned to Brent my association with Audrey but said nothing at all of our sexual exchanges. Pretending not to know Audrey was in this video, I acted surprised at the opening frames showing her in the brightly colored bed.

Brent watched in awe as the scenes unfolded. I could tell by how quickly aroused he became he was turned on by Marrilee, Audrey and the attention they were getting from those two gorgeous black studs. We couldn't keep our hands off each other as the entire video played through. I think because Brent was aware I knew some of the people in the video, there was an added sense of excitement as we watched.

Becoming brave, I said, "Brent, could you ever imagine us at a party like this?"

Thinking he would have become upset had kept me from talking with him about fantasy sex in the past. It was super to hear Brent say, "Honey, I've thought many times about experimenting with group sex but never knew how to approach you about it. There are guys I know who have been involved in these types of scenes and I always use to feel a little jealous of them when they talked about the fun they had."

We had the most incredible sex into the small hours of the morning. After sleeping for only a couple of hours I awoke with a start to find Brent between my legs, licking and sucking at my pussy. He must have been, without a doubt, turned on by what he had seen in the video... or was it the prospect of attending one of Audrey and Jared's parties which motivated him? Whatever it was, I remembered Audrey telling me this was what Jared would periodically do with her. Lying there with my eyes closed I smiled thinking of Audrey and how much my life had been so wondrously enhanced by her association.

No sooner had Brent and Jenny stepped out into the morning when Audrey telephoned to invite herself over for tea. She was so eager for me to disclose all of

the intimate details of Brent's reactions to the video. She didn't know I had told Brent I knew the people in the video. Audrey almost fell over when I told her Brent and I wanted to plan a very special erotic evening with only her and Jared. That very same weekend we became initiated into multiple-partner sex.

For more than two years, Brent and I lived for our weekend sex parties. When I eventually had sex with Jared, I couldn't get enough of his intriguing textures nor his exotic sweet-tasting secretions. Most of all, I enjoyed the way he filled me with the dimensions of his huge penis. Jon, although not as massively endowed, was just as irresistible to me. We played with countless other couples in one-night stands as well.

Unknown to Brent, I continued to have intimacies with Audrey during the day. Our fooling around ultimately led to daytime rendezvous, first with Audrey and Jared, then later with Jon, Marrilee and assorted friends of theirs, for all-out sex orgies. I kept my daytime dalliances from Brent, paranoid he would have seen me for what I had become. I had become literally dependent on having sex, anywhere, anytime, with almost anybody who would have me.

What started out as mischievous fun slowly turned into a living nightmare. The adult video store, I quickly discovered, was a great place to meet sex partners. For months on end I blatantly approached physically appealing men and suggested to them they could watch their movie selections at my home. I felt as though I was a drug addict chasing after a fix. With time, the search for sexual partners was more exciting and a greater stimulation than sex itself.

• caught

My world crashed down on me one day when Brent came home far earlier than was normal. I had, early on that disastrous day, visited the video store. Two young black men in their late teens were perusing the shelves when one of them spotted a title he was interested in. I approached and told him his selection was the same movie I had come to the store to pick up. When he wouldn't part with it, I invited them both to come home with me so we could all watch it together. I think you can guess what happened next. Brent walked into the family room to find me on my hands and knees performing oral sex on one of the young men while the other was having me anally.

Over the course of the next few days, Brent and I did nothing but talk. I disclosed every detail of my secret sex life. After a solid week of nonstop talks we made an appointment with our family doctor. We did so initially because of concerns with the possibility of having exposed ourselves to sexually transmitted diseases. Holding nothing back from our family doctor, Brent and I openly discussed the reasons for our concerns. To my complete and utter surprise we learned of the realities of sexual addiction. I was completely devastated.

A few days later I was admitted into a facility for treatment of my disorder. Addiction to sex, we learned, is a psychological ailment first recognized as a *bona fide* disorder in the early 1980s. Sex addicts describe a euphoria similar to that described by drug addicts. The speculation in the medical community is this euphoric state is an effect of endogenous chemical compounds in the brain. Its effects on the brain are similar to the effects of cocaine, crack cocaine, amphetamines, compulsive gambling, and other such behaviors and substances.

The following five and a half weeks of treatment can only be described as a living hell. During the first week of withdrawal, sex never once entered my mind as I desperately searched for someone to blame. I tried justifying my behavior by accusing Brent of not being as attentive to my sexual needs as he might have been. Maybe it was Audrey who was at fault – after all, if it wasn't for Audrey, exposure to kinky sex would have simply remained an idle fantasy. I looked for anything and anyone I could as a reason for the devastation I was feeling.

During my second week of treatment, I became aware of the absence of the euphoric state once produced as a result of my sexual escapades. This period lasted for more than ten days and was the most difficult part of the rehabilitation process. Sleepless nights seemed to last forever. On the nights I was able to fall asleep, I would wake up screaming with vivid, violence-filled, sexual nightmares. Profound irritability and depression set in as I wallowed in self-pity.

Over the course of daily psychotherapy sessions, I was led to confront every aspect of my life in an attempt to discover the reason for my fall from grace. I hadn't ever once previously considered the possibility there were issues in my upbringing which were to play a major role in my behavioral patterns. The process was so painful that had I attempted to undergo treatment while living at home, I'm certain the consequences would have been either a return to sexual involvement or alcoholism.

After forty days, the addiction treatment program was concluded. I'll never forget the day I was discharged. I will forever remember the happiness I felt when walking out of the center into the waiting arms of Brent and our beautiful daughter Jenny.

Brent, Jenny and I remain very happily and totally involved. I continue to work out at the fitness club and every so often I run into Audrey. We sometimes sit on the patio to catch up on each other's lives. As much as I'd like to think in terms of Brent and I getting together with her and Jared for an evening of sexual involvement, I know that's something I couldn't handle from an emotional standpoint. It would be the same as an alcoholic "falling off the wagon." It's a difficult way to have to live my life, but thoughts of losing Brent and Jenny keep me from following through on the fantasies I carry with me to this day. Who

knows? There may come a day when I may be able to indulge myself... but... just a little.

bisexual activity and
on-premise swing club trends

Female bi activity has not only become an acceptable behavior at on-premise sex clubs, it is also being recognized as an inevitable part of club activity. As many as 75 percent of female attendees do at some point become sexually involved with another woman. Single females the world over are welcomed to attend on- and off-premise club couples functions at any time.

So enthusiastically has the female membership of on-premise clubs accepted female sensual interaction, there has been a recent trend at American clubs to regularly schedule "Bi Female Only" nights (as have been held for many years at many of Europe's leading swing clubs). One such club which has been quick to detect this trend has been promoting itself as specializing in female-to-female fantasy realization.

Male bisexuality, in virtually all North American swing clubs, is not an acceptable form of on-premise activity. Men who share this interest are strongly dissuaded from openly exhibiting bisexual behavior. Instead, males are encouraged to confine all exchanges of a bisexual nature to secure areas, such as private rooms which have locks on the doors.

European swingers' positions on male bisexual exchanges are far more liberal than the attitudes which prevail in North America. The country with the most unbiased views on male bisexuality seems to be France. Essentially all French on-premise clubs are open to single men daily. In contrast, only a small number of North American clubs schedule regular events to include single males.

Would it be fair to say, based on the European progression and evolution of attitudes toward male and female bisexuality, North American swingers may be on the brink of taking on a less hostile point of view toward the issue of male bisexuality? Are many of the new thousands of couples coming into recreational sex clubs bringing new attitudes along with them? We think so.

Over the course of our Internet IRC study of five consecutive months, when "speaking" with a minimum of two thousand men and women, we purposely searched for an answer to several questions. "To what specific fantasy circumstances were people most responsive?" was a big one. The two of us composed several different introductions, which we posted in an open IRC channel for all present to see and respond. A representative one was:

> Lovers are a couple in the Diamondville Canada area. She is 42, 5'5," 115lbs. brwn/hazel, a very sensuous and elegant woman. He is 45, 6'5" 185 brwn/brwn, a very youthful creature and consummate gentleman. Would enjoy "falling in lust" with an attractive like-minded couple for first foursome both could do just about anything with the right couple... message us... okay?

We generally received two or three responses each time we ran our message and would chat, in simultaneous typed conversations, with the men and women who responded. In our time in various swingers' chat rooms, the thrill seekers and wannabes grew to become easily identifiable and were very quickly detected and ignored.

Over the course of the first month or so, we befriended, as much as one can through a computer, many of the regulars who found our intro to be fascinating. The majority of regulars never once brought up the issue of male bisexuality. When the subject did come up it was introduced by men who were openly searching for couples and the wives of men who had bi curiosities or were in fact bisexually experienced and looking to contact like-minded couples. The line in our intro, "both could do just about anything with the right couple," was taken by only a few respondees as suggesting we might both be curious about more than heterosexual foursomes.

During the second month of our daily IRC sessions, we changed our intro to read:

> Lovers are a couple in the Diamondville Canada area. She is 42, 5'5," 115lbs. brwn/hazel, a very sensuous and elegant woman. He is 45, 6'5" 185 brwn/brwn, a very youthful creature and consummate gentleman. Both are very bi curious, he from a orally passive perspective. Would enjoy "falling in lust" with an attractive like-minded couple... message us... okay?

When we first posted our refashioned ad suggesting some degree of dual bi curiosity, our messages increased to a volume which we found impossible to deal with. An unexpectedly surprising number of men were admitting to their own

bisexual curiosities. Wives were divulging their husbands' secret desires. The biggest surprise came from the ranks of the regulars. People who privately acknowledged experiences and interests in male bisexuality, but only after hearing of our interest first. Is it only a matter of time before the prevailing European attitudes are adopted by North Americans?

The issue of sexuality has, over the past ten years or so, become part of our social reality. k.d. lang, Ellen DeGeneres and countless others have stood up and announced what most had known or at least suspected. Many companies and governments are offering same-sex workplace benefits. Meanwhile, one of the most prominent sexual fantasies among men is having sex with two women who in turn are having sex with one another. At the same time, many women revel in the fantasy of having sex with two males simultaneously, or of making love to another woman.

Reading through personal ads of couples looking for partners, the term "bi-curious" has become extremely commonplace. Ten or fifteen years ago, people may have thought about this activity but would never have admitted they were "curious" to learn more. You should be aware of and prepared for this growing reality within the swinging lifestyle.

If you are a man who feels hostility towards other males who may find you desirable, we suggest you are not ready for this changing world. Further, we don't believe these types are ready to involve themselves with people who are not threatened by bisexuality, either as participants or as people with an open mind regarding these issues. This has nothing to do willingness to experiment with bisexuality, but everything to do with accepting human beings for who they are.

Male bisexuality exists! That's a given. What remains an unknown is the actual numbers of lifestyle males who have, at some point, either participated in bi sex acts or had fantasies of bi sex involvement. Our speculation is that this is an area of male sexuality which will "come out of the closet," so to speak, in the early years of the new millennium.

You may or may not be attracted to the idea of including other men in your sexual explorations, and nobody should force you to do something that isn't of interest to you. But if you can't accept people open-heartedly for what they are, we'd further suggest you are not prepared to open your relationship and should forget about fantasy realization for now. Try to figure out what it is that triggers these feelings of hostility. Many men react this way for reasons of past trauma or of out-of-date information. Think about it! Talk over the issue with your lover. When you discover what your particular reason is, you may no longer feel hostility in a like future situation.

ashley & douglas

I know I'm different from most of the guys I know. Many of the guys I work with may love their wives, but they sound so self-serving and cold towards them. There are always the stories of how the wives nag, how they're never satisfied with their houses, cars, their wardrobes. I'm telling you, it's strange that they feel like they're on a dead end street and all they ever do is complain. I love my wife in a gentle, respectful way. I could never imagine calling her "the old lady" or "the battle axe" or any of the other names I hear guys call their wives. It seems, as the years go by, that our marriage just keeps growing stronger.

Most of the guys at work are always complaining about how they never get enough sex at home. I have several co-workers who see prostitutes, others who practically live at bars hoping to get lucky, and one who continuously just drinks himself into oblivion whenever he's not working. What a waste of life, all of them!

I know my wife and I have a very special relationship. Our sex life is out of the ordinary. We have both enjoyed a wide variety of sexual practices, with one another and also with a close circle of special friends. We view having sex as a simple carnal pleasure which is merely enhanced by having sex with a new partner or partners. Having had the experiences we've had, we see no reason to deny each other this earthly delight in the name of love. I might mention this belief of ours applies to all aspects of life and not exclusively to sex.

Ashley and I came by our attitudes through consciously preserving the wide-open lines of communication we had from the earliest moments of our time together. We were married in our mid-twenties and had a very passionate, sexually exclusive relationship. As time passed, we found that other people were sexually appealing to us. Ashley and I started talking about our interests and eventually started to play a game in which we would each try and pick out people we thought the other found sexually desirable.

We both agreed, should our desires build to the point our curiosities about others got the better of us, we would proceed together as a couple, rather than

separately. In this way our sexual growth could occur without either of us having to cheat and lie and become lesser beings in our own eyes. I mean, things like sneaking behind the back of your partner for extramarital sexual encounters can have a profound negative impact on relationships. Who needs it!

Our first group sex experience was with my wife's childhood girlfriend. Bernadette stayed with us for two weeks while vacationing from British Columbia. She had been in a quite a number of our fantasy talks, and my wife fully well knew how attracted I was by her. She was five feet seven inches tall and large-breasted, with a slim waist, strong muscular legs, and a shapely perfect bottom. Ashley was not threatened by Bernadette, I think, because they look so much alike. So much alike, in fact, many of the people we know initially thought they were sisters.

One evening, while indulging in a little smoke and wine and feeling very laid back, Ashley playfully told Bernadette how good a masseuse she was married to. Our initiation came as easily as that. Soon afterwards the three of us broke out our oils, spread a sheet in front of the fireplace and took off our clothes. Here I was, the great masseuse, with two pairs of hands rubbing the back of my body as I lay on my stomach. Ashley finally urged me to roll over on my back. I was somewhat hesitant to do so because I was fully erect and throbbing. When I did turn over they just joked and laughed while claiming various parts of my anatomy for their own.

For hours, we experimented with every possible sexual experience it's possible for one man to partake of with two women. Ashley went down on her first woman with and without me in her, I had one woman as I orally pleasured the other at the same time, then switched positions and did it all again. The adventure was phenomenal!

After Bernadette left, our sex life went from excellent to outstanding for several months. We sought out and met several women and involved ourselves in threesomes, always following the blueprint of seduction which had worked for us with Bernadette.

Ashley finally opened up about her desire to have what she had given me all along, a threesome with two members of the opposite sex. We certainly didn't have anyone in mind and didn't know where to go to try to turn this fantasy into a reality. Fortunately, we live not too far away from downtown Toronto which is home to many gay and mixed bars. It seemed we went to all of them, looking to find a male to bring home, but all we found were strictly gay men. We chose to go to a regular straight night spot, split up and leave the rest to fate.

We decided that any male that approached my wife would be suspected of being bisexual. If he was friendly and respectful towards Ashley, she said she would bluntly come right out and tell them what she was there for. If the idea was agreeable to him she would invite the man to an intimate party at our home.

When we split up in the bar I tried to approach the first person who fit the fantasy. I got terribly nervous, but I hung in there. I made myself busy speaking with males who fit my wife's taste: tall, slender, and young. Twice I met bisexual males who would have sex with me alone but not with both Ashley and me. The third time, when I told my newfound male friend about my wife, he casually asked if I could introduce him. The bar was so packed I hadn't seen my wife since we split up. When I finally found her she was talking to a good-looking blond gentleman. When I introduced Jerry, she introduced David.

After having a drink, which accommodated a short get-acquainted conversation, the four of us left for our place. As soon as we arrived home, we lit the fireplace, fixed some drinks, and moved the conversation onto the subject of body massages. Our new friends were receptive to the idea, so we spread a sheet onto the floor in front of the fireplace, and promptly took all our clothing off. Never having been engaged in sex of this kind before, I was genuinely nervous, but also, surprisingly, quite aroused.

Ashley, absolutely ecstatic at the prospect of having three men at the same time, quickly volunteered to be massaged first. When our two male friends started actually trying to massage her, I decided the time was right to break the ice. With copious amounts of warming body oil and compliments about how great her body looked, I gradually worked my way down and pressed my mouth between her thighs and began gently licking.

Jerry and David moved in and got comfortable. Ashley arched her back and raised her hips up off the sheet, a blatant open invitation for me to favor her with uninhibited oral attention. After a minute or two, I raised my head up for some air to see Ashley going down on Jerry while David rubbed oil onto Jerry's body.

I became so overpowered by the intensity of sexual activity I began shivering from exhilaration. When I got up for a moment my penis oozed long strands of sticky juices. Moving back, I gently persuaded Ashley into changing positions. While I lay on my back, Ashley squatted over me. With her back to me, she leisurely lowered her beautiful bottom hole down over my penis until she came to sit across my hips.

Slowly, not wanting to let me slip out of her, she lay back onto my chest. Within, Ashley was molten and fiery; on the outside, her flesh felt wet and cool. We lay still. Almost intuitively my hands reached toward Ashley's center. As I traced the outline of her now fully engorged slippery folds with my fingers, David moved between her long slender legs. I held Ashley open as now David followed her intimate outlines with fingertips. Lowering his head, he traced her contours with the tip of his tongue.

Jerry had been lying on his side, breathing heavily, quietly watching in wonderment. At least that's how I remember him. I was kissing and licking Ashley's left ear when he knelt at the right side of Ash's face. He deliberately leaned over our faces. Was his tumescent penis intended for Ashley's mouth, or both our mouths?

Once more, David moved between Ashley's legs. Instinctively my hands reached for David's penis. From the missionary position between our legs, he seemed filled with desire to occupy the opening he had just so delicately kissed and tongued. David's penis was fully hardened, slick and throbbing in my right hand. My left hand was cupped to David's tight testicles. He was looking down at Ashley's center and my hands, which were lost in probing exotic and intriguing textures for the first time.

My remaining memories take on the surreal quality of a science fiction movie. Chant-like tones of sexual euphoria saturated the setting. My thought process became abstract, exaggerated. It seemed to me we became four members of the human tribe, lost in inner space. Ashley raised her head off my shoulder to take Jerry into her mouth. I slowly pulled David forward, urging his pulsating penis to Ashley's wet opening. His hardness pressed and slid against mine as he wholly entered her. As we rocked Ashley between us, I could feel David's throbbings mix with my own through the delicate tissues separating rectum from vagina. Ash was lost in pure sex. Her cries of passion echo in my mind to this day.

When David and I increased the urgency of our combined thrusts, Ashley swallowed as much of David's shaft as she could. Tiny gurgling noises were coming from deep within her throat. Ashley was writhing and moaning, pinned between David and me, unable to do anything more than twitch her hips.

The way Ashley performed on Jerry intrigued me greatly: I'd never been in a closer position to an act of oral sex. I started to fantasize from this strangely unfamiliar perspective. I imagined what Jerry must have been feeling with each thrust into Ashley's mouth. Then I fantasized it was my mouth which was performing oral sex. David, from only inches away, began to lick at Jerry's testicles.

Increasingly, the pleasure was overpowering Ashley, causing her to breathe even harder. Her heavier breathing, coupled with the physical pleasure David and I were administering, led Ashley to stop sucking Jerry until she rode the waves of an unquestionably intense climax. Once her orgasm dissolved, Ashley watched as David went down on Jerry. While David swallowed, he and I continued rocking Ashley between us, crowding her openings. His act didn't repulse me.

I knew Ashley was savoring more pleasure than she had ever before experienced in past group sex scenes. Each preceding group exposure showed she was capable of holding onto a distinct degree of control. Tonight was different.

Ashley had never let go of herself as completely… she'd become altogether unrestrained by modesty.

While I continued licking and kissing her earlobes and neck, Ashley moved her mouth closer to David's. I felt David's stiffness increase. His penis stimulated my own as our penetrating thrusts grew in urgency. Both worked as one.

Ashley, at the edge of yet another orgasm, reached for Jerry. She took his penis from David's mouth, turned her face to mine, and deliberately gazing into my eyes, ran her tongue across its shiny head. Dazed by the overabundance of sexually compelling sensory perception, I had feelings as though I were floating in a dream. I raised my head slightly. Without premeditation, I licked the head of Jerry's blood-engorged penis. My first sensation was the extraordinary smoothness of the glans. Then my lips encircled its shiny surface.

I hadn't ever so much as wondered what it would be like to go down on another man, yet here I found myself in an act of fellatio. I eagerly performed on Jerry exactly the perfect blow job for myself. Jerry pushed his penis entirely into the depths of my throat, effortlessly. His breathing became heavy. I could tell from his moans he was about to climax.

David buried himself completely into Ashley's vagina. I felt his penis throb He cried out. I could feel the first surge of his semen at the base of my own as it started its way forward up his length, splashing against the thin wall of flesh which separated us. Ashley went wild. She cried out at the same moment Jerry did as he pushed his way back into my throat, letting out his flood of semen. Ashley took Jerry's penis from me, and moaning in total abandon, milked his remaining load into her mouth. I couldn't hold back any longer and came in rivers deep inside her firm tight bottom.

I don't know if it was the magic of the moment, or perhaps because David and Jerry's attitudes were a result of having accepted their bisexuality – but unlike the standoffishness of the men I'd encountered in our past group scenarios, Jerry and David's attraction to one another was apparent even after the climax of the scene was over. They continued to have oral sex with each other. Ashley and I lay watching in the afterglow of what she refers to as being the night of the best sex she has ever known possible.

Ashley and I had no idea this was destined to be our last group sex scenario. It was a night of pleasure which opened me up to having a bisexual experience. I thought negatively about it at first but have since come to grips with the occasion. It did bother me for quite a while, but I can finally look at my actions and know I am heterosexual. Men have not and do not turn me on sexually. It was the moment and the sex which drove me to open to bisexuality. I was, after all, having sex with other men and a woman.

It's been many years since that wild night, but I sometimes catch myself looking forward to my next bi adventure. The opportunity may never again become available, but that hasn't stopped me from having my periodic daydreams.

Perhaps one day, maybe, we'll consider swinging again. Who knows?

jan and bridget, 2000

"Pleasure-seeking wild abandon, uninhibited, pure fantasy. Oh well, maybe one day!" – "Bridget and Jan visit the Red Umbrella Club"

Our twenty-year-long fascination with the recreational sex lifestyle has, without doubt, been an exciting journey. Over the course of two decades of exposure to swinging and swingers, we found the questions people ask, and have asked, are repeatedly the same. We hope *Swing Stories* will help answer many of these difficult questions for individuals who may be considering entry into the lifestyle.

Many couples, prior to their first lifestyle community exposure, undertake lengthy decision-making processes. Very few couples can say they made their decision in only a matter of a conversation or two. This communication stage normally lasts several months, and in many cases one, two, even three years or more. During this dialogue stage, individuals invariably seek out as much information on the subject as they can possibly find. That was certainly the case for us – we discussed our decision very carefully over a long period of time before making the decision to begin to explore together.

Off-premise erotic couples clubs were an idea which had just begun spreading across the continent in the mid-nineties to coincide with our reentry into the lifestyle. Only one year later, the number of such clubs had exploded – a growth we foresaw twenty years ago after our "Red Umbrella Club" experiences. It's as though there was, and still is, a collective consciousness out there. People were, and are, looking for new ways to escape the bounds of tradition.

Shortly after writing our remembrances of "The Red Umbrella Club," we wondered if we could perhaps now, at this point in our lives, lose ourselves in that wild sexual abandon we witnessed. We revisited the talking stages, only to learn our own fantasies had changed with the times. The memories we shared from those experiences were as vivid, close to twenty years after the fact, as if they were barely days old.

When we ultimately made our decision to revisit the lifestyle, it wasn't as an impulse. Over the years since The Red Umbrella, we'd studied and discussed volumes of information gleaned from daily newspapers, magazines, videotaped television news specials and the Internet. There wasn't one reason either of us could offer not to follow our instincts. The pleasurable thoughts of participation in multi-partner sex were an extremely compelling force.

We were well prepared. We didn't hold any preconceived notions. Our sole intent was to simply enjoy an evening in an erotically charged environment with like-minded couples – nothing more.

• **the first try** As we were getting ready that first Saturday night, we would catch each other's glances as we checked to see if either of us showed any visible signs of discomfort. There was no way we were going to walk out the front door if one of us even hinted of being uncomfortable. We weren't going because one submitted to the wishes of the other. To do so would have been contrary to everything we believed.

After an hour's drive we arrived at the club, which we found to be housed in a small commercial plaza along with an all night food market, a submarine sandwich joint, a beer store, and a 24-hour donut shop. The drive was sexually intense. We both had the same feelings toward one another we remembered having when we had first gotten together. You know… those feelings inspired by the promise of what might be…

At about 8:30, on a typically dark, cold and rainy March evening, we arrived for our introduction to the mid-'90s version of a swing club, this so called "swingers' lite" variation. A place which supposedly involved all of the eroticism of swinging short of intercourse. A place of innocent intimate fondlings. Just like we had heard about, read all the hype about.

Then reality came crashing down. What a laugh we shared while wondering if any more than just four cars would join ours in the parking lot. We sat not knowing what to do. Should we go in? The longer we sat the more uncomfortable we became. It was hilarious.

The windows of this restaurant during the week, and swing club on Saturday night, had been hurriedly covered with long strips of aluminium foil. There was a sign on the door which stated, "Private Party – Open to Members Only." Yeah, members only. All eight of them! What a laugh we had. Nobody was in the mood that night, we guessed.

After a period of probably 45 minutes of waiting for the parking lot to fill up, we'd had enough. Our curiosity unsatisfied, we drove to a night spot located a few minutes away in the center of town. Two hours later, on our way home, we

passed by the so called "swing club" again and saw one additional car parked in front of the club. We waited to see someone… anyone. The only person we saw was the owner of that one additional car, who climbed back in with a box of donuts in his possession. Down the highway we rode, laughing. A restaurant with aluminium-foil covered windows. Would you care for some fries with that fellatio?

Nevertheless, having slipped out into the night with our secret destination in mind was the catalyst for a distinctively memorable evening of lovemaking. In a way, we had come back from our adventure as new people. We had taken our first step. We made love that evening as though we were celebrating lust and sex for the first time. It didn't matter that no one celebrated with us. We had stepped into the lifestyle, across that boundary line, into a shared state of mind. It changed us.

We explored each other not only physically but mentally. Initiating conversation during sex, we took turns spelling out exactly what we might do with a third, maybe even a fourth or fifth person, while at the same time we coupled in boldly adventurous, not to mention physically challenging, sexual positions. For days on end we enjoyed tremendously gratifying daytime and nighttime sexual encounters. Our libidos had never before been as tightly wound.

While spring turned to summer that year, many subtle changes to our lifestyle were taking place. Without any premeditation, demanding physical activity became a part of our daily routines once more. Weights, ab crunches, cycling, in-line skating… we did it all with hardly a thought of anything but having fun. We became extremely aware of our health and well-being. The benefits to our appearances were startling. All of these changes were taking place without either of us having made a conscious decision to improve our levels of health and fitness, with none of the effort it usually takes to introduce such a radical change to one's lifestyle.

Why, we wondered, had this radical change taken place? We came up with one theory…

As many of our friends' marriages had come apart through the years, we'd noticed that every one of them, within six months of separating, was in far superior physical condition to what they were when they were living together with their mates. Had the same mechanism which altered the appearances of our friends and acquaintances worked within us as a result of our sexual aspirations? There were images of the ideal couple in our minds. Were our minds subliminally monitoring our habits to be more in keeping with the powerful and erotic images of our fantasy ideals?

• **trying again** By mid-summer of 1996, fitter and more turned on than we'd ever been before, we eventually found another club in our geographic area. Feeling somewhat jaded by our previous exploration, we

called to ensure we'd at least be at a club in the company of more than only five or six other couples. Oh no, we were assured by the club's president. Some weekends they were forced to turn people away at the door due to capacity rules and regulations. Forty to sixty couples regularly attended their Saturday night couples' parties at a location in a very secluded unpopulated area northeast of the city. He even went so far as to guarantee a minimum of thirty couples would be present on any given Saturday night.

Between the time we discovered "Club Wildside" and our first visit, two more clubs came out into the open as if overnight. The well-educated, computer-inquisitive, sexually curious couples who had legitimized pornography all the way to the top of the New York Stock Exchange were going through their own version of "coming out of the closet." This generation of lifestyle devotees is accustomed to everyday escapes and diversion in a way which the world has never seen before. Satellite digital television, hi-tech computer flight simulators, Nintendo™, Play-Station™, "adult" videos played back on systems with home-theater-quality sound and vision. Now, thanks in great part to the Internet, these people are having a chance to explore sexual curiosities like never before.

We were moderately surprised to find somewhere in the range of ninety to one hundred couples enjoying this '90s version of a swinger's night out. This place was rocking. A few uncomfortable moments came when we were ushered to a desk which was set up immediately inside the entryway of the main party room. After paying our admission fee, we were required to sign a memo of understanding which spelled out, in specific terms and language, exactly what we would be exposing ourselves to. Failure to properly identify ourselves and to sign this memo of understanding would have resulted in our being asked to leave.

But that wasn't the uncomfortable part. It was the lamp at the desk. For the few moments it should have taken to do the paperwork, it was as though we had been intentionally manipulated into standing in the spotlight, a kind of center stage, to be presented to the membership for their first look at yet another new couple. That old familiar sense of being simultaneously scanned by dozens of eyes was difficult to ignore as we stood in the most conspicuously well-lit spot the darkened room could possibly have offered. We were at a disadvantage for the entire time we stood in that intensely bright light. Others could see us but we were blind to the dark outside of the limits of the light's beam. Finally, the light went out just as we began to maneuver our way into the crowded area at the bar.

Standing room was the only option open to us. The available tables, booths and chairs had long been spoken for by men and women who conducted themselves in a way which suggested they were well versed with the pace and purpose of the parties. We had indeed negotiated a path directly into the center of an erotically charged environment we'd previously envisioned in our many lifestyle discussions.

No sooner had we become acclimated to our surroundings than we began to exchange opinions concerning the sex appeal of several individuals who had caught our eye. It was hard not to. Unknown to us at the time, what we were doing was establishing our preferences and guidelines for the future. More years than either of us would care to admit had passed between our first venture into a sexually liberal environment and this day. Mysteriously, the years had stood still when it came to our preferences. We were both strongly attracted to couples who were in their mid- to late twenties, the same age at which we first ventured into a moderately similar environment. The nicest part about the evening was the thrill we savored when our silent interest in a few particular individuals was returned.

The general attitude of this unconventional fraternity of like-minded individuals could easily be interpreted, at first glance, as being unfriendly and cliquish – however, we were quick to comprehend the reality of our circumstance. The fact was we were standing in the midst of perhaps 20 or 25 couples who, like we, were here for their first or second visit. Realizing what was happening put us at ease and into a comfortable and enjoyable people-watching mode for the remainder of the evening.

Beyond the crowded bar area was a very dark dance floor. Gathered around the perimeter was a human border two and three people deep. In the middle of the dance floor, two couples, both women topless, wearing only stockings, garter belts and high heels, were increasingly becoming the center of everyone's attention. The anonymous foursome were dancing to music we'd never heard before, a Spanish flamenco-style guitar backed by a slow, heavy rock beat. Sexy, very sexy. The music and the dancers came together in such a way they seemed to share a common point. Both were mysterious and unknown, and both delighted the senses of the attentive audience.

The female individuals weren't cover-girl beautiful. Their husbands were average Joes, Saturday morning fishing buddies. Just everyday people, but you forgot that as they moved their bodies in sync to the hypnotic instrumental rhythm. The music, the energy of the eroticism, the attention of their audience... these were magical moments.

The taller woman's husband was behind her, his arms wrapped loosely around her waist. She moved her body in beat to the rhythm, her back slightly arched against his chest. Her arms were up over her head, her hands gently guided his head as he kissed and licked the flesh of her neck below her ear. She swayed side to side while he bumped in beat to the music against the naked flesh of her buttocks.

Situated directly in front of them were the second couple duplicating the first couple's every move. The taller woman bent toward and moved her face to the readily available breast of the woman before her. She suckled a nipple, never

losing a beat, while dancing. The men held each other's partners as the women took turns licking and nibbling the other's breasts, offered from the hands of their own husbands. Hands were kneading, rubbing, opening, never missing a beat of the mood-inspiring music. As the song built to its final climax, the women held their bodies closely together, their fingers provocatively working between sultry shaven intimate folds.

What took place on the dance floor then set off a chain reaction of activity. The floor quickly became close to overflowing while we slowly negotiated our way back to the "newbies" and the standing-room-only section.

The desk lamp flared out into the darkness as yet another couple were placed on display to sign the required newbie forms. We watched the routine from the other side of the spotlight this time, and wondered if we might have come across as nervously and insecurely as this couple did. People did stop what they were doing, it seemed, to meticulously appraise the steady flow of new couples being guided into the spotlight.

It wasn't unfriendliness or cliquishness at all. The atmosphere of the bar area was somewhat tense, it seemed, because of the newness of the experience to many in the standing room area. People looked as though they hesitated to say hello as if fearing this casual friendly gesture might be interpreted as the first step to a person next asking them if they'd like to participate in a "full swap."

The volumes of dialogue expressed through some individuals' glances and body language, directed in our way, were enough to entirely drown out the conspicuously nervous conversations in the immediate environs of the bar area. On a few occasions, those glances became locked lingering gazes into eyes which were discreetly gazing back into ours from various dimly lit portions of the establishment. These moments created a sense of *dejá vu*, a recall of our Red Umbrella Club experiences, however tame by comparison.

• **the game** Oh, the thrill of watching in someone's eyes that certain, fleeting look which gives away one person's intrigue in another. Those dreamy eyes, slightly glazed over. That slight, almost mischievous, smile that forms on the lips, before the sudden movement of the head to one side. And then, eyes half-closed, glancing away in another direction with a look of one perhaps savoring the sensations of physical contact.

A large screen television glowing out of the darkness of the rear portion of the facility, projecting video images of youthful, lithe-bodied people engaged in explicit sexual activity, seemed to underline how decidedly tame this '90s version of swinging was compared to our Red Umbrella Club era. For brief moments, we recognized the emotions of our earlier experience when we caught ourselves in the contemplative gaze of some alluring creature.

We didn't stay at the club much past midnight. Most of our evening was spent at the bar, watching couples becoming progressively more daring, as the night wore on. Kissing and fondling while dancing was the furthest extent of visible sexual activity within the confines of the establishment – unless you counted the activity between the porn stars on the video monitors. This was simply a "singles" bar for couples. A place where people meet, the same way they have at singles bars for many years.

Several days into the week and we hadn't yet stopped talking about our night out at Club Wildside. We couldn't deny the fact we had enjoyed ourselves despite the unanticipated fact much of the evening was spent in a somewhat introverted, people-watching mode. It was all so much like a game, this couples club lifestyle. This game was fun.

Some days later, while discussing another out-of-the-blue remembrance of our club experience of Saturday night, we more or less stumbled across a sincerely interesting train of thought. Our night out had been fun and it really was all just a game. As children, playing games was one of the first things we learned to do. When children grow tired of the same old game they change to another game and then another. A desire to play games is bred into each of us. Everybody likes to play, don't they?

We recalled the countless number of games we played in the innocence of our formative years. Then, a little later, when we discovered there were differences between boys and girls, there were new games to play. Did you ever participate in the game of "Doctor" as a child? Innocent, wasn't it? An innocent kids' game inspired by unknown curious emotions. It was the last game involving physical intimacy boys and girls played together before the real boy/girl games began.

Then there came adolescence, when mom and dad would go out and leave us at home with an opportunity to "play house" with that cute little creature from down the street. Then, even later, our first apartment, or shared accommodation. Remember the games we'd play for the sake of love? Did you ever invite someone over for dinner with thoughts of how nice it would be if that particular person stayed overnight? Can you remember the fantasies you painted in your mind on the nights you most wished a certain special someone was lying beside you? Oh, the games we'd play to make our wishes come true!

Witness this excerpt from the transcript of Dr. Betty Dodson's keynote address to the "Orgasm – Recent Models and Methods" symposium at the 1998 joint conference of the Society for the Scientific Study of Sexuality and the American Association of Sex Educators, Counselors, and Therapists.

People who are having lots of sex with more than one partner are usually more sexually sophisticated. To learn about sex we need to be intimate with more than one person. I know this is tough for people

who are married and monogamous, but restricting sex to one partner rarely works. Seeing people having sex in groups would be a prerequisite for a complete sex education, to my way of thinking. No one would mind doing any of these things if once a month we could go somewhere and agree to do safe, fun sex. If we could occasionally relax the rules and have sex with different people, and see everybody having sex together, we'd experience as well as see the vast differences [in our ability to enjoy our sexuality]."

"*I know this is tough for people who are married and monogamous, but restricting sex to one partner rarely works.*" What rarely works? Monogamy? How eminently thought-provoking! MonoGAMY. The mono game. Together. Together alone, then ultimately, alone. Are these the present-day rules of the marriage game?

We didn't realize, at the time of our second visit, how quickly attitudes were changing within this specific community of expertise. Dr. Dodson, a widely influential and respected professional sex therapist, validated views we've held for more than two decades. Our biggest obstacle was our personal disappointment in not being allowed, by the laws of the land, to spend a few hours in an environment specifically built to accommodate our interests.

• **the third try** Searching out alternatives, we happened across Club Providence, a well-established club which had experienced such tremendous growth in numbers they'd been forced out of their limited restaurant party quarters. Indeed, swing club operators across North America were compelled to establish quick business plans to accommodate this latest wave of continent-wide interest.

Club Providence's Saturday Couples' Nights took place in a discreetly located modern suburban hotel ballroom. Every weekend, at least two hundred couples were lured by their fantasies and the promise of fulfillment. We decided to take a look for ourselves.

Whereas Club Wildside was small, crowded and dark enough to hide most moments of erotic melodrama, Providence wasn't at all. Our reminiscences are of a huge, well-lighted hotel meeting room, complete with skirted tables randomly arranged around a parquet dance floor. An impressive state-of-the-art digital sound system, complete with professional DJ, pumped out the oldies to an eagerly responsive audience who competed for a small piece of the crowded dance floor. Two dimly lit bar areas did a brisk trade.

In this well-lighted environment, we were able to discover, completely by accident, a secret new set of silent rules to a fascinating couples' meeting ritual. We'd unknowingly been involved in this game before, on our every exposure to

swingers and swinging since our earliest days at the Red Umbrella Club, but seeing it for the first time through others' eyes was inspiring.

It's a game we've all played before: the eye contact game. Remember when we were single? How many times did you find yourself in a party atmosphere and notice an attractive individual making eye contact with you? It's the same game, but now with a highly complex set of rules and directions.

You could see the electricity between one particular tall lithe blonde woman and the male half of a couple. She was paying for two drinks at the bar when she drew the attention of a gentlemanly-looking, tall continental type. His eyes sparked automatically when he looked into her eyes. She picked up both drinks, noticed this gentleman's interest in her and hesitated for a brief second. Then, as if changing her mind about leaving, she set her drinks on the bar top. At the same instant, her mouth opened slightly, and an inquisitive smile lit up her bright mouth. They became still for an instant, as if surrendering to the forces of the energy they created.

We were fascinated by this theatre of life, this drama, this lustfully stirring play. The blonde woman very casually leaned back against the bar and briefly feigned an interest in the activity on the dance floor. The gentleman, while continuing to hold her in his focus, whispered into the ear of his attractive partner. She smiled as she closely studied the blonde woman who, it was becoming clear, was playing a game of nonchalantly offering herself to their scrutiny. All the classic body posturing we'd ever heard of pertaining to giveaway signs of sexual attraction was being enacted between these three lovely individuals.

When the blonde woman turned her attention back to the couple, she saw them gazing and smiling, catching and holding her gaze. The blonde smiled, her beaming grin locked into first the woman's eyes, and then, with a look as though she was saving him for last, the gentleman. Her eyes sparkled in the light. Her excitement quickly became physically obvious in the way her taut nipples protruded through her flimsy silk top. She was savoring the moment, growing bolder with the attention she received from these warmly receptive sophisticates.

She left her drinks on the bar when she decided to slowly walk in the general direction of the couple, continuing with her steady gaze at them. In unison, three people were smiling broadly to one another. The chemistry between them was dynamic. The blonde walked close to them and then past the couple in the direction of the powder room. The entire time she was absent, the couple threw glances in the direction of the entranceway as they exchanged comments, all the while smiling.

Their anticipation was eye-catching. She innocently hung her head and blushed when, with his arm around her holding her closely, he whispered something in her ear. Maybe it wasn't a blush after all. It might have been the rising heat of

passion which overcame her cool demeanor. They waited for the sexy blonde's return.

This real-life drama affected us in a most erotic way. Our own rising urges created an unexplainable sense of closeness as we stood holding one another, watching.

The blonde returned, and this time, as she passed the couple, the gentleman said hello, gazing directly into her eyes. For a brief second, her interest in the couple was strongly implied in her body language. The blonde, visibly blushing, raised her drink almost as if in a silent toast to the couple. Now, we were certain, it would be only a matter of moments before one of the three would make the next move, write the next line of the story as it unfolded. Our intrigue intensified.

Like a painstakingly built house of cards, the fantasy came crashing down in slow motion. Remember, we were watching a game. Only now did the rules start to play out. The blonde lady was joined by her partner. She continued glancing in the direction of the classy couple. As she excitedly related her story to him, he began to nonchalantly study the couple in question. They, however, had suddenly become engrossed in the dance floor activity. The blonde lady showed signs of disappointment, but we knew she understood. Their response may well have been conditioned by a history of similar memories. Her partner was odd man out.

The continental couple responded politely and sympathetically: there was an "Oh well, maybe next time" kind of body language. There was no way anyone seeking fantasy images could have imagined the blonde lady's partner taking part in a sexual episode involving the blonde and the classy couple. The fellow with the blonde seemed a slight bit agitated and noticeably more animated following this incident. We agreed that he showed signs of having been stung by rejection.

That chemistry which so engrossed the continental couple and the blonde lady is the prime most prerequisite for any relationship to work. What, would you imagine, are the chances of this imperative chemistry materializing in the circumstances of three individuals? It's a rare and delicate thing. Of course, the odds of achieving a similar level of chemistry between *four* human beings are astronomical.

Later, when we found our own sparks of chemistry, we found that we could detect that special glint in the eyes of another person without exchanging a word. On the rare occasion when three found that near-transcendental space, a fourth person would soon be involved in the game, with aspirations of complementing whatever intimate chemistry may have already developed.

An unwritten, unspoken, sensual ritual it seems now, where primal instincts take over. Everyone was either playing the game, or wanted to. To the knowing eye, the ways individuals said "no, not interested" or "I'm intrigued," to one another, without having uttered a sound, was spellbinding. When it came down to actually

participating in this game, we discovered just how extremely sexually stirring it all could be.

On the side available to our view, an attractive woman, her arms in the air, thrust her hips forward to the beat. A man danced in front of her, one hand holding her short skirt, exposing her silk stockings supported only by garters. His other hand was at her most intimate of centers as he held her pink folds open with his fingers in a upside down V sign. Another man dancing behind the woman kneaded her breast. Eyes closed, she bopped to the hypnotic rhythms of the music, seeming to slip back and forth between fantasy and reality. Catching herself and letting go, on and on she danced… a sensuously erotic study in desire.

Given our experiences at the Red Umbrella twenty years before, we felt quite comfortable in the relatively tame environment of Providence. We found ourselves missing the more explicit intimacy we'd previously experienced, and we believed others felt the same way… we could practically see the players wishing they could take their activity to the next level of intimacy, longing for their fantasies to become a reality.

A bottle of spring water in his hand, a glass of wine in hers… we noticed the identical, previously learned telltale signs of intrigue being directed our way. The game began. We glanced at one another and knew it was okay to play to whatever ending this story might have. The feelings of intimate freedom, trust and wonder were overpowering. We were the center of intrigue to a young Asian woman in her late twenties and her partner, a dark-complexioned Latino of about the same age. We could feel her removing clothing from our bodies with her wide alluring dark eyes.

This was one of those rare lightning strikes where the chemistry of four separate entities created sparks. The pleasures found in being regarded with desire, and casting admiring glances of our own, was exhilarating. Drifting on surges of adrenaline, we four entertained one another's curiosities for quite some time.

Unnoticed by us, at the time, the four of us began shifting our positions in the room, unconsciously forming a configuration which might allow us to maneuver into each other's space. Were they perhaps hesitant to approach us because of our ages? Feeling relaxed but intrigued, we let the grace of our years lead us. We decided we had nothing to lose by just walking over, saying, "Hi," and seeing where an introduction might lead. We wouldn't have expected what happened next in a million years.

The electricity between the four of us was undeniable. It was present in the sparkle of the eyes, the lingering penetrating looks directly into the others' eyes. It was there in the way those eyes welcomed and seemed to enjoy those deep and potent penetrations. When we'd occasionally catch glimpses of each other while interacting with the couple, for brief seconds at a time, we could see one another

as if from the past, the way we used to be, when we only had eyes for each other. We knew, left to our own devices and in the proper place in time, the mysterious chemistry we shared with these two could easily blow up in an explosion of sensual carnal intimacy.

It didn't take long before they provided a clue to their rather experienced past. When they boldly broached the topic of what it was we were looking for, we didn't know quite what to say. Something about the way they quizzed us seemed to diminish the intense levels of electricity which had permeated the air only seconds before. They voiced their personal preferences, what they were looking for in swing partners, and watched for our reactions.

This couple's immersion in the lifestyle became progressively less ambiguous. High school sweethearts, married for only the past couple of years, they eagerly admitted to seeking out women to satisfy her lesbian yearnings. She, as their story unfolded, wasn't into fooling around, as she put it, with men other than her husband.

Perhaps, to someone watching us interacting with one another, there were subtle outward signs of the four of us having discovering our mismatched fantasies. The female half of the couple began to stare off into space. Her expressions were soon those of a woman playing the game we'd discovered. The glint of the eye, the provocative little half-smile… she possessed the unmistakable appearance of having been captivated anew. A few minutes later, two individuals, flagrantly rude in manner, approached our party of four and placed themselves squarely in front of us, facing the couple we were speaking with. Drinks in hand, standing with their backs to us, they proceeded to slowly back up to purposely repel us away from the core of their foursome. We just smiled into each other's disbelieving faces and hastily left the four to their pursuit of lust.

Stepping outside for a smoke, we quietly watched a drunken argument. At first, we couldn't hear the couple in their disagreement… but as her eyes bugged out and the veins at her temples bulged, the decibel level of their immature argument rose in overheated intensity. It was soon obvious, to anyone who'd care to listen for a moment or two, what the argument resulted from. She had been strongly attracted to a male half of a couple, while the female half "hadn't hit it off" with her husband. She more or less blamed him for not being able to "pull it off," thus standing in her way of a sexual involvement with the other male. Her words were blatantly abusive and meant to do nothing but hurt. He nervously scanned our faces as we looked away, pretending not to have noticed his plight. He looked into the faces of the several couples caught in the uncomfortable circumstance before he turned his back on her and walked directly out the door and along the path into the darkened parking lot. She immediately made her way back to the main ballroom.

Perhaps we might have followed, but the leather couch, warmed by the blaze of the stone fireplace, looked too enticing to disregard. We stayed behind in what now felt like an area of safety. Neither of us could believe what we had just witnessed. Comforted by the fire, we sat silently and watched people come and go for a few minutes.

In the half hour or so we had been outside of the main party, the mood of the crowd and the temperature of the room had risen a considerable number of degrees. The dance floor was packed to overflowing with bare flesh. Couples were roaming through groups of people, mingling, smiling, only pausing to whisper in each other's ear when it became noticeable they had become intrigued by someone. These particular folks, the roamers, were exceptionally easy to meet and speak with. All one had to do was take notice of being at the center of their attention and say hello. That's how we met many couples. A couple we met that night we'll call Les and Janice, we were later to learn, had attended an average of two swing club functions a month for the past five years... and were still waiting for that special evening that would see them meeting with their perfect fantasy partners.

• kindred spirits

It was easy to relate to Les and Janice. They had a wide-eyed innocence that made it difficult for anyone not to appreciate their presence. They were a model example of a couple who appeared to be quite satisfied with their positions in life, their future, each other's company, and above all, happy with their own unique brand of core values. "If it's meant to be, it will be," was advice we'd often hear them convey in the weeks and months which were to follow our initial meeting.

Their immediate circle of friends were an exceptionally easy group of couples to meet, very much like Les and Janice in many ways. The women were in their late thirties to early forties, the guys in their early to late forties. Without exception, they shared an attitude of quiet confidence. These folks were people who, it was clear to see, were happy to enjoy each other's company without the need for alcohol to help facilitate a removal of inhibitions.

The couples we met weren't what either of us would have considered to be our ideals when it came to fantasy. They were just like we were – busy with their lives, but adventurous and secure enough to allow one another to think in terms of the possibilities they could discover at an off-premise swing club.

They offered a sharp contrast to what had become the general mood of this evening's revelry. A woman dressed in panties, garter, black stockings and a push-up peekaboo bra staggered past our group. When she got to the bar, her elbows supported her weight as she stood leaning against it. A man approached her from behind and reached around her body to cup her breasts with his hands. She pushed her upturned behind into his crotch a few times before turning to put

her arms around his shoulders and kiss him fully on the mouth. Another man at the bar stretched his arm toward her. Kneading her buttocks, he moved into position behind her. The first man was grinding against her front while the second repeated his actions from behind.

The woman was unquestionably looped. When she had a problem in maintaining her balance, the man positioned in front of her guided her limp body several feet to a table which had earlier held a buffet of food items. She seemed to welcome their advances with open arms, legs, and mouth. Several additional men joined the first two in exploration of her body. Fingers, mouths, hands, all were full to the limits of acceptable behavior. In at least one instance, one of the most important rules of off-premise swing parties – no penetration – was broken as fingers explored a woman's nether regions with fervor. Not until this licentious behavior was broken up by one of the party hosts did we recognize the woman in the earlier argument in the lobby of the hotel. We wondered how she would feel in the morning when thinking back to the incident. Would she even remember? Some fantasy!

The dance floor's frantic activities escalated as the midnight hour approached. Just as most dancing groups of various numbers made their way back to the tables, a group of seven very large women, well over 250 pounds each, took to the dance floor in various stages of undress. Couples who planned on sharing the next dance changed their minds and allowed the women to have the floor to themselves. They were alone, exposed, the center of attention – they may as well have been naked. One of the women, knowing her group was putting on an exhibition which was ridiculed by many, stumbled off the dance floor to seek refuge at her table with her significant other.

The audacious dance of the overweight ladies seemed somehow inexplicably timed to coincide with the mass exodus of celebrants. It was "Party Time," we learned. Janice asked if we'd be interested in checking out a new party house.

On previous outings to various off-premise clubs, we'd often wonder why so many couples left the clubs shortly before or after midnight. Our assumption was that it had to have something to do with house parties. The fact that most left the clubs to partake of a party at a single location was astonishing.

We left the club with the understanding we would head for home if the look of the location were to throw us off. Were we headed for some dilapidated sleazy-looking bungalow on a crowded avenue of similar homes?

We followed a caravan of vehicles to the outskirts of town and beyond. Our destination turned out to be a magnificent three-story home set back at least a half mile from the roadway. Probably a farmhouse more than a century ago, it had been completely and meticulously preserved and extended – the new

construction blended perfectly with the home's obviously rich history. Feeling safe, our fascination gave us confidence and the will to proceed.

There had to have been a hundred cars on the lane between where we parked and the side entrance of the home's lavishly appointed backyard. The unmistakable sounds of men and women playing in a swimming pool grew progressively louder as we strolled up the walkway we'd been cordially directed to take. Both of us were relieved to see Janice and Les and a few other familiar faces waiting for us just beyond the trellised gateway.

Just what was the motive of the host and hostess? Why, weekend after weekend, would they open their doors to such a large number of couples? Our new acquaintances speculated on the possible answers to those and a few more questions we collectively came up with. This was one party where you had to have an invitation to attend. Les and Janice, like many of the folks in attendance, had a standing invitation which included any friends they cared to invite on any given house party night. What we found was far removed from any fantasies we'd ever shared in our pillow talks.

Throughout the entire premises, the pent-up sexual tensions brought on by several hours of earlier dance floor foreplay were finally being released. Everywhere one could look were drastically unfamiliar scenes of uninhibited sexuality. Couples split up to go their own ways in search of sexual fulfilment.

Female-to-female exchanges were prominent, and in several instances deliberately performed for the benefit of enthusiastic audiences. A crowd had gathered by the hot tub, which was situated in a cabana where a two-man, one-woman threesome began to be played out. Behind the wide open windows of one dimly lit room, one could clearly observe several men, their backs to the action in the hot tub, leaning against the window ledge. Every man who was leaning against that ledge was receiving fellatio. The women, facing and occasionally pausing to watch the threesome activity in the hot tub, performed their oral sex acts while nude, or very close to it. Oddly, it seemed, the men remained dressed. Only their zippers were let down to accommodate the undertakings of the women bowed before them.

After an hour or so of conversation, Les and Janice said they couldn't wait to get home and get their hands on one another. Not wanting to be left behind, we walked down the driveway back to our cars as we made plans for another night out with them and a few of their cohorts. They gave us a calling card and asked that we keep in touch.

The low and high points of that evening – the drunken couple and the ridicule of the overweight women, the friendly attitudes of Les and Janice and their friends – played an important role in forming our attitudes, beliefs and, more importantly, trust in this '90s version of the lifestyle in general. Club

Providence, Club Wildside, and many of their throngs of new followers, were like a charcoal sketch of this piece of life. What we perceived as black and white sketches were now beginning to take on hues, the colors of a truer, more realistic depiction of this canvas of lives and times.

conclusion: rationality, lucidity, mind and reason

"It can be the most beautiful experience you think you may ever have, but, it can turn into the ugliest memory you'll carry with you for the rest of your life if you're not careful."

For every yin, there is a yang. For every action there is an equal and opposite reaction. What's waiting for you, on the other side, after you decide to take the plunge into the swinging lifestyle? Will the memories remain as being *"the most beautiful experience you think you may ever have?"* Sorry, there just isn't any ready answer to this question.

Here's what we *do* know:

- Swinging works out best when couples are in a steady, happy relationship, and are able to talk to each other honestly about their desires and fears.
- Swinging and intoxicants aren't a good mix. If you need alcohol or drugs to overcome your inhibitions, that's a danger sign.
- Swinging is a collaborative enterprise. If you and your partner can't agree wholeheartedly on whether or not to explore swinging, you're not ready to try it yet.
- Proceed slowly. There's always time for further exploration later. Try a small challenge, talk about it, and if you enjoyed it, try another challenge later.
- Communicate, communicate, communicate.
- Have fun!

Jan & Bridget Abrams
February, 2002

Other Books from Greenery Press

GENERAL SEXUALITY

Big Big Love: A Sourcebook on Sex for People of Size & Those Who Love Them
Hanne Blank $15.95

The Bride Wore Black Leather... And He Looked Fabulous!: An Etiquette Guide for the Rest of Us
Andrew Campbell $11.95

The Ethical Slut: A Guide to Infinite Sexual Possibilities
D. Easton & C.A. Liszt $16.95

A Hand in the Bush: The Fine Art of Vaginal Fisting
Deborah Addington $13.95

Health Care Without Shame: A Handbook for the Sexually Diverse & Their Caregivers
Charles Moser, Ph.D., M.D. $11.95

The Lazy Crossdresser
Charles Anders $13.95

Look Into My Eyes: How to Use Hypnosis to Bring Out the Best in Your Sex Life
Peter Masters $16.95

Supermarket Tricks: More than 125 Ways to Improvise Good Sex
Jay Wiseman $11.95

Turning Pro: A Guide to Sex Work for the Ambitious and the Intrigued
Magdalene Meretrix $16.95

When Someone You Love Is Kinky
D. Easton & C.A. Liszt $15.95

BDSM/KINK

The Bullwhip Book
Andrew Conway $11.95

A Charm School for Sissy Maids
Mistress Lorelei $11.95

The Compleat Spanker
Lady Green $12.95

Family Jewels: A Guide to Male Genital Play and Torment
Hardy Haberman $12.95

Flogging
Joseph W. Bean $11.95

Jay Wiseman's Erotic Bondage Handbook
Jay Wiseman $16.95

The Loving Dominant
John Warren $16.95

Miss Abernathy's Concise Slave Training Manual
Christina Abernathy $11.95

The Mistress Manual: The Good Girl's Guide to Female Dominance
Mistress Lorelei $16.95

The New Bottoming Book
D. Easton & J.W. Hardy $14.95

The Sexually Dominant Woman: A Workbook for Nervous Beginners
Lady Green $11.95

The Topping Book: Or, Getting Good At Being Bad
D. Easton & C. A. Liszt $11.95

FICTION FROM GRASS STAIN PRESS

The 43rd Mistress: A Sensual Odyssey
Grant Antrews $11.95

Haughty Spirit
Sharon Green $11.95

Justice and Other Short Erotic Tales
Tammy Jo Eckhart $11.95

Love, Sal: letters from a boy in The City
Sal Iacopelli, ill. Phil Foglio $13.95

Murder At Roissy
John Warren $11.95

The Warrior Within (part 1 of the Terrilian series)
Sharon Green $11.95

The Warrior Enchained (part 2 of the Terrilian series)
Sharon Green $11.95

Please include $3 for first book and $1 for each additional book with your order to cover shipping and handling costs, plus $10 for overseas orders. VISA/MC accepted. Order from:

 greenery press

1447 Park St., Emeryville, CA 94608
toll-free 888/944-4434 http://www.greenerypress.com